Artist Navigators II

SELECTED WRITINGS ON CONTEMPORARY TAIWANESE ARTISTS

旗艦巡航－台灣當代藝術選粹（二）

一五·四十方·
劉薰於板南家中.

Chang Chien-chi
Peng Hung-chih
Michael Lin
Wang Wen-chih
Huang Chin-ho
Kuo Wei-kuo
Hsu Yu-jen
Chen Hui-chiao
Lee Kuo-min
Wu Tien-chang

目次 CONTENTS

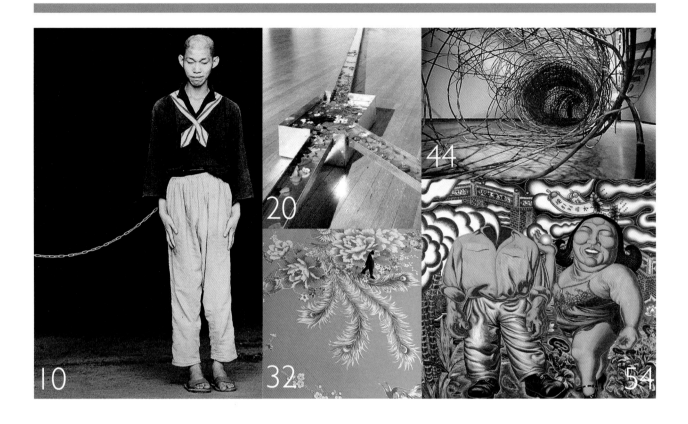

序

臺北市立美術館自1983年建館以來，已走過25個年頭，回顧當年的設立，在台灣美術發展史上等於宣告了「美術館時代」的來臨。而伴隨美術館成長的館刊《現代美術》則忠實記錄了台灣美術發展的轉變與軌跡，也見證了台灣藝壇在面對國際潮流的衝擊之下，勇於創新的亮麗表現。

這本有著專業、豐富內涵的雙月刊，自第100期開始進行改版，每期以一位台灣當代藝術家為封面人物，並以「旗艦巡航」單元針對此一藝術家作品作深入探討介紹。「旗艦巡航」一詞，乃本館前任館長黃才郎先生思考發想而來，意味著這些藝術家大多從美術館發跡啟航，就像等待揚帆的水手，蓄勢待發，準備航向浩瀚的藝術天際。而事實也證明，他們日後不但在國內藝壇上發光發熱，也在國際舞台上嶄露頭角，備受矚目。

繼去年（96年）12月，本館出版《台灣當代藝術選粹》一書，蒐羅過去各期《現代美術》的「旗艦巡航」單元，介紹了包括陳界仁、袁廣鳴、劉世芬、林書民、姚瑞中、王俊傑、陳順築、黃致陽、侯俊明、湯皇珍、崔廣宇、高重黎、王德瑜、吳季璁及曾御欽等十五位藝術家。今年接續推出《台灣當代藝術選粹II》，透過胡永芬、王鏡玲、王嘉驥、張晴文、秦雅君、游崴等國內優秀的藝評家，撰筆介紹張乾琦、彭弘智、林明弘、王文志、許雨仁、黃進河、陳慧嶠、吳天章、郭維國、李國民等十位當今臺灣重要藝術家的創作點滴與成果，期能提供給關心台灣藝術發展的同好們，作為日後研究或收藏的資訊。

臺北市立美術館
館長　謝小韞

Preface

Founded in 1983 in the midst of Taiwan's "museum boom", Taipei Fine Arts Museum (TFAM) is now well into its 25th year. As the official journal of the TFAM, *Modern Art* has since not only faithfully recorded the details of Taiwan's artistic development and trajectories of the transformation of Taiwan's fine arts, but also attested to the remarkable achievements made by Taiwan's artists under the strike of international trade.

Modern Art is a bimonthly journal graced with professional execution and rich contents. From Issue No.100 onwards, Modern Art has undergone a radical makeover. Each new issue features one Taiwanese practitioner of contemporary arts on the front cover, to be supported by a detailed account of the work of the artist in the new section 'Artist Navigator'. The term 'Artist Navigator' was first coined by Mr. Huang Tsai-lung, former Director of TFAM, to signal the pioneering achievements of these artists. Mr. Huang compares the artists to sailors, suggesting that these artists were once like sailors waiting for the wind, as they got ready to spread the wings in the vast world of contemporary arts. Facts have spoken louder than words with regard to the subsequent progress of these artists, as they have all indeed continued to conscientiously sow the seeds of their future accomplishments in the art scene both domestically and internationally.

Selected Writings on Contemporary Taiwanese Artists I, which was published in December 2007, include feature stories from the Artist Navigator section of Modern Art Bimonthly from Issue 100 onwards. These feature stories account for the artistic careers and works of 15 contemporary Taiwanese artists including Chen Chieh-jen, Yuan Goang-ming, Liu Shih-fen, Lin Shu-min, Yao Jui-chung, Wang Jun-jie, Chen Shun-chu, Huang Chih-yang, Hou Chung-ming, Tang Huang-chen, Tsui Kuang-yu, Kao Chung-li, Wang Te-yu, Wu Chi-tsung, and Tseng Yu-chin. Thanks to the contribution of the brilliant art critics, Hu Yung-fen, Wang Ching-ling, Wang Chia-chi, Chang Ching-wen, Chin Ya-chun, and Yu Wei, TFAM has been able to publish *Selected Writings on Contemporary Taiwanese Artists II* this year. This collection again introduces to the public outstanding Taiwan contemporary artists Chang Chien-chi, Peng Hung-chih, Michael Lin, Wang Wen-chih, Huang Chin-ho, Kuo Wei-kuo, Hsu Yu-jen, Chen Hui-chiao, Lee Kuo-min, Wu Tien-chang and their works . We hope that this anthology will serve as a useful source of information for researchers and art lovers who share interest in the development of Taiwan arts.

Hsieh Hsiao-yun
Director, Taipei Fine Arts Museum

無以迴避的主觀與偏見

看張乾琦的圖片故事

文／胡永芬

觀察、拍攝龍發堂前後斷續歷經了八年，直到某一個同樣平淡懶散的午間餐後，張乾琦請院方幫忙，讓排隊魚貫前往集合場的病患們，在上路之前稍稍按耐、停頓一下，讓他能夠咔嚓定格。

然後，底片裡的影像換到另一個場景空間，被以逾人身的高度重新顯影，影像裡以一條鎖鏈相連的一對一對病患，無論他們在定格的當時採取什麼樣的姿勢與表情，當空間轉換到靜默的美術館殿堂中以15度的俯角面對展場時，每組畫面都意外地顯現了同一而強大的戲劇化張力與荒謬性；當觀者迎面遭遇這個視覺時，或許未必會感到同情（有些人物在畫面中的狀態，竟然能讓我聯想到中世紀的吟遊詩人），但必然，是一種無法略過而詭異的震動經驗。

張乾琦以龍發堂病友倆倆相鍊的畫面所組成的〈鍊〉系列作品，可能是他十年來極其少數帶有「擺拍」（被攝對象的狀態是經過拍攝者有意識地安排的拍攝方式）成分的影像，而不純然是「抓拍」（在人物、事件以他自然發展進行的狀態下，攝影者所瞬間抉擇的影像）式的作品，對於一位新聞攝影出身的報導攝影工作者而言，在決定的當刻，心中當然清亮而瞭然這看似毫釐的差異，對於影像呈現的意義上具有何其巨大的殊異，但是張乾琦似乎決定要選擇「特別不要去釐清它」的態度，甚至似乎是詭譎而蓄意地借用了觀景窗前後，雙方關係中宰制與被宰制、主導與被主導之間瞬息可變的曖昧性，來成就這一系列作品更濃郁的影像張力。

龍發堂的知名度簡直比台灣許多觀光名勝還要高得多，它的爭議性也是數十年來不曾稍息，拍過這裡的攝影家不在少數，其中拍這個題材最難以令人遺忘的侯聰慧的影像裡，常常只見晃動於虛渺空氣中的背影，處於觀景窗之後的攝影家，彷彿是就著龍發堂中某一個個體的眼睛，望向他所身處的群體，相對於張乾琦選擇與病患之間的對面而視，兩者所採取的迴異視點，已經意味著全然不同的觀看方式。

被院方與攝影家安排在固定位置的被攝對象們，其中有些卻顯然能夠以一種具有奇異強度的自由精神能量，成功地掌握了整幅影像的主導權與宰制位置，這讓我想起傅柯於《瘋癲與文明》中所述，對於在文明社會裡瘋癲人的定義，是與一般所謂理性人與社會互動方式的相對性而言的，若此而言，「文明」與「理性」倒成了宰制你我的框架，而那些無論在生活或是影像裡面被我們視為瘋癲的人們，才是這個世界真正的自由人。

以「文明社會」的框架來看張乾琦這次僅有的半「擺拍」（畢竟他還是無意、也無能為力於全然地掌握、擺置這些瘋癲的人們）系列作品，首先面對的，就是一個牽涉到一點所謂道德敏感性（或者說是爭議）的問題，便是被拍攝者人權的問題。

對於張乾琦的報導攝影生涯而言，〈鍊〉系列絕對是一組極其獨特的作品與經驗。張乾琦經常地在說明自己的工作方式時，會特別強調一點：「我一定會徵得被攝者的同意。」這是一個持相機的報導攝影者在掌握著影像權力時一種特別困難的自制力，

尊重被攝者的人權與主權，更優先於已經嗅到能拍出一組好故事、好照片的誘引力。而〈鍊〉系列的難處在於，他是以全然的正面肖像來呈現影中人物，卻無法徵求這些在法律認定上已經喪失獨立行使意志權力的病者同意與否，只能退而求其次地徵求管理單位，龍發堂院方的同意與協助。作為一個身上掛著人道主義光圈的馬格蘭攝影通訊社（Magnum Photos Inc.）成員，當被問及在這項工作進行的當下，他心裡對於龍發堂被攝病患人權之考量權衡時，張乾琦並沒有直接回答這個問題，只聳了聳肩說：「隨便別人怎麼想。」

張乾琦，他最為榮耀而醒目的標籤，便是甫於去年正式通過成為馬格蘭攝影通訊社成員的身份。能夠儕身為馬格蘭攝影通訊社的一員，可以說是所有以報導攝影為職志的影像工作者理想中如夢幻般不可

得的身份吧，馬格蘭是於1947年，由布列松（Henri Cartier-Bresson）、卡帕（Robert Capa）、羅傑（George Roger）、西蒙（David Seymour）四位報導攝影史的耆宿所共同創立的，五十五年的歷史至今，只有四十三名成員，張乾琦在歷經六年被觀察的準會員資格之後，在四十歲那一年便通過成為正式會員，這固然證明了張乾琦在報導攝影這項工作上所付出的努力被看見、被肯定，但這項榮譽顯然如果僅止於努力是絕對不夠的，更關鍵的，還是他對於攫取觀景窗外的瞬間影像，極其敏感而銳利的直覺。

出生、成長於台中縣的烏日，一個鄉間技工與洗衣婦所組成的普羅家庭中唯一的兒子，雖然他有好幾個姊妹，但是在那樣的台灣家庭而言，他依舊是以獨生子的身份被看待與期望的。在東吳大學畢業以前，張乾琦所學都跟攝影沾不上一點邊，整個人生

「紐約唐人街」系列
New York's Chinatown series 1990s

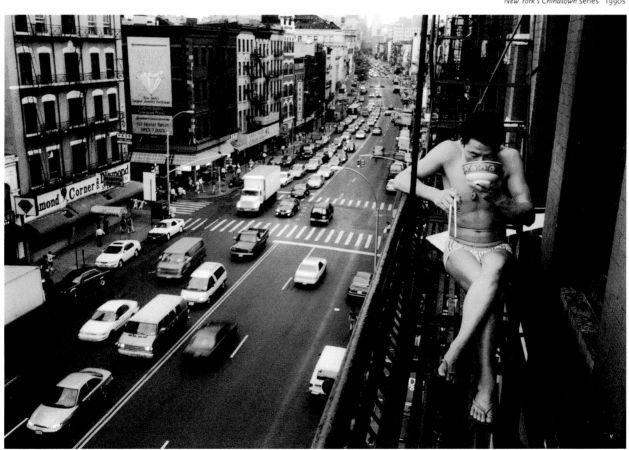

11

規劃原本一直是中規中矩的，到美國去唸印第安那大學的時候，修的也是教育而非攝影。但，人生便是這樣，在某一個不知名的小路口，一個偶然順性的小轉彎，往後走去，就變成一條完全不一樣、而且是不可能再回頭的路了。

關於攝影，一開始張乾琦不過是有一個幫學校報紙工作的機會，「拍完交回去之後，他們又給我幾捲新底片，要我再拍另一個題目。」就是這樣打工式的開始，張乾琦偶然轉彎走上一條全然不同的人生之路。

1988年到美國，拍照非常短的時間，1990年張乾琦就獲得了美國年度大專院校傑出攝影家首獎，然後又因為這個獎，提供他進入西雅圖時報（Seattle Times）實習的機會，西雅圖時報有非常出色的報導攝影傳統，歷年來得過多次普立茲獎，即使在美國也是少見的會鼓勵攝影記者發展自己的圖片故事的報社，張乾琦此時已經非常確定自己所愛，「透過相機，把我對視覺的感覺傳達出來，這非常吸引我。」他說，「攝影成為我認識這個世界的窗口，相機則是我的護照，讓我能進到平常不可能到的地方。」而從按下快門完成拍攝，然後經過一段時間，再回頭在另一個時空與當時所拍下的影像相照面，這整個過程經常會有意想不到的感覺觸動著他。

在西雅圖時報兩年半，雖然他很明白，對於像他這樣的異鄉客而言，這不只是認識美國最好的機會，還是一個不可多得的好工作，但是對於每天不可能迴避的制式化新聞工作，他依然是無法忍受。「我實在受不了拍了就走的方式，對於吸引我的事物，我習慣的方式是待下來，待在那裡過一陣子，再拍。」因此，他決定拍拍屁股走人，離開已經夠好了的西雅圖時報，雖然過了半年錢都花光了，他不得不又找個工作討生活，短暫的進到巴爾的摩太陽報（Baltimore Sun），不過在待過這個他感覺上對亞裔非常不友善的報社之後，張乾琦終究確定了自己這輩子要盡可能的作一個自由撰稿人（Free-lance）

的方向，儘管，真實生活中有太多的擺盪與殘酷的掙扎，但是，人畢竟還是有可能藉著把生活的需求減到最低限，以用來換得生命最大自由的機會。

張乾琦喜歡拍自己感興趣的故事，更甚於去拍一個被委託、因此一定有收入的故事。或者可以這樣看：他所選擇去拍的故事，很大的一部份都跟他自己的生命經驗、他自己生命狀態所面對的困惑、所必須要解卻無法可解的問題……，有著某種程度的關係。

作為一個異鄉的遊子，或者可能成為第一代的移民，張乾琦獲得1990年美國年度大專院校傑出攝影家首獎的作品之一，就是一組以日本第一代小移民美智子的圖片故事而獲選。兩年前他又以一組拍攝滯居紐約的中國非法移民生活照片，又獲得了荷蘭的世界新聞攝影獎「日常生活組：圖片故事系列」的首獎。從大量日常生活的平淡影像中，抓拍到能夠精準而濃郁地表現事件與人物背後真實感情的瞬間影像，是何其不可名狀的纖敏直覺，大部份報導攝影者為了要抓到對的影像的工作方式，都是「勤能補拙」，以謀殺大量底片來換取機率上的準確性，有趣的是，身為一個Free-lance另一面的意思，就是表示所有的花費都必須靠自己，經常是沒有人會付你底片、食宿、交通……等等，所有的開銷，因此身為一個Free-lance的報導攝影者，張乾琦不但練就一身能打探出美國飛台灣機票不到三百元美金的門道、基本上可以一天不吃飯的功力、以及還要具有能夠忍得住不隨便按快門浪費底片的「才能」。

習慣於長時間保持靜默的張乾琦，其實是一個無時無刻不以持續的速率「進行」著的人，因為靜默，而將對於被攝者的心理侵犯性減到最低，因為靜默，而讓自己在滲透進一個新場域時能以最快的時間融入，也因為靜默（的姿態），而能夠即使置身擾嚷中仍能沉澱地進行著他的觀察、咀嚼、映照著自己心底真實的感受而不被打擾。美智子與中國非法移民的故事，不只是故事可敘述的部份與張乾琦的個人生命經驗有相對應的區塊，影像瞬間凝凍的情

緒狀態，又何嘗不是揭露出包括張乾琦在內的，眾多個體在群體中非自主地被邊緣化、感受著茫漠疏離卻又無能操舵的生命情境。「我拍攝的是我的主觀與偏見」，他總是這樣說。

習慣了攝影者、觀察者的身份，張乾琦比一般人更迴避、更抗拒成為別人鏡頭朝向的對象，但是事實上，他用鏡頭來說別人的故事的同時，卻已不自覺地於幽微間吐露了自己的故事。美智子與中國非法移民在紐約的圖片故事如此，拍攝台灣婚紗工業的〈我願意〉系列又何嘗不是如此！？

這個題目開始於張乾琦返鄉參加妹妹的婚禮開始，身為家中的獨子，過了四十歲猶然在異國飄蕩，沒有一份家鄉老人家可以理解的「固定的工作」，沒有婚姻、沒有家庭、沒有子嗣⋯⋯，即使嘴上不說，心裡何嘗沒有矛盾與壓力？何嘗不會思考這個問題？用他的影像，總是捕捉到應該歡樂的場景中的

無奈與心力俱疲，張乾琦又一次靜默卻明晰濃洌地表達了他對「婚姻」這件事主觀的感覺。

張乾琦從來都認為自己是一個報導攝影工作者，更明確的說，他從來不曾關心在意過所謂的美術史，他知道傅柯，卻疑惑的問：「波洛克？是誰？我不知道他做的是什麼。」不過這完全無傷他以充滿張力的影像在當代美術展覽場域上攻城掠地，這是當代藝術之所以有趣的一個部份：它是如此的明確，又是如此的寬懷，願意在不同的時間點隨著人類新的經驗逐漸擴大，產生美學。報導攝影、新聞攝影、影像創作⋯⋯之類枝枝節節的分類方式，再當代藝術的範域裡都已經不再產生什麼關鍵性的意義，一切都可以簡化為什麼是有意思的、有原創的、有才華的作品，即使它並不令人只產生愉悅的感覺，都可以簡而言之是好的藝術。　　　ᗱᗱ

（本文原刊於2002年2月，《現代美術》第100期）

「迷走」系列
Gone Astray series 1999

Unavoidable Subjectivism and Bias

A Picture Story by Chang Chien-chi

Hu Yung-fen

Chang Chien-chi took spontaneous photographs at Lungfatang for eight long years until one day, after an ordinary and lazy lunch, he actually asked hospital officials to help out, calling on patients to stop for a moment before setting off to queue for the assembly area and thereby catching them posed on film. The images on the negatives were then transferred to another spatial arena and displayed from a position above head height. Regardless of their poses or facial expressions, as soon as the setting becomes a silent exhibition hall in a museum, the images of patients chained in pairs and looking down from an angle of 150 are unexpectedly infused with a powerful sense of dramatic tension and absurdity. As visitors look up at the pictures, they do not necessarily experience pangs of empathy (surprisingly the condition of some of the characters in the pictures recollect the Middle Ages), but many are unable to pass by without being strangely moved.

Chang Chien-chi's "The Chain" series, made up as it is of pictures showing patients in Lungfatang chained together, is one of only a handful of "fixed-position" (where the photographer consciously determines the way the subject is poses) pieces the artist has produced over the last ten years, as opposed to his preferred choice of snapshots (selecting images based on the natural development of people and events). For someone with a background in photo-journalism, the huge difference in the meaning of the images is immediately apparent. It is interesting then, that Chang seemingly makes a conscious decision to "most definitely not clarify them." Indeed, he takes this to such an extreme as to deliberately focus on the world both in front of and behind the camera. To that end,

the changeable ambiguity inherent in issues of control and being controlled, guiding and being guided in this relationship, infuses the series with a strong sense of influence and tension.

Lungfatang is more famous than some tourist sights in Taiwan and it has remained a subject of contention for decades. Of the many photographers who have taken pictures here, perhaps the most unforgettable images were from Hou Tsung-hui. In his pictures we often see people's backs swaying in the distance and in this scenario the photographer plays the role of the eyes of an individual who lives there, casually looking at the groups of people around him or her. In contrast, Chang Chien-chi chooses to look directly at the patients. This completely different point of view signifies a diametrically opposite way of looking at things.

Although the photographed inmates are arranged by hospital staff and the photographer into fixed positions, some of them are clearly infused with such spirit and energy that they successfully seize the initiative in directing the arrangement of the photographed images. This brings to mind the words of Faucault in *Madness and Civilization* where he observes that in a civilized society the definition of madness stands in contrast to the behavior of so-called rational men and methods of social interaction. If this "civilization" and "rationality" is used as a framework to control us, then those we view as insane, whether in society or these images, are in fact the only truly free people in the whole world.

Looking at the "half-arranged" (because in the final analysis much was not done on purpose and the artist was unable to completely arrange the patients as he

would have wanted) pictures taken by Chang Chien-chi from the perspective of a "civilized society," a number of issues are raised - Firstly, there is moral sensitivity (or contentiousness) and the rights of those being filmed.

An overview of Chang Chien-chi's photo-journalist career shows that the "Chains" series represents a distinctive work and experience. Often when discussing his work Chang takes time to emphasize: "I always make sure I get the permission of those I photograph." However, this imposes a particularly onerous limit on the autonomy of any photo-journalist and his/her power to control the images he/she takes. This problem is always one of balancing respect for the human rights and autonomy of the people being photographed against one's nose for a good story and the temptation to take good pictures when the opportunity presents itself. The difficulty in the "Chains" series is that the artist takes portrait pictures of the characters that appear in his work and yet is unable to get consent because the subjects have legally lost the capacity for independent thought and action. Instead, he has to seek permission from those in charge of the patients, namely the agreement and assistance of staff at Lungfatang. Chang is a member of Magnum Photos Inc. with its reputation for humanism, but when asked what he considered when balancing the rights of the patients being filmed at Lungfatang at the moment it was happening, he skirted the question, shrugged his shoulders and said: "Other people can think what they want."

The label of which Chang Chien-chi is most proud and attracts most attention, is his elevation last year to full membership of Magnum Photos, something to which many photo-journalists unsuccessfully aspire. MP was established in 1947 by Henri Cartier-Bresson, Robert Capa, George Roger and David Seymour, four giants in the world of photo-journalism. Over the last 55 years it has accepted only 43 members and Chang was only admitted as an official member at the age of 40 after six years as a candidate member. This indicates that a photographer's dedication to his chosen profession has been noticed and recognized, but such an honor is not bestowed on the basis of hard work alone. What is even

more important, are the fleeting images he captures with his camera, based as they are on a highly degree of sensitivity and acute intuition.

Chang was born and raised in Wuji, Taichung County, the only son of a father who worked as a technician and a mother who washed clothes for a living. Although he had several sisters, in such a Taiwanese family he was still treated as a single son and much was expected of him. Before graduating from Soochow University, Chang's studies had nothing to do with photography. His life plan was consistently based on doing the right thing and behaving properly, so when he went to study at Indiana University in the US he majored in education not photography. But as is often the case in life, a casual turn at a nondescript intersection set him on a completely different path, one from which there was no going back.

To begin with Chang was given the opportunity to help out the school newspaper: "When I'd finished taking the pictures and handed them over, they gave me several new rolls of film and told me to take pictures on another subject." In other words, Chang's photographic career started out as a part-time task, but had an impact that changed the rest of his life.

Arriving in the US in 1988, Chang Chien-chi had been taking photographs for only a very short time when he received the college photographer of the year award in 1990. That opened the way to an internship at the Seattle Times, with its outstanding tradition of photo-journalism and multiple Pulitzer Prizes. The paper was also one of only a few media outlets that encouraged photo-journalists to develop their own picture-stories. At this point in his life, Chang was already certain of his first love: "The idea of using a camera to convey my own feel for visual images really appealed to me." "Photography became a window through which I sought to understand the world. The camera as my passport let me go places I would not normally be able to visit." After taking his pictures, Chang would wait for a time and then revisit the images in a different space and time, a process often gave rise to completely unexpected feelings.

During his two and a half years at the Seattle Times, Chang Chien-chi recognized that such a job was not

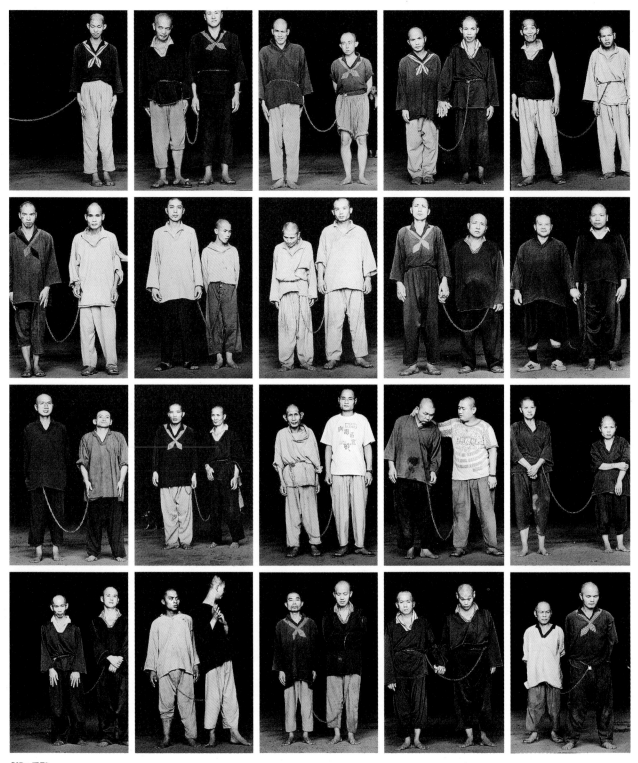

「鍊」系列
The Chain series 1998

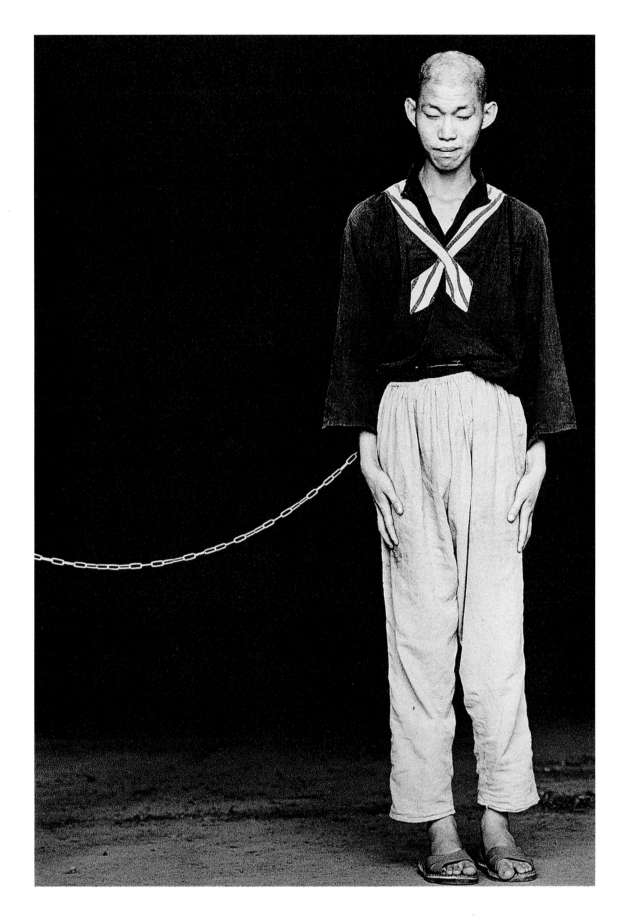

only an excellent way for an outsider like himself to gain a good understanding of the US, it was also pure and simple a good job. However, he increasingly found himself having trouble with the unavoidable formulaic reporting day in day out: "I really can't stand taking pictures and leaving a scene. When something appeals to me I like to hang around and keep taking pictures." With that in mind he left the Seattle Times, but after six months had spent all his savings and had to find a new job to make a living. As a result he took up a temporarily post at the Baltimore Sun. After spending some time at a paper he came to consider particularly unfriendly to Asians, Chang finally decided to work as a freelance photographer. Although real life is filled with much instability this can perhaps be used to minimize what one demands of life and thereby maximize one's freedom of movement.

Chang Chien-chi prefers to take pictures of stories he finds interesting himself rather than things he is commissioned to photograph and that provide a fixed income. To that end, much of what he shoots has a certain relationship to his own life experience, the difficulties he faces in life and questions to which he wants answers but has as yet found none.

As someone away from home in a foreign land, one might consider becoming a first generation immigrant. In 1990, one of the works for which Chang won the college photographer of the year award was a picture story about Michiko, a first generation immigrant to Japan. Two years ago, he won a World Press Photo Award "Daily Life Category: Picture Story Series" for pictures of the lives of illegal Chinese immigrants living in New York. By taking a large number of ordinary images of daily life as it happens, the photographer is able to accurately capture fleeting glimpses of the reality that lies behind people and events, something that requires an indescribably sharp intuition. As they go in search of the "right" image, most photo-journalists believe "hard work can overcome natural shortcomings." This often means they take a large number of pictures in the hope of finding one or two that reveal their subject. Because freelance photographers are often in situations where they have to pay for their own prints, board and

lodging and transport costs, they need to be more circumspect. Chang Chien-chi has mastered the art of not only hunting down airline tickets to Taiwan for less than US$300, but sometimes doesn't eat for days and forces himself not to casually take pictures so as not to waste the negatives.

Used to remaining silent for long stretches of times, Chang is in fact always working. The silence minimizes the impact of external distractions on the photographer's state of mind and also enables him to become one with a new arena as quickly as possible. At the same time, a state of silence means that even when surrounded by hustle and bustle a good photographer is still able to observe, mull over and reflect his/her own true feelings without being disturbed. If we look beneath the stories of Michiko and the illegal Chinese immigrants, we can see a narrative and of Chang Chien-chi's personal life experience. Does not capturing of a momentary emotional state reveal the way in which so many individuals, including Chang himself, are marginalized within a collective entity, feeling dissociated and trapped in lives they have no way of controlling? "I photograph my own subjectivity and prejudices."

Used to being an observer and a photographer, Chang Chien-chi avoids and has a dislike for being the subject of other people's photographs. More intriguingly, even as he uses his lens to tell other people's stories, he also unconsciously reveals much of his own story. This is true whether he takes pictures of Michiko or illegal Chinese immigrants in New York, and certainly his "I Do" series on the marriage industry in Taiwan.

Chang first became interested in this subject after returning to Taiwan to attend his younger sister's wedding. As the only son in the family, he suddenly found himself wandering around a strange country at the age of 40, without a "steady job" worth the name, unmarried, with no family and no-one to carry on the family name. Even though he does not discuss such things. Is it really possible that mentally and emotionally he does not feel the contradictions and pressure of his situation? If we look at his pictures, then quite often they show glimpses of helplessness and emotional exhaustion in situations that are

supposedly happy. Chang may remain silent but his images clearly express his subjective feelings on the subject of "marriage."

Chang Chien-chi has always considered himself a photo-journalist, to which end it should be noted that he has never shown any interest in the history of fine art. He knows of Foucault, but puzzled asks: "Who is Pollock? I have no idea what he did?" Still this show of bravado fails to undermine his tension-filled images and their rightful place being displayed in an art museum. Indeed, this is one of those interesting things about contemporary art. The genre is so broad in its

sweep as to continually expand in the face of new human experiences in different time periods, thereby generating its own aesthetics. Whether we seek to categorize these pictures as photo-journalism, news journalism or image creation is already moot within the boundaries of modern art. Everything can be simplified to works of interest, innovation and talent. Even where they do not merely give viewers a sense of joy, such pieces can be classified as just good art.

(This article was originally printed in February 2002, *Modern Art* No.100)

「誓言」系列
The Vow series 1994-2000

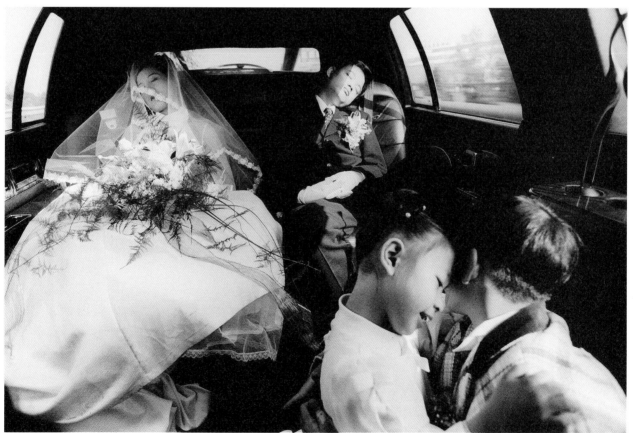

述說七○年代的莫名委屈—
看彭弘智的擬人寓言

文／胡永芬

五年級後段班（民國58年次，西元1969年生）的彭弘智，當下此時，正處在他人生中一段很舒服的狀態—創作正發展到前所未有的隨心所欲與飽滿的高點，而心智則仍耽溺於充滿探險樂趣的青春期。

台灣的藝術家跟世界上其他地區的創作者比較起來，相對性地晚熟一些，通常是必須很正統的經過學院學習過程的認證，然後才開始比較具獨立性地自我發展，34歲的彭弘智過去幾年的藝術發展歷程就是其中的典例。

彭弘智是從美術實驗班唸起的，「很會畫」這一層能耐自然是不在話下，考大學也很順利地考進了藝術科系最高分—師大美術系。進入大學那時，正是台灣剛剛解嚴之後，「學校裡的美術教育幾乎還是停留在二次大戰前的觀念，但是真實世界裡的經濟、社會、政治結構與生活方式早就已經不是這麼回事了。」說得有些誇張了，但從彭弘智對於回憶的敘述方式，可以更貼近地理解他當時那種心理困頓的狀態；那時在師大任教的，也是當時師大美術系老師中唯一一位裝置與多媒材藝術的創作者盧明德，「對我而言，就成了一個出口」，彭弘智說。

那個年代，社會與人文環境中有意思的東西一下子多了起來，彭弘智還記得自己當時已經覺得「台北畫派」很夠勁，「二號公寓」也酷斃了，有一回有個機會在「二號公寓」參展，還被當時也還很年輕的「二號」元老范姜明道訓了一頓：「搞這麼傳統的東西，真沒意思！」其實那時彭弘智已經很不甘願畫中規中矩的人體素描，而開始人體變形的嘗試，但是素描課的某老師完全無感於他求變的心理狀態，還以為他是素描技巧太差、畫不像呢，又在畫紙上幫他重新給改得「像」回原樣了（嗚呼哀哉，卻又莫可奈何）。

大學四年過得竟然比生理上的青春期還要青澀苦悶！

「非走不可！」還在唸書時，「出國」這個念頭就成了支撐彭弘智唸完大學學業的主要原因。「當時覺得這裡從體制到環境都很不好玩，因為有太多老人了，看不到藝術，只看到太多非關藝術的人際關係在裡面運作…，悶斃了，非走不可！」無疑這是年輕血液中的叛逆因子在發生作用，不過彭弘智想得很清楚，他不服、反叛的對象是存在於體制與學院裡的現象，而非體制與學院本身，「我從來沒有不相信體制與學院，尤其，我一向崇敬學問，我相信學問不夠的話，叛逆是沒用的」。這裡頭有矛盾嗎？從彭弘智一路沿著學院的形式與思維發展而來的作品來看，這無疑是毫無任何矛盾與衝突的。但是他當年所要反叛與擺脫的一切，如今卻無一不猶原存在，那麼，曾經一心叛走的彭弘智，回來之後又如何重新面對這番原狀？他沒說，但在此番觀看與閱讀彭弘智返國後所有作品時，我總時時不免會對照著這個問題揣想思索。

其實，應該說彭弘智並不算是「非常」叛逆的。那「有一點」叛逆的因子讓他能在異國那個很不一樣的環境裡恰如其份地達成「脫胎」的效果，而不致過於極端的個性，則讓他在脫胎之後仍然能保持著學

院出身的整體氛圍。

1997年的作品〈文化之胃〉或可視爲彭弘智「脫胎」之後第一件創作，也是他以玩具爲材料的第一件作品。他把在舊金山中國城偶然發現的微笑機器青蛙，放置在一個以人工製造、從展覽場地中央小荷花池塘分流出去的人工水道裡，裝上電池轉緊了發條的機器蛙快樂奮勇地、很快便游到水道盡頭邊緣處（水道的去向原本應該象徵著未知的理想？但在這裡卻猶如一個誘引的陷阱，引向無路可逃的徹底絕望），但在電力尚未耗盡之前，牠沒有可能作第二個選擇，只能兀自微笑地、繼續向已經臨界、阻擋在他面前的壁邊原地划撞向前，一直到電源耗弱（機械蛙於垂死掙扎之時仍保持慣常如一的微笑）、殆盡爲止（終致僵直不動的蛙肢還是配上一絲慘然詭異的微笑表情）。

回到台灣於伊通公園發表的個展「有關於玩具與藝術」也出現這件命運凄慘可憐的荷塘青蛙，同時又出現了跟青蛙差不多悲慘的玩具鴨子、小鳥、魚……等等各種造型熟悉可愛的小動物。這些玩具都可以說是台灣特產——形似西方與日本流行的卡通腳色

遷移 Migration 1997

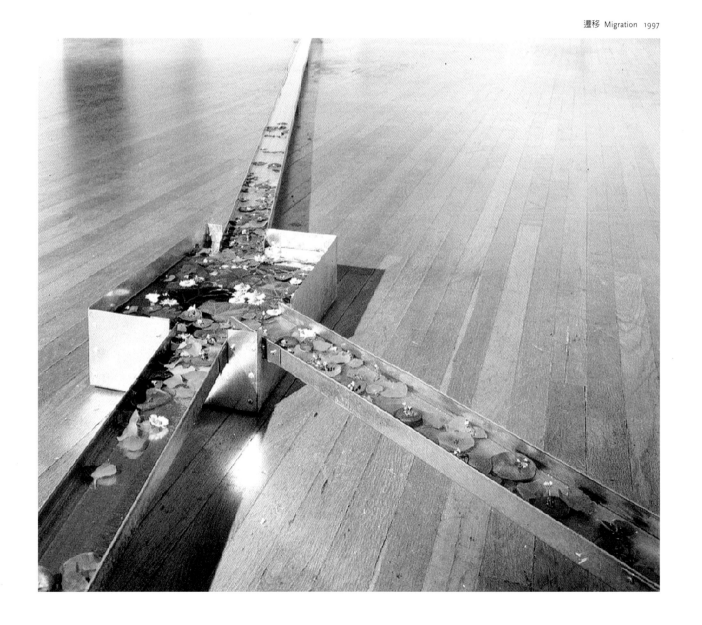

造型，實則全都還是仿冒製品。跟游水青蛙同時展出的還有一隻唐小鴨（仿製唐老鴨造型的玩具），正對著一面鏡子有如強制性自虐狂一般不停地點頭如搗蒜，鏡子上面隱藏的針孔相機全程錄下唐小鴨的癲狂舉措，輸送到另一個空間裡的另一個螢幕上播放出來，供人觀賞。

小鳥跟魚的處境比青蛙跟鴨子好不到哪裡去，也被他封在某種沒有出口的「通道」裡面，在還有能源供應的期限內，因為行為過度地反覆，而成為近乎於癲狂的舉止，在電源將盡時又顯露出瀕臨絕望般的滯殆與掙扎，這些「玩具」同時都在展覽場域中進行著一種讓人覺得一點也不好玩的黑色遊戲。充斥著滿滿的辛酸，與令人惱火的荒誕性。

1969年生的彭弘智，透過作品所闡述的物質性，以及其中頗具有自覺的對於被強制性的輕微反抗意志，對於相對性地貧乏、懵懂的，一個六〇年代前半段於小鄉鎮出生的人（我）而言，是少有雷同的經驗，毋寧說彭弘智所表現出的，是更靠近七〇年

代城市兒童的共同生命經驗吧。

七〇年代這個世代的悲情是什麼？比起前面的人——六〇年代、五〇年代，乃至於四〇年代的LKK們，七

流通 Circulation 1997

○年代小傢伙最委屈的是，他們的悲情已經失去了強而有力的正當性！前面的人們總能夠有一個鮮明澎湃的對抗目標──戒嚴時代、髮禁、填鴨與體罰並用的教育體系、白色恐怖、社會集體的貧窮匱乏⋯林林種種，對於前面好幾代的人而言，「叛逆」都是一種很屌的形象；但是到了七○年代，他們所面對的人生：愛的教育成為家長與學校的共識，在以鼓勵代替處罰的大原則下，只要不觸犯法律，一切皆百無禁忌，搞任何怪都可以被正面解釋為「有創意」、「有個性」而鼓勵之，父母、學校、社會甚至可能會對搞怪的人提供更多資源（更多的經濟援助與機會供給）來鼓勵他「發展」，搞怪的「叛逆性」在愛的教育最高指導原則的披覆之下被徹底全面銷解了：在這麼幸福美好的年代裡真還要搞叛逆？那麼唯一真正的叛逆就是拒絕這些被餵養的資源！這可一點都不屌了，而且還是一件絕對得不償失的、很ㄙㄞˋ的事！對於七○年代的孩子們而言，乖絕對是比叛逆更為精明準確的策略！

真是委屈了，所有的委屈都失去了一個宣戰起來很名正言順地、值得去對抗的目標！但是人性中的叛逆因子一如青春期的賀爾蒙，勢必是需要發洩投射的有效管道的，「藝術」在此顯然成了彭弘智的發洩通路：青蛙、鴨鴨、小鳥⋯，看起來都是極其快樂、向陽而奮發的，實則他們是缺乏選擇拒絕現成

豐沛資源的勇氣，而不得不表現得如此吧？這種強制性行為究竟是被迫？還是自我制約（自找）的？對照七○年代這一世代的生命情境之共象，不能說只是巧合。

而這次個展：「有關於玩具與藝術」，彭弘智的幾件作品都有很恰如其分的完成度、侃侃而談而不失情致的的述說方式，宣示了學院教育對他成功的作用力，同時也宣示他正式跨過了創作生涯的平面手繪時代，脫胎成為一位多媒材的創作者，這是他過往多年一度曾經擺不脫的難題。

1999年的新作〈眼球位移〉，可以說是彭弘智風格化創作的一個重要轉折點。很快地，〈眼球位移〉那顆讓觀眾戴上頭盔就可以像象鼻子一般上下左右伸縮游走視界的單眼球，就正式發展成為「狗眼看世界」那個總是從低處看人的「狗眼」，更確切地說，是發展成了以狗的視點取代你我所慣於的人的視點。

〈眼球位移〉的形式更接近於是一個遊戲，主要是因為在這件作品中觀眾的參與是作品被完成的一個必要過程，但這也是彭弘智歷來唯一一件交出作品完成之主導權的作品，再之後，雖然還有幾件作品觀眾是可以透過視鏡被帶領經歷「狗」（小白等）的視界，但畢竟是被動的，不若在〈眼球位移〉一作中

一隻大麥町／一隻靈犬萊西 "One Dalmatian" & "One Lassie"
燈箱或數位相紙 100x100cm each 2000

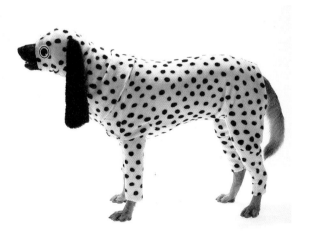

面對面 Face to Face 2001

取代了作者的主體操控位置。這件作品顯然是一件彭弘智在探尋過程中所出現的過渡性之作，想像他當初嘗試時的狀態是很自由、很放鬆的，也因此而有些意外地留出妙不可言的、很大的開放性，很像是一個小孩子的遊戲，說穿了有點無聊，但卻足以讓人玩得興味盎然了。

〈眼球位移〉之後，彭弘智還是持續使用以物擬人的手法，這個階段是一系列以〈小白〉名之的「狗」系列作品。小白的眼睛成了創作者與觀者共用的觀景窗，我們透過小白的視點高度、小白散步或奔跑的速度、小白在狗群裡混戰狂吠時躍動的腳步…，透過小白，看到了一種我們平時完全不可能看到的視覺角度；此外還有幾件跟狗有關的作品：一隻大玩具狗是以數以百千計的機器小玩具狗組成的，轉上了發條以後大狗身上的小狗千狗齊吠，對觀眾而言，在感官上確是一種奇詭莫名的刺激；另一件作品是兩隻小狗──小黑與小白的即興演出錄影作品，藉由兩隻幼狗的進食行為，再鮮活不過地闡明了動物社群中關於「階級」的天性；還有一件畫面看起來讓人誤以為頗是典雅精緻的作品，卻是在燻臭不堪的流浪動物之家作的，彭弘智把一隻流浪動物之家裡的雜種流浪狗給穿上大麥町的造型外衣，跟另一隻穿上臘腸狗外衣的玩具機械狗一齊都放回狗群中，機械狗上了電池發條，便很歡悅開心似的搖尾迎人，而披著大麥町外衣的土狗不只是自己感覺到不自在而瑟縮，更引起籠內狗群對牠不友善的示威吠叫…。以上，不管是哪一個故事，在我感覺彭弘智都是在說一個身份與認同、腳色與階級的問題，這種寓言化了的說教方式雖然流露出創作者內心一絲絲的無力感，卻還充滿著不滅的童心便是了。

透過看什麼都低的狗眼，彭弘智發展出了屬於他的彭氏寓言系統。

寓言之所以為寓言，而不是「格言」或「訓辭」，就是區別在那一點帶著哲思餘味、卻再質樸單純不過的故事情節。七○年代那個世代的孩子基本上是透過影像學習、成長，透過影像看待他們所存在的、

那個莫名就讓他們感到很委屈的世界：基本上更傾向歸屬於七○年代人類的彭弘智，便是用他所創的「狗眼影像寓言」，一方面顯影了這個世界的內在真實，但另一方面，又何嘗不是故意藉著影像故事把「真實」的重量給虛質化了，藉以來銷解他那屬於七○年代人類內心裡虛渺的無力感，以及那股子莫名地委屈？！ ∃ξ

（本文原刊於2002年4月，《現代美術》第101期）

The Nameless Grievance of the 70s Generation
Peng Hung-chih's Allegorical Art

Hu Yung-fen

Born in 1969, Peng Hung-chih, is in a rather comfortable position at this stage of his life, as he is enjoying an unprecedented level of freedom and fullness in terms of his creative work, yet mentally he is still allowed to indulge himself in an adolescent's idea of fun and adventure.

Taiwanese artists are somewhat late developers in comparison with artists from other parts of the world. They usually undergo a period of formal training in the art academy before independently developing their own styles. The artistic career of 34-year-old Peng Hung-chih is an exemplary case of this tradition.

Peng Hung-chih's artistic career started when he was chosen for an advanced-placement art class in high school, so there is little doubt about his technical ability. With relative ease, Peng obtained outstanding grades in the university entrance exam, and won himself a place in Taiwan's leading art department at National Normal University. Peng began his undergraduate studies immediately after martial law was lifted. However, according to Peng, "University art courses were still dominated by outdated, pre-WWII ideas. This created an unbridgeable gap between university art education and our current economic and social situations, political structures and life styles." Peng may have exaggerated the bleakness of Taiwan's university art education, however, the way in which Peng recollects these memories shows the depth of his frustration regarding the situation. At that time, Lu Ming-te was the only tutor in the entire department who practised installation and multi-media arts. "That became the light at the end of the tunnel for me," said Peng.

While Peng was still in school, Taiwan witnessed a sudden proliferation of fascinating phenomena in the overall social-cultural milieu. Peng recalls thinking, at that time, that the Taipei Art Group was extremely cool, and Apartment 2 was drop-dead cool. On one occasion when Peng took part in an exhibition at Apartment 2, Malvin Fang Minto, the then young senior member of the gallery group, reprimanded him for producing such uninspiring traditional crafts. In fact, by that time, Peng had already begun experimenting with alternative figure drawing, because he was no longer satisfied with academic drawing. However, his drawing tutor at the time ignored Peng's desire for innovation, and mistook his experimentation for poor drawing skills. So the tutor 'corrected' Peng's drawing by making it more realistic. Peng thought he was at his wit's end, because his four years in college turned out to be even more boring and frustrating than his adolescent years.

"I've got to get out of here and go abroad!" became the only impetus and aspiration that carried Peng through his uninspiring university education. "I felt, at the time, that this place was utterly boring from inside to out--from the institution itself to the overall environment--because there were too many older professors at the academy. They were blind to art; they were blinded by the office politics totally unrelated to art. It was suffocatingly dull. I had to get out." Undoubtedly youthful Peng Hung-chih had rebellious blood running in his veins. However, he was fully aware that what he was rebelling against was not the system of academia itself, but what was going on in the system. "I was never sceptical about the institution of academia. In fact, I have always respected knowledge, and firmly believed that rebellion without the backing of knowledge will ultimately come to

nothing." Is Peng contradicting himself? Judging by his series of artworks, whose forms and rationales show clear signs of rigorous training and discipline from the art school, this statement, undoubtedly, makes perfect sense. But what, then, does Peng make of the situation upon his return from studying abroad? Apparently not much has changed since he left; all the things that he had tried to rebel against and depart from remained more or less the same in Taiwan. Peng has not addressed this issue, but whenever I look at all the work Peng has produced since his return, I cannot help asking this question. In fact, whereas Peng's somewhat rebellious character permitted him to finally achieve a metamorphosis in a foreign land, which was drastically different from what he had been through at home, at the same time, his moderate side enabled him to maintain an overall disposition of an academically trained artist.

Peng's 1997 work, "Cultural Stomach", was perhaps the first piece of work after his 'metamorphosis'. It was also the first of his series of works which utilised toys. The artist placed a smiling mechanical frog he had chanced upon in San Francisco's Chinatown in an artificial canal, which stemmed from a lily pond at the centre of the exhibition venue. Powered by batteries and ready to go, the mechanical frog quickly swam to the side of the canal, happily and enthusiastically. (The direction in which the canal went may originally have signified an unknown future; but in this piece it looked as if it was a trap that led one to total confinement and desperation.) However, the frog did not have a choice as to which way it went; it could only keep on smiling and trying to move forwards, even though it had hit the side of the canal, and could do nothing but continually bang its head on the block ahead of it until the batteries died. The mechanical frog still kept on smiling as usual even when it was on its last leg, and eventually it died. Although it was dead and motionless, the frog still wore a smile decorated with a touch of cold misery.

Upon Peng's return to Taiwan, he had a solo exhibition at IT Park called "ArToys". This exhibition saw this wretched frog once again featured in Peng's work, along with other similarly adorable yet equally miserable toy animals such as a duckling, a bird and a fish. These toy animals altogether can be regarded as a speciality of Taiwan, and more specifically, despite their resemblance to popular Western or Japanese cartoon characters, all of them are, in fact, counterfeit. Exhibited along with the mechanical frog was a toy duckling (a Disney Donald Duck knockoff) which kept nodding forcefully in front of a mirror as if suffering from compulsive masochism. A pin-hole camera hidden on top of the mirror captures all the antics of the toy duckling, and transmits the recording to a different room where it is played on a screen for the audience.

The fates of the bird and the fish were not much better than those of the frog and the duckling. Similarly, they both were trapped in a channel without an exit. They continually repeated certain movements before the batteries ran out. These movements made the toy

遷移 Migration 1997

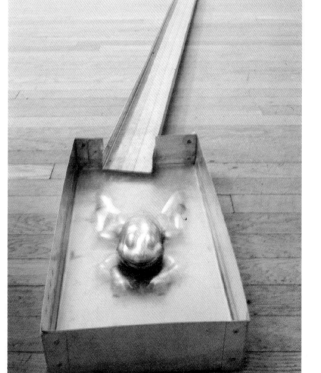

animals look highly animated, but as the batteries ran low, the toy animals struggled with a torpid desperation. Together, the toys seem to play a game of black humour in the exhibition venue - a game which is not fun at all, as it is filled with sadness and irritating absurdity.

The materiality as well as self-conscious rebellion against authority demonstrated in the works of Peng Hung-chih, born in 1969, did not quite resonate with me - someone who was born in a small uninteresting town in the early 1960s and grew up in relative ignorance. Perhaps what Peng has shown in his works is closer to the experience of urban kids born in the 1970s.

What has created the sorrow of the 1970's-born generation? Compared to their predecessors - those born in the 1960s, the 1950s, or even the older generation of the 1940s - the saddest thing for the 1970's-born generation is that they have been denied

the right to express wrath and melancholy!! The older generations have always been able to find a clear reason for their furious rebellion, such as the authoritarian regime, restrictions on student hairstyles, spoon-fed education characterised by corporal punishment, the White Terror of the martial law period, or the society's overall poverty. It could be argued that for those older generations, rebellious was synonymous to cool. However, for the 1970's-born generation, loving education became the overall consensus amongst parents and school-teachers. Under the principle of encouragement instead of punishment, everything within the law was allowed, and anything naughty became understood and encouraged as creative and full of personality, with a good chance of earning the culprits more support and opportunities for further development. In other words, naughty rebellion is cancelled out by the over-riding principle of loving education. Why would anyone need to rebel in this golden age? The only real rebellion under the

對話 Dialogue 伊通公園畫廊 1997

circumstances, then, would be to refuse what is on offer! That would really be uncool, and in doing so, these kids would stand to lose more than they would gain. It's just purely shitty! As far as the 1970's-born generation are concerned, being obedient would be a far smarter strategy than being rebellious.

It's really sad that these kids seem to have lost a clear and legitimate target for their rebellion. But it is only human nature that rebellious blood, just like the hormones of an adolescent, needs to find a way out, and clearly art became the solution for Peng Hung-chih. While the toy frog, duckling and bird all appear happy, sunny and hard-working, the fact is, they could only obey because they lack the courage to refuse the plentiful resources given to them and to make a choice of their own. Are these compulsive acts a result of coercion, or are they self-inflicted? Looking closely at the common life experience of the 1970s-born generation, one can hardly suggest that it was only a coincidence.

In this solo exhibition, " ArToys", Peng's works are all nicely completed with consistency. The way in which the artist delivers messages with fervour and assurance demonstrates the strong influence of rigorous training from the art academy. It also signals the transition of Peng's artistic practice, as he moves from two-dimensional hand drawing to multimedia - an area which was once a haunting challenge for Peng.

Peng's 1999 work, "One Eye Ball", can be seen as an important turning point in his artistic style. Later the same eyeball that allowed the vision of the helmet-wearing viewer to move freely like an elephant's hose was again used and developed as the central aspect of "Dog Matters". More specifically, it became a dog's eye which retained the dog's lowly viewpoint. In so doing, Peng forced his audience to replace their much taken-for-granted viewpoint with that of a dog's.

單眼球 One-Eye-Ball 1999

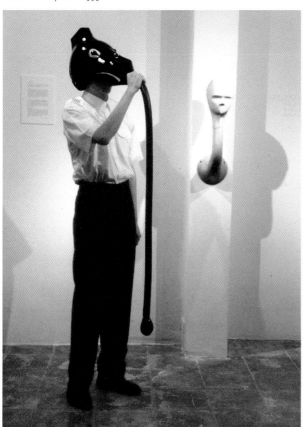

小白 Siao-Pai 1999

衣錦還鄉 To Dress up at Home 2001

The form of "One Eye Ball" is rather similar to a game, because the participation of the viewer is inseparable from the completion of the work. This is also the only piece of Peng's work in the last few years in which the artist has handed the control over to the viewers. After "One Eye Ball", although some pieces still allow the viewer to see through the lens from the viewpoint of the artist's dog, Siao-Pai, the viewer is, nonetheless, only to passively accept the artist's arrangements. This situation is rather unlike the setting of "One Eye Ball", which demands the viewer to pass over control to the artist. "One Eye Ball" is clearly a transitional piece in Peng's exploratory processes. We can imagine that while attempting this work, the artist remained rather relaxed and carefree. The work therefore has a broad openness to possibilities, and eventually generates a touch of genius and wonder accidentally, just like a children's game - albeit silly, but still sufficiently engaging and fascinating.

After "One Eye Ball", Peng Hung-chih continued his unique approach of personification in the creation of the series featuring a dog named "Siao-Pai". The eyes of Siao-Pai became the shared window through which the artist and the viewer saw the world - that is, looking from the level of Siao-Pai, and in the speed that Siao-Pai strolls or runs, or in the pace that Siao-Pai jumps while fighting with and barking at its peers. Through the eyes of Siao-Pai, we discover a visual angle which is otherwise alien to us. Other works can also be seen to feature personified dogs, such as the work "Little Danny", a large toy dog, which is comprised of numerous small mechanical toy dogs. Once powered-on, these small toy dogs begin to bark collectively, creating for the viewer an unspeakably treacherous and stimulating sensation. Another piece features a video recording starring two puppies, Ebony and Siao-Pai. The eating habits of the two puppies vividly demonstrate the operations of a ranking system in the community of animals. Another piece showing an image which might be mistakenly considered classy and exquisite, was in fact filmed at a suffocatingly foul-smelling home for stray animals. The artist dresses a mongrel as a Dalmatian and places it, along with a mechanical toy dog dressed as a dachshund, back in the cage with a group of stray dogs. When the toy dog is turned on, it starts to cheerfully wag its tail at the other dogs. The mongrel-Dalmatian is confused by its dress and feels uneasy and timid. The tension prompts the other dogs in the cage to bark at the mongrel with hostility. All the stories mentioned above seem to be raising questions regarding identity, social roles and class. Although these allegorical messages seem to show a sense of helplessness on the artist's part, they are still largely characterised by a touch of undying childlike innocence.

Through a dog's eyes, which look at everyone and everything from a lowly viewpoint, Peng has developed his own unique system of allegories.

What distinguishes an allegory from an axiom or an aphorism is the simplest story with a touch of philosophical reflection. The generation born in the 1970s have largely grown and learned through images and it is through visual images that this generation has come to terms with the world in which they live--in fact, the world which also has given them unspeakable grievances. With an overall disposition more similar to those of the 1970s-born generation, Peng Hung-chih highlights the inner truth of their world with the visual allegory of a dog's eye-view. On the other hand, Peng's visual allegory could also be understood as an attempt to diminish the weight of truth with images, in order to ease the profound sense of emptiness, helplessness, and unspeakable sadness which characteristically belongs to the generation born in the 1970s.

(This article was originally printed in April 2002, *Modern Art* No.101)

離「家」出走的男孩

看林明弘土花布紋的蔓生

文／胡永芬

一個好的藝術家的創作，很難不跟他的生命經驗有關係，或者是說，很難不跟他的性格、品味、以及身世有關係；而一件好的藝術作品，可以跟理性、邏輯有關，也可以無關，卻很難不跟感性有關，也就是跟感覺、感官、情緒、情感……這些東西有關。

林明弘1994年在伊通公園舉辦了他第一次在台灣的個展，展出一些烤上艷色油漆、直接從牆面上向空間杵出來的長方形鋼板等等的，有些低限、有些工業感況味的作品；當時旅美華裔策展人楊蕙如走進伊通，開口第一句話就問：「這是不是一位從洛杉磯來的藝術家？」那些作品確實是林明弘在洛杉磯求學時期構思，回到台灣之後成形做出的作品，但是這一個輕描淡寫的提問，讓林明弘開始用力地思考一個藝術家（他自己）和他所身在的環境之間的關聯、和他自己所曾經的生命經驗之間的關聯。

古典美術史的發展之中，即使藝術家們致力於研究光線、透視、構圖、色彩……這些科學性的要素，苦心於描繪出莊嚴、神聖、悲憫、華麗、浪漫、喜悅……等等各種準確的氛圍，無非都是為了以精妙的技藝，創造出前人所未能淋漓盡致地做到的、在視覺上所能達成的官能效果，並以此樹立成為自己一家的風格。而當代藝術之中當代感的傾向，則是在以上這些目標之外，還可能有更多要闡述的思考與意見，或者可以廣義地來說，當代藝術史的書寫方式更多的是「觀念」——這個說法並不是「什麼東西都可以成為藝術」的托辭，反之，是再度地說明了「藝術」是為人類思維、文明達到之高度的指標

的這個事實，到今天為止所發展到的一個階段。

從林明弘第二次在伊通的個展「室內」，可以看見他在遭遇楊蕙如的提問之後反芻的結果，以及他創作思路上根本的遭變；林明弘在這個展覽中整理出在他的生活以及個人化的品味當中，跟他內心很親密的兩個元素——「家」與「空間」。

那段時間，林明弘所有的心思與熱情都專注在設計、佈置他的新家，展覽的呈現其實非常單純而直接，直接到就把原來舖在家裡的幾塊地毯搬來，舖在伊通原本非常低限、純白牆面的展覽廳中的水泥地面上（同時還附設了家庭音響）；另一個空間的牆上就掛著他新家以三塊地毯為空間區隔的設計圖，一筆一筆填上地毯花紋的色塊，還有幾張台灣早年主要是做棉被被面的土花布圖案，也是他手繪填色的。這應該是林明弘的土花布圖案第一次在他的展覽中現身。

我們現在已經很習慣於展覽場的空間一概塗灰或刷白的做法，這與工商業發達的美國六〇年代有絕對的關聯，自從安迪·沃荷說：「我的畫室即工廠！」畫廊也便在此時紛紛搬進了便宜而又挑高的廢倉庫、舊工廠，然後把牆面一概漆得雪白，等著隨時填進各種性格特異的「藝術品」，人們走進這些公共空間時，便一律是以直立的方式觀看、停佇、瀏覽。而林明弘的三塊地毯，輕易地把走進這個空間的直立人全給攤在地上，在這裡或坐、或躺，都容易，就是只有堅持站立觀看的人有些艱難與尷尬。

脫了鞋踏上地毯所規範的這塊空間之內的人，一開

始必定有意識於這是件「作品」的特定性格，但是坐臥於地毯上、隨性挑選音樂播放、與地毯上其他的人天南地北地聊久了，便可能不自覺地放鬆到近乎處於私領域的心理狀態。

林明弘在佈置家的過程同時構思這一件作品，顯現當代藝術中一種辯證的特性，亦即是他作為一名創作者所要闡述的思維與意見：藝術家（的生活）跟他的環境（家／展覽場／公共空間）之間，兩者可以如何連結？這兩個部份對於林明弘當下的生命而言都是如此地親密，於是他嘗試把在展覽空間（公共領域）中原本被排除掉的一些東西：裝飾圖案、織品、乃至於往後作品中又增加進來的塌塌米、木頭、家具……等等（本屬私領域的物件元素）全放進去，完全改變了長久以來大家對於展覽空間的習慣──這不只包括了視覺上的觀展習慣，還包括了置身其中必須與空間／作品對應之狀態的習慣。

我們現今所熟悉的林明弘作品，就觀念上而言大抵是「室內」展的衍伸──私領域與公領域之間的辯證與對話；個人私密的生活經驗（如睡眠狀態的影像紀錄）與公眾（作品展出時的觀者）分享的方式：透過這些，我們很容易於辨認這個習慣於台式和風居室空間、放鬆自在地與人分享的大男孩的創作語彙、風格，與個人特質。

林明弘的出身是霧峰林家他這一代的長男，1964年出生於東京，同一年與家人一起返台，八歲以前一直成長於霧峰林家大宅，那段時期跟他最親的人就是祖父，祖父精通英法德日四國語文，也是前輩畫家顏水龍的好朋友，更是將西方文學理論哲學帶回台灣的學者，被稱為台灣啟蒙思想家的林攀龍。八歲之後，研究所畢業之前，林明弘被送到美國受教育、生活，中間只短暫地回台灣受教育兩年；大多數的時間裡，他是以美國為中心，隨時隨意地往來於台灣、日本、法國幾個地方；從這整個成長背景看起來，林明弘首先最讓人感到興趣的，便是他在身份與文化認同上的觀點，但是對於林明弘而言，這並不是一個複雜的大問題，而且它有一個明晰而單純的答案──他所歸屬之處，就是他的「家」，

左：「閒逛」伊通公園 台北 "Huh（Meander）" IT PARK Gallery, Taipei 1994
下：枕頭七號 Cushion N7 75x75cm 1997-1998

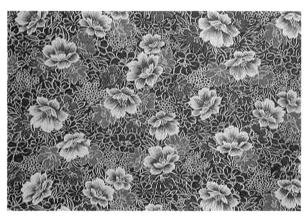

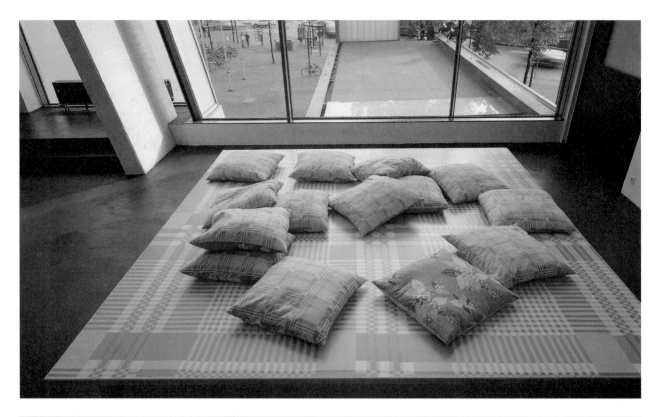

上：「共生共存37日」 臺北帝門藝術中心 "Complimentary" Dimension Endowment of Art, Taipei 1998
下：「你說／我聽」 法國碧松當代藝術中心 "Tu Parles/J'ecoute" Centre d'Art Contemporain, La Ferme du Buisson, France 1998

「家對我而言是一個很直很強大的柱子，隨時在我背後可以靠的。」林明弘回憶，無論家人住在哪個國度，他一回到家只要看到公媽桌（祖先牌位）前正焚著香，就知道爸爸已經回來了，父親的教育方式尊重而寬容（在林明弘的記憶中，「父親從來沒說過我不能做什麼。」），但在面對家族觀念時卻又顯得非常的傳統，每天出門前、返家後的第一件事，就是以長子的身份給祖先牌位上香。「清明掃墓，我家掃的是五代的墓；對我而言，身份的來源是毫無疑問的。」

儘管如此自我剖析，林明弘對於文化與身份的問題，其實還是比大多數人更具敏銳度，「文化與身份的問題其實是所有的人都需要面對的問題，從某個角度來看，普普、極限主義的源起，一部份原因也是要和美國文化所從出的歐洲切斷臍帶，也是在尋找自己美國文化的定位與身份。」那麼，「我的創作，所屬為何？」這個問題對林明弘而言比他自己的身份認同複雜。

林明弘解決的方法，就是把複雜的問題簡單化，讓他的創作，歸屬到與他平日生活的連結，很有意思的是，這個簡單化的結果，卻又自然明白地顯露了他身上的各種文化元素：日式的塌塌米、台灣的土花布圖案、以及把原本很民俗感的花樣手繪出像工業拷漆般平整明亮的放大圖案；一切都融合得非常自然。

林明弘的作品除了平易易辨的視覺語彙之外，作品本身的對話性格也非常適合跟其他作品並列的聯展，當他的作品介入一個展覽空間時，最普遍產生的效果就是把原來展覽空間低限或是中性化的個性給銷解掉，變成另一種比較散漫而有人性溫度的場域，在林明弘所創造的場域看其他藝術家的作品，也會有跟在其他展覽空間觀展時很不相同的感知，這正是林明弘創作的真正「要點」——改變一個已被概念化的空間經驗；改變一種已經被定型化的觀展

「君自故鄉來」竹圍工作室 "Back from Home" Bamboo Curtain Studio, Taipei 1998

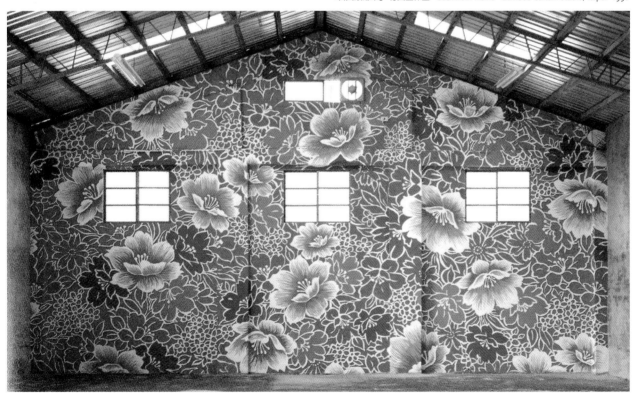

經驗。

從一開始，林明弘將自己家裡小窩的佈置物件搬到公共展覽領域構建成一個展覽開始，後來林明弘規模越來越宏大的創作逐漸走向以展覽空間為第一規劃場所，並盡可能地於現場施作的情況；表面上，所展現的多數是在公共場域佈置出一個具有私領域氛圍的空間，但作品本質上的精神面已經大異逕庭了。把自己真實的家搬出來變成展覽的佈置，這種直接的移轉與挪用具有本質上衝突的張力，但是一個原本為展覽而施作的空間，雖然仍然能創造出私領域的親密感，但其規格、配置，還是讓人一目可知這是一個純粹為展覽而施作的空間作品，私領域的情調是作品創造的氛圍，但與本色已無關。從「室內」展這個原點出發的延展已經全然完成其質變的過程，蛻化成為另個論述的重點。

這裡面有一個甚為有趣的辯證：當一件作品在一個空間中完成時，它的形成自然地會與那個空間產生不可分割、相互作用的一種關係，而當它離開這個空間進到另一個空間的時候，形成作品之初的一些條件就被剝除、改變了，它與新空間的關係固然可以被作者有意識的重新賦予，但勢必不若在原來空間那般天成，這也是為什麼有些純藝術的急進主義者反對繪畫作品可攜帶、可因地制宜地展示懸掛等特性，認為那崩解了作品創作之初的完整性，只淪為商業主義產物的原因。「室內」展恰恰有趣的卻正是整件作品（居家的室內設計）被有意地挪移到了屬性相悖的空間裡，因為蓄意的剝離原空間、也蓄意的介入新空間所產生的對話，突顯了創作者生命中過往的背景以及情感上未來的去向，崩解了作品創作之初的完整性的目的，就是藉以述說創作者當下生命與情感的完整性條件。

後來林明弘的作品，即使有少數是使用之前使用過的舊材料，因為裁切的形狀與新空間不相符合，而流洩出了舊空間的痕跡，但這種挪移跟當初的「室

「共生共存37日」 台北帝門藝術中心 "Complimentary" Dimension Endowment of Art, Taipei 1998

內」已經全然不同。從1998年的「你說我聽」展、1999年在印度的工作營、2000年台北國際雙年展與「粉樂町」展、到2001年的威尼斯與伊斯坦堡雙年展，再到今年於比利時歷史博物館的展覽、巴黎東京宮的展覽以及海牙市政府的邀請展等等，這些作品的處理方式，巨大的手繪土花布圖案都已經跟空間結合爲一體，純粹處理的是公共空間、展覽場所的問題，「室內」展當時所處理的對話，述說著當時林明弘生命的重心與情感的去向，對照於他今天因爲國際四處頻繁的邀展，而像個候鳥一般走上羈旅天涯、逐展覽而居的生活，當初林明弘生命中最親密的元素「家」，今日已經與他越去越遠，「當一個男孩子面臨到家與事業的選擇的時候，我很難說服自己不去衝衝看。」這是他難以掩飾些微失落的坦率，「家」曾經是林明弘出發的起點，卻也是他走上成功之路以後，回不去的地方；他現在的作品，仍然是很有興趣在處理空間（尤其是公共性的展覽空間）與人（觀展的人以及同展的其他藝術家）的對話，但這些多數都是落在公共議題的層面，跟他以前作品中那種分享的親密感與溫度，已經很不相同了，就像一個原本膩人撒嬌的孩子，轉眼間，長成了懂得自律、節制情感的男人，固然有所得，也必然有所失吧。

（本文原刊於2002年6月，《現代美術》第102期）

巴黎東京宮「當代創意區」Site de Creation Contemporain, Palais de Tokyo, Paris, France 2003

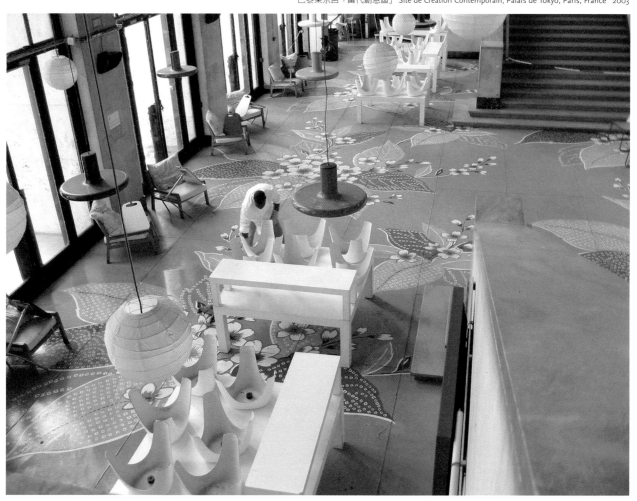

The Boy Who Left "Home"

Viewing the Local Floral Patterns of Michael Lin

Hu Yung-fen

The creative work of a good artist is almost always closely related to his or her own life experience or alternatively individual character, taste and life. A good work of art can be rational and logical or not, but it is much harder for it to not be connected in some way to perception, that is to say feelings, senses and emotions.

In 1994, Michael Lin held his first solo exhibition in Taiwan at IT Park Gallery, where he displayed rectangular metal sheets painted in bright colors and protruding directly from the wall in an upwards direction, infused with a slight sense of minimalism and industry. On arriving at the gallery, the first question asked by curator Alice Yang, who had herself spent time in the US, was: "Does this artist come from Los Angeles?" These works were indeed conceived when Lin was studying in LA but only given shape after he returned to Taiwan. However, this is a problem to be mentioned in passing and one that started Lin reflecting seriously on the relationship between an artist (himself), the environment in which he lives and his life experience.

In classical art history artists researched the interplay of light and shade, perspective, structure or color or devoted themselves to the correct depiction of solemnity, holiness, benevolence, magnificence, romance, joy etc. Such developments can be attributed to a desire to use the "new" precision of their craft to create something artistic predecessors had been unable to produce - to visually realize a certain perceptual effect and then use this to establish a distinctive style.

Moreover, trends in the sense of modernity that infuses contemporary art lies beyond such objectives. There may also be other ideas and opinions on which an artist wishes to discourse. Put more broadly, contemporary art history is written in a way that is largely "conceptual." This is not an excuse to claim "anything can become art," rather it is an opportunity to explain how "art" is an indicator of the very peaks of human thought and culture, providing a framework that can be used to look at where exactly that development has reached today.

Looking at "Interior," Michael Lin's second solo exhibition at IT Park, we get to see the results of the artist's cognitive reflection after being questioned by Alice Yang and the fundamental change that his creative thinking has since undergone. As part of this solo exhibition, Lin highlighted the two elements most intimately related to his life, personal taste and inner world – "Home/Family" and "Space."

At that time, nearly all of Michael Lin's ideas and passion was focused on designing and decorating his new home, so the layout of the exhibition itself was very simple and direct. So direct in fact, that he brought a couple of carpets from home and placed them on the concrete floor of the exhibition space at IT Park Gallery, with its low-key white walls (he also positioned the family stereo system there). The wall of another space is decorated with the design diagrams of three carpets used as spatial dividers in the artist's new home, the carpet patterns added one stroke at a time.

Lin is also particularly adept at painting the sort of local floral patterns that used to be popular decorations for duvet covers. This probably marked the first time local flower patterns appeared in a Michael Lin exhibition.

Today, we are already familiar with exhibition space being painted grey or white, which is intimately connected to commercial developments in the US in the 1960's. Andy Warhol observed: "Our studios are factories!" It was exactly at this time that many galleries moved to cheap and empty warehouses or old factories with high ceilings and chose to paint the walls white, in readiness for different "art." As soon as an individual enters such a public space he/she tended to view pieces from an upright position. Michael Lin's three carpets draw the attention of visitors to the floor. It is easy to sit or even lie down here, only those who insist on standing find themselves uncomfortable and embarrassed.

Those who take off their shoes and walk into the space defined by the carpet are aware that this is a "work of art," but sitting or reclining on the carpet and selecting whatever music one wants to hear whilst chatting with other people perhaps causes visitors to unconsciously relax to the point where they feel psychologically as though this is their own private space.

Lin came up with the idea for this work whilst decorating his home, which highlights the dialectic nature of contemporary art as a vehicle for relating ideas and opinions the artist wants to convey. Exactly what connections are there likely to be between the artist (life) and his/her environment (home/exhibition arena/public space)? These two elements were very close to Michael Lin's life at that moment and so he attempted to make use of things that are usually eliminated from an exhibition space (public space); decorative patterns, fabrics and with later works he even started bringing objects in such as a tatami, wood, furniture etc. (objects that belong specifically to a private realm). Through these actions, the artist completely changes people's long established understanding of what constitutes an exhibition space – This includes not only the visual habit of viewing an exhibition but also the habit of being in a state that corresponds to space/work when viewing.

The works of Michael Lin we are familiar with today are conceptually speaking extensions of the "Interior" exhibition – a dialectic and dialogue between private and public spaces. This involves the sharing of an individual's private life experience (a video record of someone sleeping) and an audience (visitors to the exhibition). Through these we can more easily identify the creative language, style, and character of the artist, who is used to sharing with others in his Taiwanese style Japanese living environment.

Lin (the eldest son) was born in Tokyo, Japan in 1964, the same year his family returned to Taiwan. Before the age of 8 he grew up in the family home in Wufeng, a time when he was particularly close to his grandfather, who was fluent in English, French, German and Japanese and a close friend of renowned artist Yen Shui-lung. Indeed, Lin Pan-lung was a renowned scholar in his own right, introducing Taiwan to western literary theory and philosophy and widely regarded as one of the most enlightened thinkers locally. From the age of 8 until he graduated from graduate school, Lin attended school in the US and returned only briefly to Taiwan where has was schooled for just two years. Most of the time, the US was the center of his life, though he did travel to Taiwan, Japan and France. Given this background, Lin is often asked his opinions on identity and specifically cultural identity. However, the artist maintains that he has never really considered this to be a major issue. His simple answer to all such questions is - He belongs to his family - "For me, family is a pillar of strength, something that is always there I can depend on." Lin notes that regardless of which country the members of his family live in, whenever he visits and burns incense in front of the ancestral memorial tablet, he knows in his heart that his father is there. It was his father that taught him the value of respect and tolerance (Lin recalls "my father never told me I could not do such and such a thing") and when faced with the concept of family he is very traditional. Every day the last thing he does before leaving home and the first thing on returning is to burn incense to his ancestors in his role as the eldest son. "During the Sweeping of the Graves

ceremony my family swept the graves of five generations. For me, the origins of my identity could not be clearer."

Despite such a degree of self analysis, Michael Lin is more sensitive about issues of culture and identity than most people: "Everyone has to face problems of culture and identity. From a certain perspective the origins of pop and minimalism can be traced back to the rupture between US culture and its European parent, an attempt on the part of the US to find a distinctive position and identity for its own culture." As such, asking Lin "Where does your creative work belong?" is an even more complicated issue than that of personal identity.

Lin resolves problems by first simplify seemingly complicated problems so that his creative work is connected to daily life. What is especially interesting is that this process naturally reveals the various cultural elements than makes up his identity; Japanese tatamis, Taiwanese floral patterns and the way in which he takes what were originally relatively crude flower patterns and paints them as what appear to be brightly colored magnified industrially painted patterns – all of these elements are combined in a way that is extremely natural.

Other than the easily identifiable visual language, the dialogue inherent in Lin's pieces themselves makes them the perfect choice to be exhibited with other art. To that end, when Michael Lin's works are placed in an

exhibition space the most common effect is the elimination of its minimalist or neutral character, transforming it into a more relaxed and warm arena. Viewing the work of other artists in a space created by Lin also gives viewers a completely unique feel to displays of the same pieces in a different exhibition space. This is indeed the "focus" of much of the artist's creative work – transforming a pre-conceptualized spatial experience; changing a predetermined exhibition experience.

From the very beginning, Michael Lin has taken small decorative objects from his home and used them in public exhibition spaces to mark the start of an exhibition. More recently, he has begun producing larger and larger pieces, so much so that he now prefers to create onsite where possible. On the surface, what Lin usually undertakes is the transformation of public space into a space infused with a private atmosphere, but spiritually the work itself could not be more different. Using one's own home to decorate an exhibition is a direct transfer and usage that creates tension because of the inherent conflict depicted. Although a space specifically created for an exhibition can still create the sense of privacy that belongs to a private arena, the specifications and layout are immediately recognizable as spatial elements designed for an exhibition. The emotional sentiment of a private arena is an atmosphere created by art, detached from its original meaning. Any extension starting with the "Interior" exhibition has already changed qualitatively,

私人收藏 巴黎 Private Collection, Paris 2000

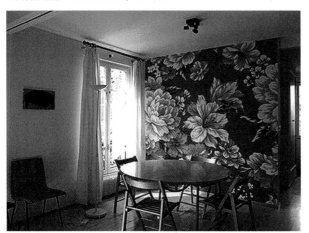

義大利威尼斯 普里奇歐尼宮 Palazzo delle Prigioni 6.10-11.4 Venice 2001

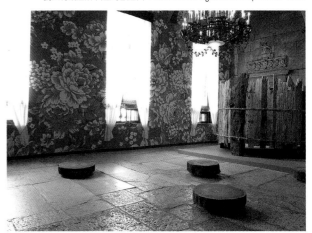

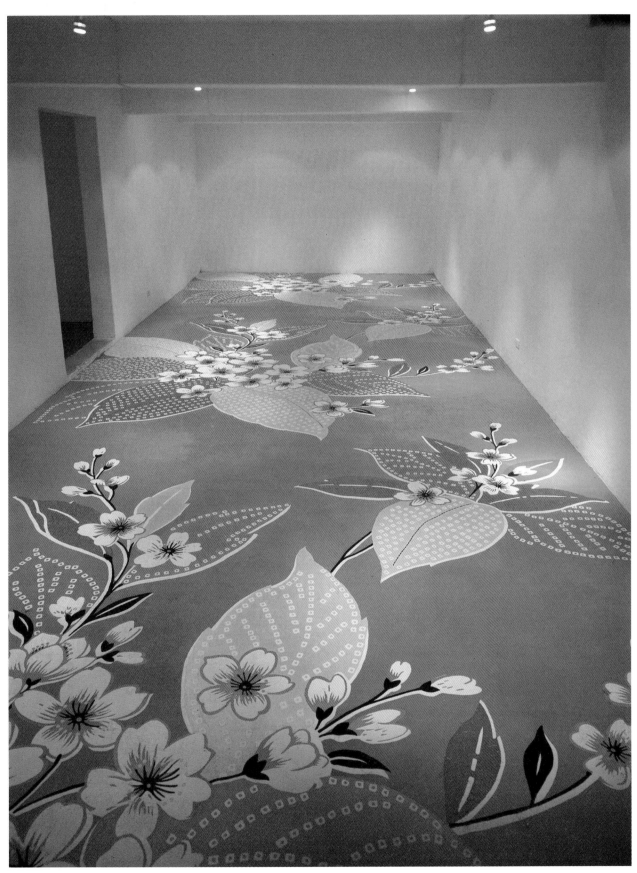

伊通公園，7月31日-8月21日，1999　IT PARK July31-August21, 1999　430x1037cm

transformed into the focus of a completely different commentary.

Inherent in all this is one intriguing dialectic idea: When a work in a specific space is completed, its form naturally establishes an inseparable relationship with that specific space. When it is placed in a different space, some of the conditions that initially formed the piece are eliminated or changed. Its relationship with the new space can be deliberately re-molded by the artist, but it is inevitably not as good as the original venue. This is also why some pure art extremists oppose the portability of paintings and the different ways they can be hung depending on location, believing in the initial completeness of the work and that portability merely makes it commercialized product. What is intriguing about the "Interior" exhibition is that the entire piece (the interior design of a home) is purposefully used in a space that runs counter to its own essential nature. By deliberately removing it from the original space, the dialogue created from placing the piece in a new space, highlights the artist's past background and future emotional direction. The objective in collapsing the initial completeness of the piece is to speak to the conditions that underscore the completeness of the artist's life and feelings at that moment.

Michael Lin's later works, even the handful that make use of the materials he previously used, were cut into different shapes and failed to match the new space, thereby revealing signs of the older space, though such applications were completely different to those in the "Indoors" exhibition. Examples include the "Tu Parles, J'écoute" exhibition in 1998, the Work Camp in India in 1999, The Taipei International Biennial and "Very Fun Park" in 2000, to the Venice and Istanbul Biennials in 2001 and this year's exhibitions at the Belgium History Museum, Palais de Tokyo in Paris and the invitational exhibition organized by the city government of the Haguec. These huge hand-painted floral patterns have already combined with space as an integral whole, dealing with issues relating purely to public space and exhibition arenas. The dialogue presented at the "Interior" exhibition spoke directly to the focus and emotional direction of artist Michael

Lin's life at that time. Today, he flits around the world traveling from invitation exhibition to invitational exhibition, staying wherever the most recent display is showing. At that time "home" was the most intimate element in Lin's life, though today he is increasingly distant from it: "When a man faces a choice between family and career, I find it very hard to stop myself rushing ahead and seeing what I can achieve." The frankness makes it all the harder to cover up his slight sense of loss. Whereas "home" was once the artist's starting point in everything, it is also the one place that success makes it difficult to return to. Michael Lin's works now are still very interesting in the way they deal with the dialogue between people (visitors to and other artists at an exhibition) and space (particularly public exhibition space). But most of this relates to public issues, a considerable departure from the sense of intimacy and warmth that infused his earlier works. The difference is like that of a spoiled child suddenly growing up into an adult and understanding the benefits of self discipline and emotional control. Inevitably something has been lost, but it is also undeniable that much has been gained in the process.

(This article was originally printed in June 2002, *Modern Art* No.102)

台北市立美術館，2000年9月9日-2001年1月7日，2000 Taipei Fine Arts museum Sept.9, 2000-Jan.7, 2001 2000 32x16m

山神與地母的兒子

看王文志內心終極的「家」

文／胡永芬

王文志從高中畢業，心裡就一念執著著「要讀最好的美術學校」的心願，有些荒謬的是，這也成了他前半生最坎坷的躓跌之路；倒是創作，無論是1990年代初採取「血的控訴」一般激越姿態的王文志，或是到了如今彷彿化身山林之子，與自然吟哦相和的王文志，始終一貫可聞的是從他家鄉瑞里所浸染的山中人的氣息；可以說，他與他的藝術的特質，差不多跟學院全沾不上干係，多數是來自生命中過往的經驗所勾動出的體驗，這產生了一個讓人感到興味，卻不會有答案的問題：如果當年王文志果真很順利地考上了他心裡認為的「最好的美術學校」，那麼他今天的藝術會是怎樣？！

王文志出生與成長的地方，是嘉義縣古稱「幼葉林」的山城，也就是今日的瑞里鄉，他的父親是個採石切石工人，為山裡造廟、開梯田整地打石頭；他的兄長則是個伐木工人，這也是當年留在山裡的男丁主要的工作項目，其他零星的副業諸如採竹筍、金針等等，也全都是體力勞動的汗水工。一直到十多年前，兄長與山裡其他人到杉林溪剪回春茶枝來種，整個瑞里的主要產業才改觀了。

山裡的生活原本跟美術完全沒關係，首先是國中來了一個師大美術系畢業的導師，覺得這孩子能畫，帶著他做海報，還買顏料送給他，老師去當兵前夕，把自己的畫具全「傳」給他，還交待：「將來去考美術系」。高中暑假山裡又來了幾個藝專的學生，無意中看見他信手的圖畫，又大大地鼓勵他去考美術系。

這個念頭像一顆種子，當兵那幾年種子早已發芽長成一棵大樹，王文志當完兵第一件事便是買齊了畫具，登門上嘉義名畫家陳哲畫室就要拜師，陳哲看來人程度，輕描淡寫的說：「再唸三年也考不上」。他也沒說錯，考了不只三年，從當時他心目中「最好的美術學校」國立藝術學院創校單獨招生一直考到該校參加了全國大專的聯合招生，他一次也沒考上，最後只勉強考到私立文化大學美術系，不過，終究也算是考上美術系了。

這期間荏苒的光陰裡，王文志都做了些什麼呢？「家鄉的男性都只有兩條路可走，要不是伐木，再不然就得離鄉到都市去工作」，過了一段住山寮的伐木生涯，中間為了家族的新事業——茶葉，他還到鹿谷的茶葉改良廠向吳振鐸老廠長求教，王文志記得，任何茶老廠長只需喝一口，就能說出茶的種類、種在什麼地方、用什麼肥料種的……，讓他受教了什麼才叫「專家」！

之後，王文志終究還是離開家鄉來到了大都市，卻從沒有想過要去補習，所以除了就這麼年年去考美術系之外，謀生的工作去過化學工廠攪顏料、做過裝濾水器工、當過警衛……，「當警衛得要常常幫人開車門，我邊開邊在想，人只差在有錢沒錢，生命的價值就差那麼多嗎？」考上美術系那年，已經是二十六歲，別人研究所唸畢業都還有餘的年齡了。

交代這一大段前傳，整個過程對於做一個藝術家而言雖然算是有一點兒坎坷，但仍不失「一分努力一分收穫」的人生格律，對此王文志表達了他發自內心的慶幸，正向思考地認為：「還好過去『玩』過

那麼多，因爲我後來的創作都是由此而來」，他說。

考上文化大學美術系，剛開始讀就覺得「好像被騙了」，一切都跟所想像的不一樣，學校裡的老師雖然人很好，但是「我想做一些『別的東西』」！他不喜歡畫人體，也一點都不想去學雕塑，胸臆中一股飽滿的盲動企欲尋求某種出口或是答案，他想出了一個「以美術館爲校」的好方法，學校的課幾乎不上了，卻頻繁地泡在美術館聽各種主題的演講，這才是他心目中所鍾情的學校。

1988年，大學三年級，卻已經三十歲的王文志，以作品〈自然的控訴〉獲得台北市立美術館新展望獎的優選，這是王文志創作生涯第一個重要的座標，不只是他首次獲獎，也因爲他因此認識了當年獲得首獎的藝術家之一陳正勳，他的創作思維與態度對王文志而言是心有戚戚且言所不能，從此迄今，成爲王文志生涯中（藝術與生活兩面）一個重要的朋友。

〈自然的控訴〉這件作品可以視爲王文志創作發展的第一個座標、起點，從這第一件重要發表的作品中，我們就可以看見王文志作品中，無論形式、材質、思維、乃至與所關切之指向等等內容與語彙，都一直延續至今仍在發展中的一貫性。

這件作品的主體是三截大體上仍維持被砍伐後之原形的林木肢骸，展覽開幕之初猶存的些許挺立濃綠枝葉，直指著樹木本身剛剛方被屠體的事實，局部被王文志削飾如柄的材幹，末端各連結一把生鐵利斧，猶有未足地，地面上還斜躺著一把長柄鐮刀，整件作品好比熱血知青的抒情白話詩變奏爲山林之子的怒吼版。對於人與自然的關係，對於城市（與資本主義工商社會）的人們習於以無感而粗魯的方式對待他生命中曾經最溫暖親近的自然，王文志以最赤裸直截而白話的、王文志式的暴力美學來──控訴。

隔年，大學畢業之後的王文志，面臨了對未來的選

自然的控訴 Appeal of Nature 1988

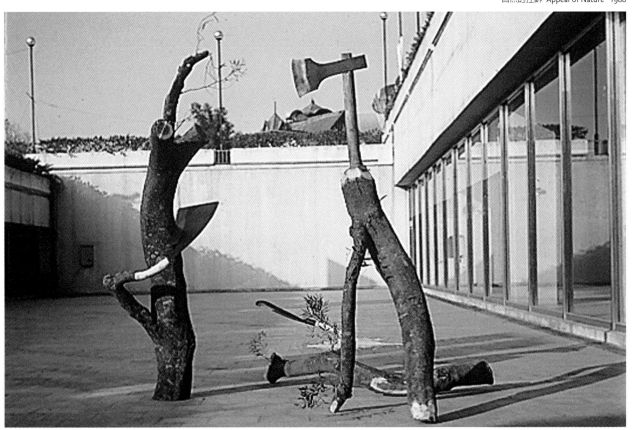

擇，知名建築師的室內設計工作室、雕塑名家朱銘的工作室都提供了他看來很有可能性的機會，但是，年逾三十，外語半竅不通的王文志卻選擇了一個從客觀的角度來看幾乎是完全沒有機會的路子——「我決定去法國，而且決定去了就不打算回來了，我決定要做到像趙無極」他心裡有很堅決的決定。可以想像，這個從山中走出來的青年胸臆中有著何其高遠而勇猛的一股「氣」！

一直迄今，王文志的作品在整體上一貫都有一種不能侷促的疏放之「氣」，幾乎是從任何一件作品，觀者都可以很直接容易的體察到作者對於幕天席地、憩於山林大地之懷這樣對於一般人而言奇特的自然經驗，是何其熟悉地不斷回眩與擁抱，而且熱情地樂與邀與他人分享。從暴力美學發展到今天對於自己早年生命記憶中山神地母懷抱的皈依，正是王文志從二十世紀八○年代末悲憤的狂飆血性青年，一路行進至二十一世紀此時，應是他四十三年生命中一切都最為飽滿的中年前期，生命與創作相互忠實對照。

1993年出國以前，王文志的作品絕多數都是有巨大的身量以及與體、面積相當的一股高亢的「氣」，雙臂無以環抱的、廟宇中具有彩繪紋飾的樑木殘塊，用以承托著陳實厚重、森森寒光的巨斧，或者根本便是把山中一塊塊如房車般巨霸、被盜伐的巨木殘根予以粗略剪裁，便在展場陳列一整排，這些作品都能創造出一種如祭儀般威嚴而又具有神聖性的氛圍，同時在凜然的空氣中能嗅出某種控訴的怒意。

1993年出國初期，儀式性的威嚴神聖性氛圍猶存，但怒意或許因為距離，已漸漸微妙地轉換為宛如迴吟般詩意地悲憫，這段時期的作品中，更多已經風化一段時日的樹木屍骸，已將近其原貌的狀態，以鋼索懸吊、檯座擺設……等等裝置手法，在現代美術館、展覽場的空間裡，宛如已經亙久存在般深沉地吟著生命與自然之悲歌。異地的生命情境，自然地催化了這樣的改變。

遊學三年之後，王文志終於放棄了留下來做趙無極的初衷：「法國三年讓我發現我對於台灣有多麼的陌生，一個藝術家連自己的土地都不清楚、不瞭解，怎麼可能是好藝術家？！」但是回到台灣的頭兩年，王文志可以說是心中感覺澎湃，卻找不到對的出口把它宣洩、抒發出來，足足兩年無法做作品，「想做空間、裝置，卻抓不住準確的方式，而此同時，以往山中生活裡很多勞動的感覺仍很深刻，苦悶的滯塞狀態中勞動的慾望則逐漸升高……」1999年文建會南投縣九九峰「當代傳奇／藝術逗陣」裝置藝術展中的作品〈九九連環〉令人印象深刻，王文志在哥哥、曾經同是伐木工的老夥伴跟竹編專家的阿伯，用嘉義的竹、傳統的編織工藝，創作出一件巨大卻不至於懾人，反而讓住民與外來客都能同感溫暖新奇的作品，從此，王文志可以說徹底地切斷了長久的控訴、悲歌時期，而進入到一種和諧從容，自在分享的階段。

2000年在台北市立美術館的個展，可以說是王文志這段時期心理狀態與創作成果的總整理、總發表，從山民於溪中捕小蝦的竹簍筒演繹靈感而來，仿若通往天堂路與地獄門，介於幽冥卻仍感溫暖的〈非常道〉，引領觀者通向面對落地玻璃窗的爍爍天光，〈觀音〉給每個願意的觀者醍醐灌頂，倒扣的竹編背簍造型的〈山美〉，讓人能裸足涉入倘佯於檜木芬多精的〈浴〉，整個展覽可說是王文志對於他童、少年生命經驗的擁抱，以及充滿喜悅地開展與分享。

這一氣而貫的作品諸如〈防洪計畫〉、〈大衣櫥〉，乃至最近一件〈藤雲駕屋〉，王文志述說的方式從來不出於簡明易懂的白話詩，只是當年氣鬱胸臆的暴力控訴版，如今已經一百八十度地轉變為天地清闊、生命如行歌般的宇宙和諧版，所有的作品，都指向著述說他內心那個人與萬物自然所共享的「家」。

藝術，便是可以如此簡單、真實、不必矯作，而仍然動人。

（本文原刊於2002年8月，《現代美術》第103期）

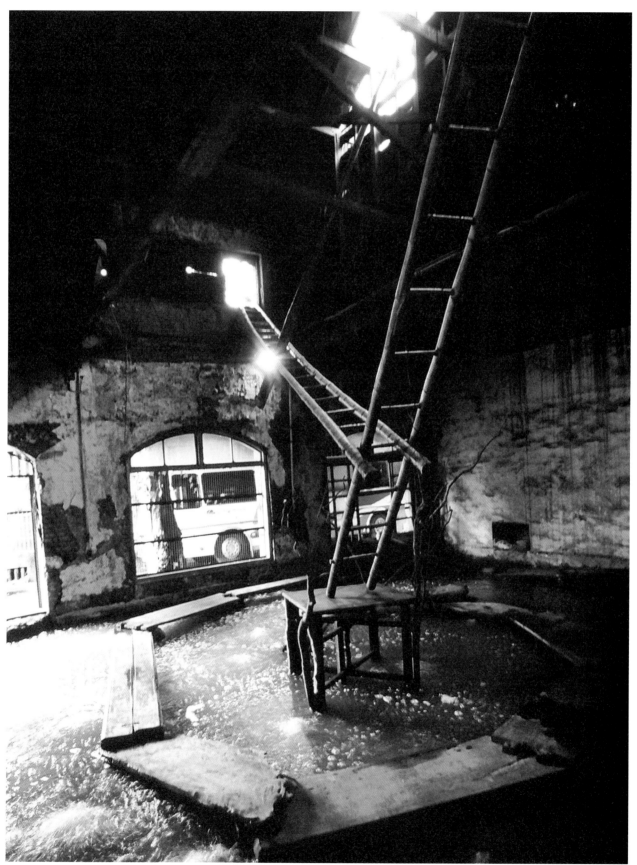

一線生機 A Thread of Life 2000

Son of Mountain Gods and Earth Deities
on Wang Wen-chih's Ultimate Idea of "Home"

Hu Yung-fen

Ever since graduating from the local high school, Wang Wen-chih had been preoccupied with the dream of attending "the best art college in the country". However, this aspiration turned out to be the biggest hurdle in Wang's younger years. Fortunately, Wang was eventually to achieve self-fulfillment in art. While he has evolved from a fiery and indignant protester of the 1990s to today's son of mountains and forests' who integrates harmoniously with nature, what has remained intact is the spirit and temperament of a typical mountain folk that he had acquired from a childhood in Rei-li. It can be suggested that Wang Wen-chih and his artistic qualities can have far less to do with his formal art training than with his real-life experience, making one wonder what would have become of Wang Wen-chih's art, if he had successfully secured a place in the "best art school of the country" as wished.

Wang Wen-chih was born and bred in Rei-li Township, Chia-yi - a mountain village previously known as Yu-Yeh-Lin, literally meaning the "Forest of Tender Leaves". Wang's father has worked as a stone miner and stone-carving master, who earned a living by helping build temples and clearing stones from the terrace, whereas his elder brother used to be a woodcutter - virtually the only job left for men in this small mountain village. Other odd jobs habitually performed in the village included picking bamboo shoots and day-lilies, all of which entailed hard physical labor. It was not until some ten years ago, when Wang's brother and other villagers had cut the shoots of spring tea to plant on their own land, that the occupational structure of this mountain village was altered.

Art had played no part in the mountain life until a fine-arts graduate came to teach in the village middle school and became Wang's homeroom teacher. The young teacher discovered Wang's artistic talent, guided him to make school posters, and even bought him paint. On the eve of his military service, the teacher passed down his painting kit to Wang, and advised the youngster to test for the art school in the future. Several years later when Wang was a high-school student, a number of students from the National Art Academy came to the village one summer. Having seen Wang's sketches, they too encouraged the teenager to test for an art collage.

The seed of such thoughts eventually grew into a mighty tree when Wang was undertaking military service. As soon as he completed the military service, frank and straight-forward Wang Wen-chih bought himself a full set of painting paraphernalia and turned up at the studio of Chen Che, a well-known local artist, to ask for art lessons. Mr. Chen gauged his standard and commented, "With knowledge and skills like that, you won't make it to the art academy even in three years!" Harsh his words might be, but Chen was right, as Wang Wen-chih was indeed to accumulate more than three failed attempts at National Institute of the Arts (NIA), which he thought was the "best art school in the country". Those years saw the NIA's admission policy changing from an independent student recruitment exam to join the national joint university entrance examination. The change made no difference to Wang Wen-chih, as he failed on all attempts, anyway. In the end, he managed to finally secure a place in the Department of Fine Arts, Chinese Cultural University. It was far from the art college of his dream, but an art academy it was, nonetheless.

What, then, was Wang doing during these years of preparation? "There were only two ways out for grown men in the village: woodcutting, or leaving the hometown to find work in the city." During a short span of woodcutting while sleeping in a building site, one day he had visited Mr. Wu Chen-duo, head of a tea refinery factory at Lu-Ku, to seek advice for his family's new business venture, i.e. tea-plantation. Wang remembers being in awe with Mr. Wu's wealth of tea-related knowledge, having witnessed how Mr. Wu was able to instantly name the type of the tea, the area of its plantation, and the fertilizer used, etc. upon taking the first sip of the tea. The experience was a real eye-opener, showing young Wang Wen-chih what it meant to be a true "expert".

Eventually, Wang Wen-chih left his hometown for the city, but was too naive to even conceive the idea of attending special intensive classes. Aside from independently preparing for the university entrance exams, he supported himself by doing a number of limited jobs including, to name a few, a paint-blender in a chemical factory, a water-filter installation worker and a doorman. "Part of my duties as a doorman was to open car doors for guests. I often thought to myself, does 'have' and 'have-not' really make this much difference to the value of one's life?" Wang had turned 26 by the time he was admitted to the art college. At this age some others may well have completed a postgraduate course plus more.

Wang Wen-chih's long road to art college may first appear to be a typical Cinderella story; it can also serve as a timeless lesson: "no pain no gain". In fact, Wang takes a positive attitude towards those difficulties he was faced with in earlier life, and even expresses gratitude for it, "Thanks to all those different roles I had played when I was younger, all those experiences have later become the backbone of my art."

However, almost as soon Wang started the art college course, he felt bitterly disappointed and disillusioned, because nothing was what he had expected of the art school. Although the tutors were kind enough, Wang had a feverish craving for something different from what he was taught. He enjoyed neither figure painting nor sculpture lessons. There were millions of questions

he desperately wanted answers to, and he finally found a way to discover those answers. Wang hardly ever attended classes in the art college. Instead, he took art museums for art schools, and immersed himself in the public lectures and activities held at those art museums, which he considered as the true art school of his dream.

1988 was a crucial year for Wang Wen-chih. Over 30 years of age but still a third-year undergraduate student, Wang won with his "Appeal of Nature" the Selection Award in the Contemporary Art Trends in the R.O.C of Taipei Fine Arts Museum. This award marked a huge milestone in Wang's life, being not only the first award that paved the way for his artistic career, but also the occasion on which he met his lifelong friend and comrade in art, Chen Cheng-shun, who won the First Prize in the competition that year.

"Appeal of Nature" is the first landmark of Wang Wen-chih's artistic career. It can be seen to establish Wang's artistic style in general. Various artistic elements of "Appeal of Nature" - in terms of the form, media, artistic ideas and vocabulary - can still be detected in Wang's later works even to date.

The main body of "Appeal of Nature" consisted of three joints of unprocessed log. Sprouts of bright green leaves were still attached to the log by the time of the exhibition opening, highlighting a recent act of brutality against Nature. Partly trimmed by the artist into a handle-like shape, each of the branches was tied with a rusty ax. To enhance the ferocious outrush of the work, the artist placed on the ground a long-handled sickle, making the entire piece appear as though a lyric poem of a hot-blooded young intellectual suddenly turned into the thundering rage of the Mountain's son. With his characteristically raw and unadorned "aesthetics of violence", Wang Wen-chih vehemently denounces humans' callous and brutal treatment of Nature, which has always held a special place in his heart.

The next year, Wang graduated from university and was immediately faced with queries about his future plans. He was offered promising positions from several studios of eminent artists and designers, including acclaimed sculptor Chu Ming and some reputed

architects. However, albeit in his 30s and having little skills in foreign languages, Wang opted for himself something which might look hopeless from an objective point of view: "I decided to further my artistic training in France and live there for good. I wanted to make it in France like Zao Wou-ki!" Wang was utterly resolute and focussed. One can easily imagine a powerful blast of energy in the chest of this young man from the mountain.

To date, Wang Wen-chih's works have always been filled with a similar sort of powerful yet unreleasable energy. Viewers can easily sense, from almost every piece of Wang's work, the artist's special closeness to all the experiences that most people can only dream of - moving freely between sky and earth and residing between mountains and grassland - how eagerly he longs to return to these experiences and to share them with others. During the course of Wang's artistic career, his style has evolved from an "aesthetics of violence" to

a style that shows his longing for a regression to the womb of Nature. The shift has indeed echoed Wang's own path of life from a hot-blooded youth of the 1980s to a mature artist of the new millennium.

Before Wang went to France in 1993, his works had been largely characterized by ornately decorated beams of unembraceably huge size which seemed to be bursting with an equally huge volume of energy. Habitually serving as an important architectural element of temples, these decorated beams were often employed in Wang's works to hold solid and powerful hatchets. Sometimes the artist even placed huge chunks of illegally-cut logs in the exhibition venue in orderly array, again with minimum artificial interference to the wood, to create a ritualistically solemn and monastic atmosphere as well as a sense of seething rage in the cold air of the exhibition room.

At the start of Wang's years in France, his works could still be seen to convey the ritualistically solemn

大衣櫃 The Big Closet 1997

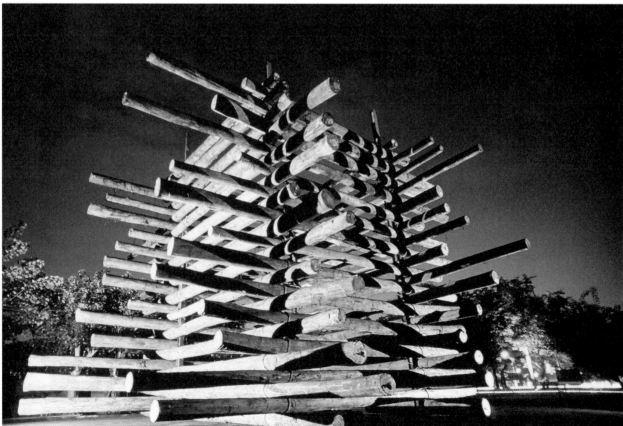

atmosphere, but the whirlwind of fury was gradually and subtly smoothed into a poetic and lyrical voice that spoke the language of compassion, perhaps due to the greater distance between the artist himself and his homeland. During this period, Wang's works often featured semi-fossilized relics of trees. Again, with little artificial interference, these tree relics, in their most original form, were placed at every corner of the art galleries and exhibition venues - suspended by the wires, or used as a table-lamp base, as though they had long been lamenting life and nature. Clearly, it was the new lease of life in a foreign country that catalyzed such obvious changes.

After spending three years in France, Wang Wen-chih decided to stop following the footsteps of Zao Wou-ki. "The three years in France made me realize just how little I knew about Taiwan. How can one possibly make a good artist if he doesn't even understand his own place of origin?" However, after his return to Taiwan,

Wang encountered tremendous difficulties in channelling or expressing the powerful complex of emotions in his chest, resulting in a two-year spell of creative block. "I wanted to make spatial installation, but couldn't grasp the right way to go about it. Meanwhile, I still felt strongly about the life of hard labor that I had been used to in the mountain, and the ongoing state of emotional congestion only intensified my cravings for doing physical labor." In 1999, Wang finally created a piece of installation, "The Memory Tie", which impressed in "Art in March – Legend Exhibition", held by Taiwan's Ministry of Cultural Affairs in the 99 Peak of Nantou County in 1999. Given technical support by his elder brother, an old woodcutting partner, and a senior bamboo-weaving master, Wang produced, using bamboo materials from Chia-yi and traditional bamboo-weaving techniques, a giant but not overpowering piece of installation art which gave a warm and refreshing feeling to all

觀音 Kuan Yin 2000

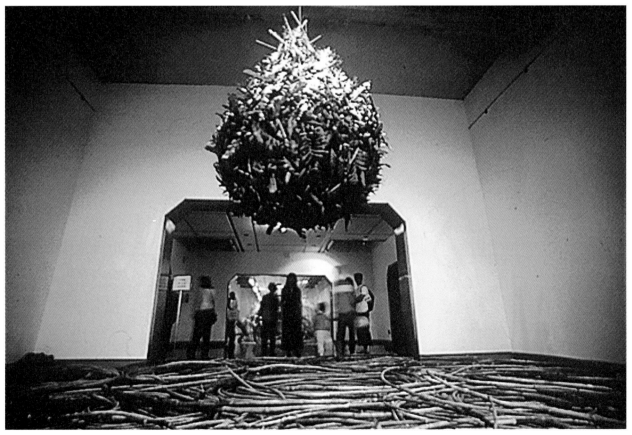

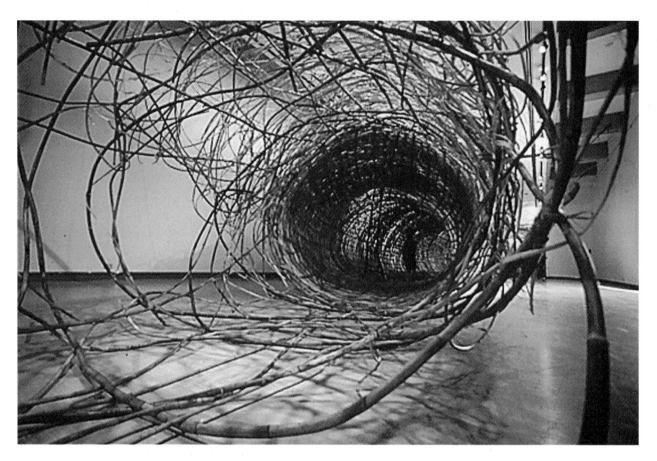

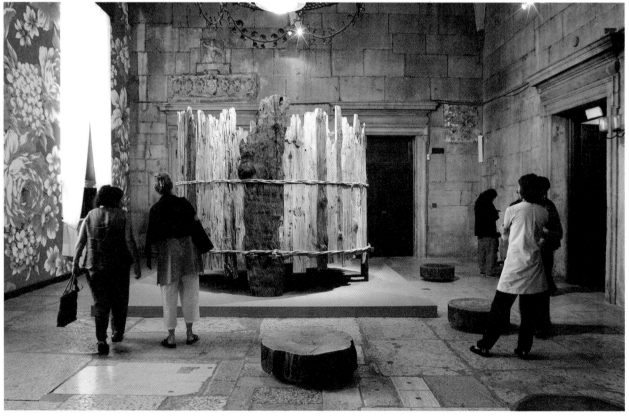

上：非常道 The Path 2000 下：方外 Beyond the Site 2001

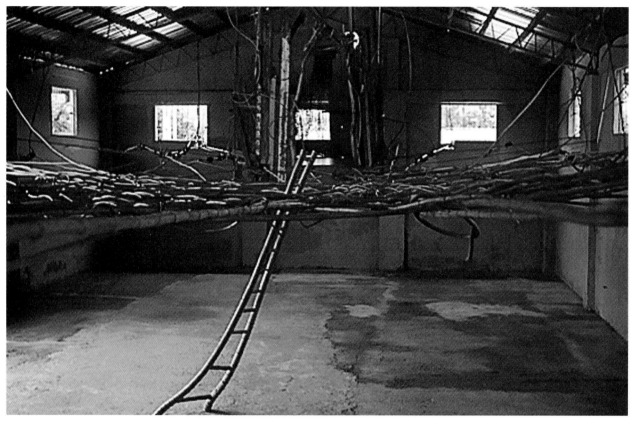

藤雲駕屋 Beyond the Cloud 2002

including local residents and visitors. "The Memory Tie" can be seen to mark the departure of Wang's artistic style from the period of poignant mourning for a brand new phase characterized by serenity, harmony and the spirit of sharing.

Held in Taipei Fine Arts Museum in 2000, Wang Wen-chih's first solo exhibition can be seen to summarize his psychological changes and artistic accomplishments during this period. The exhibition was inspired by bamboo baskets often used for shrimp-catching in the mountain stream. "The Path" radiated warmth in the dark as if it were a tunnel that led to Heaven on one end and to Hell on the other, guiding the viewers to gaze upon the glittering lights through the French window, and to receive blessings from "Kuan Yin". Meanwhile, with an appearance that resembles a bamboo bucket placed up side down, "San-Mei" invited the viewer to step in the cypress tub and enjoy "The Bath" of phytoncide. It can be said that the entire exhibition represented Wang Wen-chih's

warm embrace of his childhood and youth experiences; it also showed the artist's joy at sharing these experiences with the viewers.

Later works which Wang pursued in a similar spirit included, to name a few, "The Flood-Preventing Plan", "The Big Closet", and the latest production, "Beyond the Cloud". All these works continued to follow the artist's usual style: simple and poetic, except that the violent agitation of a young artist had been completely ironed out in the harmonious and free-flowing verse of lyric poetry about life and the universe. In either way, all his works reveal the artist's vision of 'home', which he shares with all creatures great and small.

Wang Wen-chih shows us that art can be simple and truthful, touching hearts without contriving.

(This article was originally printed in August 2002, *Modern Art* No.103)

在豔光四射裡狂笑

黃進河的視覺美學[1]

文／王鏡玲

這篇文章的目的是探討台灣當代藝術家黃進河的藝術作品所呈現的既對立又共存的視覺美學特色。黃進河將他對台灣傳統宗教經驗、歷史記憶、與現實生命所交織的視覺文化，透過豔光四射的色彩、誇張扭曲的輪廓，與擁塞拼裝的構圖，展現了一場視覺的暴力美學嘉年華。這種視覺暴力的震撼包含了藝術作品如何在優美與怪誕、高雅與「粗鄙」、神聖與褻瀆、嚴肅與嘲諷、同質性與異質性…等等現代藝術表現形式的爭議。黃進河對傳統視覺符號的負重、分離與再生的變裝，並非要找回原初視覺意義的連貫性或一致性，反而是把象徵的意涵帶向一種既回溯又邁向終末（eschatological）的曖昧未確定性的狂笑之中。

一、

黃進河所處身的台灣視覺藝術文化，大致可分為幾種趨向：第一、由中國自十七世紀明、清時期以來隨著移民潮傳來、生根發展的漢人文人書畫傳統；第二、伴隨十七世紀以來的移民潮同時帶來的漢人民間宗教傳統所呈現的習俗儀式、廟宇建築等等視覺文化；第三、自十九世紀末期起曾經統治台灣達50年的日本殖民文化，包括日本傳統文化以及由日本現代西化運動所引介的歐美藝術風格[2]；第四、國民黨蔣介石政權自1940年代後期由中國大陸來台灣執政後帶來的傳統繪畫與中國受歐美影響的現代藝術風格；第五、自1950年代起與國民黨政權關係密切的歐美勢力影響下輸入的現代藝術類型[3]；第六、自1970年之後逐漸形成的台灣文化主體意識下、去挑戰一元化政治獨裁的批判現實的多元創作風格[4]。

這些藝術表現的體系，在台灣這塊土地上，隨著不同政治統治勢力在歷史中權力的消長，匯集成不同時期台灣視覺藝術發展上的特色。在藝術的表現傳統之外，還有社會現實生活中不斷在進行的視覺景象，都是藝術家接受或改造的靈感來源。

在1990年代早期黃進河對於當時所謂「重西洋而輕本土，大中國而小台灣」[5]的台灣美術界主流的美學價值觀，投下新戰帖。黃進河所下的挑戰，不只是從文化上的外與內、西洋與本土、中國與台灣這種二元區分的分類裡，從弱勢的一方逆向翻轉，去挑戰強勢的美學陣營。更確切地說，黃進河作品的異質性同時挑戰了視覺經驗因同質性的僵化所產生的問題。這種僵化的視覺慣性包含了特定社會階級、特定政治立場所主導的意識型態。黃進河在1990年代的作品謹慎地檢視了自己的創作與主流藝術創作之間的關係，企圖將水墨畫的技法、民間宗教藝術的特質、台灣現代西洋藝術、以及當今社會的觀察，當成靈感的原料庫，從當中提煉出自己的新風格。

文人水墨畫裡追求跳脫現實的空靈、舉重若輕、簡約的構圖色調，所達到的「氣韻生動」，一直是華人繪畫表現上以「有形」、「形而下」，寫出「無形」或「形而上」的重要藝術精神。可惜在台灣現代藝術發展裡，不少文人畫因為原創性越來越降低，淪為吃老本式的反覆套用、空洞僵化的視覺樣版。黃進河並沒有走入這樣的文人水墨畫類型的死胡同，反而看到了水墨畫裡最傳神而關鍵的色彩與線條的結合。黃進河看到這種色彩與線條豐富的表現力，

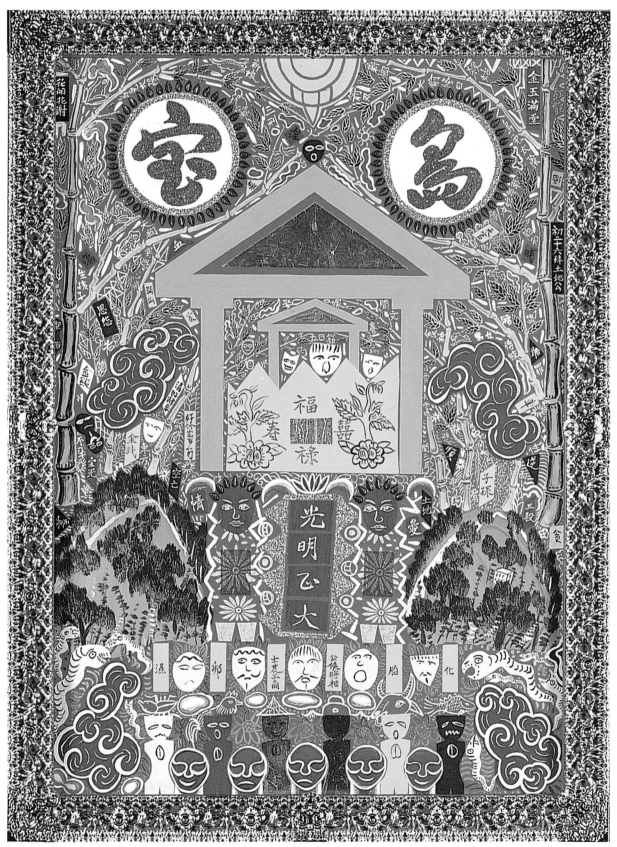

寶島 Formosa 綜合媒材 100x73cm 1993

不只是水墨畫的表現主軸，更是民間文化歷久彌新的絕活（喜喪儀式、迎神賽會、宗教彩繪、符咒、刺繡…等等）。

在西洋近代繪畫傳統裡通過光影投射到對象所產生的明暗變化，表達出藝術家對存在（being）與變化（becoming）的獨到視覺事件（happening）的佈局。中國水墨畫則透過線條與墨色來造型，線條不僅用來表現物體的輪廓，與墨色結合後，也用來表現物體的質感、明暗，以及藝術家所召喚出來遊於象外的靈光（aura），邀請觀者進入不同的視覺桃花源徜徉。這裡「光」的主控權，不來自寫實主義對單一外在光源的對應關係，而是由畫家所掌握到的物與物之間外射與收斂的特色所體現的宇宙秩序的調度。以「光」的亮度與「色」的彩度來作為畫面的重要結構，加上扭曲、漲滿與擠壓的空間場面調度，組合成為黃進河 1990 年代起畫作上的主要風格。

二、

黃進河自 1990 年底的〈接引西方〉開始，在油畫作品上，發展出漸層式的平塗法，融合了水墨畫裡墨色濃淡的漸層效果，把水墨的空靈透氣，運用油畫原料材質本身濃淡的光澤，把空靈透氣的氣韻生動，脫胎換骨，徹底質變，由「無」的空靈，徹底轉成「有」的普照。黃進河以漢人民間宗教傳統裡「五行」的原色──青、紅、白、黑、黃為基礎，把這五原色透過漸層式的平塗，拉到幾近歇斯底里的彩度與亮度，單一個體、單一色系所產生的塊面擠壓下的凝聚性，加上不同色系對比反差所形成的不和諧擴張性，拉距之下，造成畫布上視覺的昏眩感，彷彿是在夜色下「紅帕帕」、「青冷冷」、「金爍爍」、鑼鼓喧天、勁歌熱舞助陣下的金光戲、歌舞秀場般的豔色嘉年華[6]。這種豔色的昏眩感不只是色系與技法所達到的視覺感受，還包括把這些金光豔色逼到「強強滾」的那些扭曲變形類似卡通漫畫、又像傳統民俗圖象的「非」常人？妖魔鬼怪之類的怪誕造型，以及整張巨幅畫布上被擠壓脹滿到難以喘息、幾近爆破臨界點的構圖佈局（〈火〉、〈桃花

鄉〉、〈闖〉）。

從那些扭曲變貌的「非」常人怪誕圖象，以及擠壓脹滿的構圖，我們看到黃進河將普普藝術融入台灣民間視覺經驗的變裝特效。普普藝術藉由拆解物件與既有物體系的慣性意義連結，來製造出視覺上的停格、特寫、誇張、扭曲、嘲諷…等分離效果[7]，讓我們藉由慣性態度被中斷、打破，而引致新的觀看之道。黃進河想打破一種「慣性」，那就是企圖要挑戰與顛覆 1990 年代初期的主流價值：政治上──國民黨獨裁的空洞大中國意識型態；性議題上──偽善優雅的禁欲主義；階級上──知識菁英浪漫的民俗懷舊風；族群上──緊抱大中國、西方現代都會消費文化的意識型態。黃進河把普普藝術的特色，帶進了台灣宗教信仰上更內在的精神禁忌的透視，進行顛覆以及新的挪用。讓那些被視為理所當然、不可說、不可思、甚至被視為「迷信」、「低俗」不登大雅之堂的禁忌物件，例如祭祀用品、符咒、喪葬儀式物件之類，光明正大地登上畫布，不是將符號同質複製或浪漫復古地再現，而是加以扭曲變形、注入文化批判的新視野。

三、

這種文化批判的新視野從一開始就是一場視覺暴力的圖象武裝劇場。這種暴力美學來自畫家所使用的各種視覺要素──色彩、造型與構圖上的強勢，讓畫作彷彿是一道命令、一道符咒，要求觀畫者以第一人稱去參與一場降靈會似的專注凝神，謝絕事不關己、隔岸觀火式的閒逛。這種態度和目前所流行的雜食、輕食、囫圇吞棗似的觀畫態度劃清界限。看與被看的兩股力量交鋒時，彷彿金光布袋戲裡的刀光劍影的戰場。這種戰場打的不只是看畫者與黃進河審美觀之間的格鬥，同時也正是黃進河所掀起的不同於中國與西方古典優美、和諧、休閒美學趨勢的另類豔光四射的美學。

這裡要問的是：黃進河碰觸到什麼禁忌嗎？筆者認為這裡是一體兩面的現象：一是直接撞擊人們想要迴避的禁忌，另一是指出一種不願被正視的「自我」

接引到西方 Onward to Paradise 油畫 165x210cm 1990

陰暗面。有哪些禁忌讓人既恐懼又嫌惡，避之唯恐不及呢？筆者認為最核心的，首先是直覺本能與慣性上的禁忌：出於人類生命裡對於陌生、未知、帶侵略性的對象發自本能自衛式恐懼與敵意，黃進河透過色彩、造型與構圖上的武裝，製造出這種異質美學的視覺入侵感；其次是集體文化上的壓迫感：那種漢人文化裡對「死」的恐懼所衍生出來的禁忌，那種不知劊子手、死神何時出現、讓「自我」的快樂幸福（福祿壽喜財…）現狀終結的殘酷威脅。黃進河引觀者進出這禁區，透過「進」的冒險，才有「出」的困惑、瞭悟或解脫。至於那不願正視的「自我」，還包含人們面對現實威脅、在有限生活條件下沒安全感所激發的變通之道──好死不如

賴活，盡可能擴張自我中心的虛張聲勢、不惜欺騙自己的異化狀態。黃進河透過變形扭曲擠壓的圖象照妖鏡，來展現這強強滾的欲望場域，讓習慣看待被粉飾的人性光明面的人們，有機會目睹了鏡中那一向隱藏的扭曲「自我」被揭露時的矛盾與荒謬時，而產生否認、躲閃、甚至狂笑的歇斯底里。

讓我們先從死亡的視覺禁忌談起。黃進河作品裡處處可見漢人喪葬相關的符號，例如〈寶島系列〉四幅拼貼作品裡那些寫在祖先牌位或符咒上的文字、與燒給亡者、鬼煞的祭祀用物（〈小硬屌〉、〈闖〉）畫面上的輓聯、墳墓、仙鶴以及農曆七月普渡的大士爺變形。不管是透過寫實畫風的符碼、現成物的

直接挪用，或者只是顏色與喪葬符號的隱喻，這些畫作給人第一印象都瀰漫一股死亡無所不在的威脅感。這種威脅感來自漢人社會怕死文化的慣性。這些被視為禁忌的民間祭祀物體系，不管在過去的農業社會或者目前的工商業社會，依然代代相傳，方生方死，方死方生，繼續維持一個社會面對邊際經驗時的自我調節。

這些喪葬與祭祀的物體系一出現，總是座落在生命隕落、不幸與災難的現場。這些視覺圖象對於一般台灣人而言，已經變成慣性地制約反應了，只要一看見這些圖象，就是不幸；這樣的記憶也包含這塊土地上多少個人、家族與族群所歷經的無數歷史創傷，不堪回首、無語問蒼天的悼亡。面對台灣現代歷史發展至今，那些獨裁與無能的執政者，競爭激烈又沒有安全感的生存戰場，讓大多數台灣人消極地認為，只要看不見這些不幸的指涉物，或許就看不見災難與不幸本身。所以一旦喪葬禮儀一結束，這些不幸的祭祀用品總會迅速地被棄置銷毀，或者放到和生活保持一定距離的邊緣位置，直到下次不幸來臨時不得不重逢。所以當喪葬祭祀的物體系「能指」（signifier）出現在藝術家的作品上，那種直接指向避之唯恐不及的「所指」（signified）[8]？不幸事件的記憶，就立即矗立腦中。這麼一個生活在把死亡藏在生活最邊緣的漢人社會裡的一員，一旦看見黃進河的圖象劇場裡，儼然讓「死亡」禁忌的視覺符號大辣辣地站上一線主角，怎能不倍感威脅恐懼呢？不過，一旦觀者願意走進黃進河畫作的圖象世界裡，你很快地發現，黃進河透過「死亡」這種台灣特定地方習俗的「能指」所要傳達的「所指」，將不只是對應到「終結生命」的喪葬習俗而已。

黃進河的符號指涉關係的操作路線，首先是先把你要「逃避」、「否定」的視覺慣性抓出來，讓你重新注視它，一旦你有重新注視它的意願與能力時，就不再只是慣性，就不再只是一對一地對應到災禍與死亡的逃避本能，就不再只是像駱駝一樣，默默承擔傳統所賦予的機械化慣性，而是牽引著觀者繼續

思索可以和這些象徵分離開來的自我意識，進而來到產生象徵新創意的開端。這種包含「負重」、「分離」與「新生」的象徵指涉三重變換過程，正如宗教學家艾良德（Mircea Eliade）所指出的：「象徵系統不單是客觀實在世界的反映，它具有『多重意義性』（multivalence），表達了直接經驗層面無法同時顯現的意義的相關與矛盾的並存」。[9]

以〈接引西方〉為例。黃進河運用傳統與現實的圖象濃縮作用，來表現既非傳統又非寫實、遊走象徵意涵曖昧的多重功效。他把民間肥胖「福相」的神像造型，和1990年代初期流行一時的「牛肉場」裡充斥肉欲的女體造型加以組裝，透過台灣舊慣習俗裡對抗死亡禁忌所使用的豔麗「厭勝色」（以豔麗來避邪驅煞），來表現內在欲望腫脹與外在現實壓抑拉扯下的扭曲、卻自得其樂的複雜人性。葬儀物體系的色調巧妙而詼諧地被變裝，寫有「接引到西方」的「招魂幡」、燒給死者的紙厝，以及為死者超渡的蓮花，一派輕鬆地座落於背景四周。

這樣一幅〈接引西方〉有何意義呢？只是單純地令人聯想到一般喪葬習俗裡為死者送終的輓聯花圈之類的意義嗎？或者跟著這些象徵指涉的思考，我們想問，第二層的指涉作用是否可以繼續？想一下那畫面上肥腫三八、笑容可掬的舞女要接引誰到「西方」呢？是她身旁有身體卻無頭顱、不斷地從空蕩蕩的體內冒氣、瀰漫畫面上空的無頭人嗎？還是在畫面上完全不在場的「他者」呢？象徵意義的指涉路徑隨著不同的觀者，舞出不同的方向。有人看見「西方」的字眼，認為這裡「西方」並非指佛教樂土，而是暗指將受到「西方」或外來殖民文化影響的創作模式送終，從此宣告進入台灣本土藝術的新主權時代。有人則認為這裡並非台灣民間惡意地咒罵對敵「去死」、想要終結憎恨對象「以牙還牙」式的反擊，反而隱含了為台灣過去以來的獨裁殖民者去超渡那些被迫害、含冤亡魂的寬厚與包容。[10]象徵的意涵如何去詮釋呢？是逃避、害怕面對自己的死？是詛咒仇敵去死？是二元對立式的「你死我活」

的自我中心意識型態的詮釋模式？還是包含正視自己的死、從面對自己的死，到對於曾經欲致自己於死地者的寬容模式？從〈接引西方〉能解讀出對於無辜者的關照祝福、助之脫離仇恨的因果循環、泯除恩怨的「超渡」嗎？這些不同的詮釋路線，各自從畫作的符號指涉路線找到探索台灣精神現象「對立中共存」的固著與打通的連結點。

四、

除了透過宗教禁忌的進與出，來打破一般對於死亡禁忌的慣性視覺反應，黃進河對於傳統宗教畫的變裝，也打破那些只停留在複製傳統的機械對應模式。不只是透過中斷慣性，來產生分離意識，這裡還牽涉到是否要站在二元對立、否定對方的態勢；或者從分離與差異中，找到新的超越二元對立的自處之道。超越二元對立，就包含一種保持彼此的張力、卻又透過變裝偷渡的藝術創意，達到詼諧、戲謔、可以笑出來、自得其樂的能力。

黃進河的構圖佈局和傳統的廟宇彩繪、刺繡、地獄圖、祭祀用品、金光佈景戲台……等等以民間神話或歷史故事為敘述主題的圖象，儘管色彩、造型、構圖有接近之處，但所引起的視覺感受卻差異甚大。傳統視覺圖象有明顯的敘事性格，裡頭的人物有故事情節的對應關係，雖然民間傳統畫師各有其畫風，但觀者只要熟悉故事情節，輕易地可以指認出圖象中的角色與民間故事之間的關連，例如〈三國演義〉、〈封神演義〉、〈西遊記〉裡帶有道德勸說或慶典喜氣的主題。黃進河的畫作裡的主角們顯然不想滿足這種一對一式的圖象與意義對應關係。雖然觀者乍看黃進河畫中主角與宗教畫裡的主題人物在體態姿勢、主題造型幾分貌似，但是定睛細看，又發現相去甚遠。

以〈天上流氓〉為例。我們不妨參考一下台灣民間信仰的神靈觀，這將有助於我們理解黃進河圖象裡如何藉由宗教象徵，進行精彩的怪誕風格展演。在傳統台灣民間的宇宙觀裡有天上、人間與地府的宇宙空間區隔，分別是神明、人、鬼魂（與祖先亡靈）

所棲息之處 [11]。黃進河這幅千號畫作的「天上」卻看不見傳統民間神明譜系裡、道貌岸然的諸神諸佛和天兵天將，也沒有祭祀用品的金箔黃紙木刻板畫印出紅線輪廓的「福祿壽」三仙，或者一般人所熟悉的穿著古代傳統官服的三官大帝（天官賜福、地官赦罪、水官解厄），在「天上」出現的是三位「衣冠不整」、玩扮裝遊戲的「流氓」。

在民間信仰裡，「天上」有「流氓」嗎？一般台灣普羅大眾想到「天上」的神明時，印象中就像騰雲駕霧、華麗隆重的八仙過海、蟠桃盛會，那種宛若人間封建帝制的官僚體系翻版，信眾燒香祈福，趨吉避凶之心，正如對待現實生活裡的威權體系。但「神明」圖象果真如此嗎？在天上的神明，要不要「流氓」呢？黃進河畫出了圍繞在我們生活裡熟悉到視而不見的底層人物，但卻以一種「變裝」「跳接」的符號轉變形式，製造出新的視覺趣味。那些像雲又像吹氣泡泡的圓球，後來逐漸融合民間廟宇彩繪、傳統刺繡構圖造型，以及台灣日益衝突擠壓的現況，變裝成畫面上常見「強強滾」式的重要配件，是意味著騰雲駕霧、紫氣東來？還是憤懣沸騰、烏煙瘴氣呢？

黃進河以接近由上往下照的俯瞰大頭貼特寫，融合他 1990 年之前的抽象表現主義，在色彩上加入大量混濁的白色所製造出來的「髒」、「生鏽」（類似「蓬頭垢面」的福佬話，形容一個人太久沒清理外表），和之後所走的「金光」色彩風格不同（前文提及的〈接引西方〉即是緊接在這幅之後的新風格，可以清楚地看見色彩上的轉變）頭大身小、搞笑又夾帶「猥瑣」性暗示的古怪穿著。這裡同時也對台灣一般「流氓」的概念作了詼諧的嘲諷。「流氓」一般形象總是孔武有力、兇狠帶殺氣。這三位「槌槌」、有點假仙耍寶的，恐怕是冒牌貨，惡狠壞人角色改由丑角甘草型演員來擔任。畫裡這三位笑詼（福佬話）、草莽、土直、「不男不女」扮裝搞怪的傢伙 [12]，有誰會將他們和道貌岸然、華麗莊嚴的「神界」老爺爺——「福祿壽」或「財子壽」三仙聯想在一起呢？是黃進河將「神明」去神聖化、嘲諷他

火 Fire 400x815cm 油畫 1991-1992

們、把他們畫成混混、豎仔、「不男不女」扮裝癖呢？還是黃進河發現在這樣底層、邊緣的眾生裡皆有「天上的」「神」性呢？這幅作品裡黃進河給出了一種聖俗曖昧並存的戲仿（parody）。

也正因為這樣的視覺符號的曖昧性，讓原先帶有歷史故事或神話情節敘事性結構的民俗符號時間意識被打破了，畫面上的人物給出一種無厘頭串場人的隨興、偶發的詼諧感。這種詼諧、無厘頭的用意何在呢？俄國思想家巴赫金（Mikhail Bakhtin）曾指出：世界上還有什麼比詼諧更能對抗命運無情的嘲弄呢？詼諧與滑稽在民間文化裡，往往正是恐怖、悲慘與疏離的現實生活要偷渡的假面；裝瘋賣傻、扮裝搞怪、不經意地兜出幾串黃色笑話，不正是對於正經嚴肅的統治者威權戲仿、嘲諷、控訴與反抗的手段嗎？在裝瘋賣傻裡，其實可能自得其樂，又或者是孤獨、無奈、鬱卒、帶悲劇色彩的反作用力與自我解脫的努力。[13]

文化評論家邱武德認為在台灣答嘴鼓說唱藝術裡，小人物的無厘頭搞怪表演方式包含諸多生動的俚語或流行用語。在日本殖民政府或國民黨戒嚴時期的獨裁式言論控制下，這種諷古譏今的創意表達，可說是游走法律邊緣，挑戰統治者言論自由的尺度。在熱鬧滾滾強人爭鬥、緊繃的劇情發展裡，甘草型角色的笑詼幽默，在感受娛樂之餘也同時瞭解到「人間冷暖情為貴，世事滄桑欲堅強」的無厘頭之理[14]。黃進河帶著詼諧的變裝秀，繼續衝向視覺歇斯底里的狂喜狀態。在他接下來的兩巨幅畫作裡，黃進河讓詼諧人物同時變成恐怖的魔頭，讓整幅〈闇〉（1994-1998）仿若當代牽亡歌陣的重金屬噪音搖滾版，狂飆在眼前的是金光強強滾、囂張強悍的地獄變。黃進河沒有告訴我們，「誰」有資格去制訂出善惡功過格來審判慾望本尊，是〈闇〉中焰口長舌滴甘露的盲眼警察？還是〈火〉（1991-92）中手拿道教「五雷」令、墨鏡青黑金剛貌的大姊大？或者創作者本人？還是我們凝視畫布的過程？[15]

五、

黃進河既詼諧又暴力的藝術風格，並沒有採取一種去歷史脈絡的即興式或任意性的概念拼裝，相反地，黃進河在概念的拼裝經常包含了幾層視覺心理的糾結，讓觀者面對他的視覺符號意義的連結時，出現了曖昧的「對立的並存」。從視覺指涉意涵溯源的暖身，搜尋過往個人記憶庫裡的圖象聯想，到溯源過程因為似像非像所面臨的失憶斷裂感。黃進河先讓觀者對直接生理視覺經驗的強烈反差驚訝不安，然後帶領有心者進入符號的溯源旅程，卻讓觀者跟到一半時就中斷消失了，孤立而囂張的視覺符號，彷彿剛剛勃起的陽具，卻沒有找到敘事結構的支撐對口，緊接的下一個鮮豔視覺符號現身，只是一再引誘，讓新意義入口遙遙無期。這種意義的曖昧性，讓黃進河的視覺美學並未和強調沒有本尊、只有擬象（simulacrum）、去根源脈絡的意義無政府主義的拼貼模式共謀，反而黃進河這些「半調子」、帶有現成物扮裝嫌疑的視覺符號，把意義勃起卻無法射出的曖昧性，推上第一線。黃進河對傳統符號的替代性變裝，看不出要找回原初的意義的連貫性或一致性，反而是把象徵帶向一種「在……之間」的既回溯又邁向終末的當下未確定感。這種未確定性的焦慮讓觀者再度回到豔光四射的畫面視覺直接刺激上，彷彿勉力想以此昏眩的替代物來自慰，來完成欲望的暫時性滿足。這種未確定的焦慮與自慰的暫時爽快，形成一種精神分裂的自虐式對立並存性，透過構圖的空間擠壓與疏離的效果，把這種終末感推到極致。

把這種終末感推到極致，還包括黃進河油畫作品對立而矛盾的構圖特性。簡要地說，油畫構圖的矛盾性格在於擠爆畫面的豔色嘉年華裡，卻總是一個個孤立疏離的個體。畫面上每一項造型之間貼這麼近，但每個個體的輪廓所凸顯的空間卻不相干。這裡否定了宗教畫裡敘事的連續性，以幾近暴力的空間輪廓切割，壓抑了敘事結構，取而代之的是讓人目不暇給的擠脹和疏離剛硬的空間感。這種矛盾性是黃進河作品和民間宗教畫最明顯的差異，不只在

於圖象構圖的非敘事性佈局，更在於黃進河的作品
裡那些傳統宗教畫裡所賦予神明譜系明確地趨吉避
凶的靈驗性與善惡正邪判準的「神聖」界線模糊
了，或者說界線已經失憶、失蹤、脫鉤了。畫裡的
主角可能是神、是人、是魔、是欲望的化身，但是
他們都不再是台灣人的視覺慣性裡所寄託、投射的
強大他者，而像是一個個意義難辨的充氣般發光發
亮的巨怪，張牙舞爪地嘲笑那些原本壓迫本能欲望
的視覺威權符號。

黃進河畫裡難以辨識是否有公平與正義的仲裁者，
人人都可以是神、是魔，群魔亂舞、眾聲喧嘩。像
正在上演一齣沒有結局的戲碼，沒有故事的故事，
好像每一個主角都想大聲說出自己的故事，但是卻
沒有人想去傾聽另一個人，好像大家都時間不夠、
空間不夠，必須全擠在這最後的時間、唯一單一的
共同空間拼命擴張自己。於是每個畫面上的主角各
霸一方，個別看起來金光強強滾、整體來看卻是孤
寂與封閉。這種「豔光四射」的特性是黃進河視覺
美學掌握當前台灣集體歇斯底里的精神狀態最經典
的特寫，一方面是「台灣人打死不退的生命意志及
心理所嚮往綿綿不絕取之不盡的最高能量」[16]，另一
方面也是面對那些想要吞沒與宰制台灣文化主體性的
強大對敵時，不得不採取的虛張聲勢、委曲求全的自
我扭曲與變裝的防衛。在豔光四射裡對自身未來那難
以確定的悲劇荒謬命運，無法自抑地狂笑。　▣

（本文原刊於2005年2月，《現代美術》第118期）

註釋：

1. 本文的完成感謝黃進河先生提供創作理念與作品的相關資料、
邱武德先生在台灣「金光藝術」研究上的啓發；以及台灣大學
社會系林端教授和南華大學宗教學研究所蔡源林教授，在筆者
於「宗教主題研討工作坊2004總結研討會」提出大綱時，提供
了關鍵性的建議。「豔光四射」靈感取自周美玲導演的電影
《豔光四射歌舞團》（2004）。

2. 詳見顏娟英，〈規範的空間與追求新知—殖民地台灣近代美術〉
收錄於《正言世代—台灣當代視覺文化》（台北：台北市立美術
館，2004），頁10-41；顏娟英譯著，《風景心境—台灣近代美
術文獻導讀》上（台北：雄獅美術，2001）

3. 詳見蕭瓊瑞，〈在激進與保守之間—戰後台灣現代藝術發展的
重新檢視（1945-1983）〉收錄《正言世代—台灣當代視覺文化》
（台北：台北市立美術館，2004），頁42-69；蕭瓊瑞《島嶼色彩
—台灣美術史論》（台北：東大，1997）；倪再沁，《藝術家←
→台灣美術—細說從頭二十年》（台北：藝術家，1995）；郭繼
生編，《台灣視覺文化》（台北：藝術家，1995）。

4. 陳瑞文，〈藝術表現裡的文化批判--從臺灣當代的社會性藝術之
現實意識論起〉《現代美術學報》第二期（1999），頁5-28；潘
安儀〈台灣當代藝術的正言世代〉收錄於《正言世代—台灣當
代視覺文化》（台北：台北市立美術館，2004），頁70-187，可
惜潘文並未討論黃進河的視覺作品。

5. 倪再沁，《藝術家←→台灣美術—細說從頭二十年》（台北：藝
術家，1995），頁166。

6. 邱武德，《台灣日報》副刊〈金燦燦‧沖沖滾 — 黃進河的金光
視覺美學〉（2003.06.26）

7. Lucy Lippard編，張正仁譯，《普普藝術》（Pop Art），前言

8. 詳細有關「能指」與「所指」的指涉關係說明請看Roland
Barthes, Mythologies, translated by Annette Lavers （New York:
Hill and Wang, 2000），pp.114-131.

9. Mircea Eliade, "Methodological Remarks on the Study of Religious
Symbolism". History of Religions: Essays in Methodology, M.
Eliade and J. Kitagawa eds. （Chicago : The University of Chicago
Press, 1959），99

10. 邱武德，〈金燦燦‧沖沖滾──黃進河的金光視覺美學〉

11. 宇宙觀在宗教現象學上異質是神聖空間開展的重要主題，神聖
空間是異質的，具有區分為「陰」／「陽」、「上」／「下」、
「內」／「外」、「中心」／「邊陲」、天上／人間／地獄…等
等的分類秩序。這些秩序代表和一般人所生活的世界相關卻不
相同的屬性。不同的宇宙區域分別住有不同的神明、祖先、鬼
怪、仙佛、怪獸…等等神話角色。詳見Mircea Eliade，《聖與
俗—宗教的本質》The Sacred and the Profane, trans. W.R. Trask
（New York: Haper & Row, 1961），第一章：神聖空間與建構世界
的神聖性。

12. 邱武德，《台灣日報》副刊〈金燦燦‧沖沖滾──黃進河的金
光視覺美學〉（2003.06.26）

13. 巴赫金（Mikhail Bakhtin），《巴赫金全集》第六卷《拉伯雷的
創作中世紀和文藝復興時期的民間文化》，李兆林、夏忠憲等
譯（河北教育出版社，1998），頁44-47

14. 邱武德，〈戲棚金光戲的魔幻世界〉2004年6月24日起在《台
灣日報》副刊登載，引自邱武德原稿，頁12

15. 王鏡玲，〈形可形，非常形—黃進河視覺美學初探〉，《當代
藝家之言》2004秋分號，頁80-81

16. 邱武德，〈戲棚金光戲的魔幻世界〉2004年6月24日起在《台
灣日報》副刊登載

Laughing Boisterously amid Splendid Lights

On the Visual Aesthetics of Huang Chin-ho [1]

Wang Ching-ling

This essay inquires into the unique visual aesthetics of Taiwanese contemporary artist, Huang Chin-ho, with special emphasis on his exceptional blend of visual codes which appear, paradoxically, confrontational and mutualistic with each other at the same time. To be more specific, with his clinical use of bright and vibrant colors, exaggeratedly distorted figures and crowded collage compositions, Huang Chin-ho transforms visual codes from Taiwanese traditional religious experiences, historical memories, and everyday lives into a visual carnival of violence aesthetics. In the past, this sort of shocking visual violence has catalyzed endless debates surrounding the expressive forms of modern art, and more specifically the ways in which contrasting elements, e.g. the beautiful and the grotesque, the graceful and the vulgar, the sacred and the profane, the solemn and the satirical, the homogenous and the heterogeneous, are juxtaposed in the representational space. Although Huang remains committed to dismantling and rearranging traditional visual codes, his intention is not to recover their 'original' or 'authentic' meanings, but instead to have these symbolic meanings exploded amid a burst of derisive laughter, bringing them to a state of ambiguity between the recessive and the eschatological.

I.

The sort of Taiwanese visual culture which has nurtured Huang Chin-ho's art can be seen to reflect a number of cultural influences: first, the Han-Chinese tradition of literati painting, which was brought to Taiwan by Chinese settlers of the Ming and Qing Dynasties from the 17th century onwards. Second, the visual culture heavily influenced by the Chinese folk beliefs which, again, have been brought to Taiwan by the Chinese settlers since the 17th century. Third, the 50-year Japanese colonial rule, which brought to Taiwan not only traditional Japanese culture, [2] but also the wealth of Western art which had been introduced to Taiwan amid the Westernization movement of Japan. Fourth, new schools of traditional Chinese and Western-influenced modern painting which were brought to Taiwan following the retreat of Chinese Nationalist government (aka the KMT) in the late 1940s. Fifth, modern Western arts imported to Taiwan from the 1950s onwards by Western powers which had close economical-political ties with the KMT. [3] Sixth, the wide variety of art styles which have been emerging from the newly recovered Taiwanese nativist consciousness from the 1970s onwards, denouncing the injustices of political dictatorship and effectively challenging KMT's one-party political monopoly. [4] Although their influence varied depending on the political barometer, these artistic styles and cultural legacies, together with a far wider range of visual spectacles that permeate our everyday lives, have all become important sources of inspiration for Huang Chin-ho.

In the early 1990s, Huang Chin-ho poses a new challenge to the mainstream aesthetic value of the Taiwanese art community, which has tended to "favor the Western over the locals (cultures), and to prioritize China over Taiwan". [5] It should be noted that what Huang did was not merely for the suppressed side to reverse the tide against the dominant aesthetic values in the context of dichotomies between the foreign and the domestic, the Western and the local, or China and Taiwan. More significantly, the heterogeneous nature of

Huang's artworks raises questions concerning the ossification of visual experience as a result of homogeneity. These ossified visual codes include those of certain social classes or political affiliations. In his 1990s works, Huang Chin-ho carefully examines the relationships between his own art practice and the mainstream art world, developing a unique style by blending together techniques of ink painting, visual vocabulary of religious art and Taiwan's modern western-styled art, as well as themes concerning social realities.

Chinese literati ink painting is traditionally characterized by an emphasis on the minimalist symbolic imagery capable of creating an aura of emptiness and spirituality. Its ideal of "vivid sensuality" has long been considered the most important artistic conception of Chinese painting, which often seeks to articulate the metaphysical world by means of physical realities. However, it appears that in the context of Taiwan's modern art, many literati paintings have suffered a significant decline in originality, and consequently become a repetitive and uninspired pastiche of clichés. Huang does not fall into the same trap with regard to the literati ink painting. Instead, he discovers the essence of ink painting, i.e. its striking expressive power of color and line, to be featured heavily also in all forms of Taiwanese folk culture, such as weddings and funerals, god-worshiping rituals, religious paintings, talismans and embroidery.

Modern Western paintings often express an unique pattern of being and becoming with the artist's rendering of light and shade. Chinese ink paintings, on the other hand, tend to use color and line to create the desired shape of the subject. Line is employed not only to form the contour of the object, but also, when combined with ink-color, to articulate the texture, shades, as well as the metaphysical aura, inviting viewers to enter a variety of visual utopias. It is worth noting here that the dominance of light in Huang's paintings does not result from the perspective of realist paintings, but from the artist's maneuvering of the peculiar cosmic order which emerges from the convergence and divergence of the objects. It can be

suggested that the quality of light and intensity of color have themselves become key elements in the structure of the paintings. These, added with the artist's astute handling of the twisted, swelling or compressed [representational] space, have become central to Huang Chin-ho's artistic style from the 1990s onwards.

II.

Beginning with his "Onward to Paradise" (1990), Huang Chin-ho often applies a peculiar kind of coating techniques in his oil paintings to paint a gradient between colors. In other words, it could be said that the artist uses the gloss of the oil paint to create the color graduation effects, and especially the aura of emptiness which is often considered to be characteristic of ink-and-wash paintings. In so doing, Huang thoroughly transforms this aura of emptiness into a sense of materiality. Besides, Huang often use the five primary colors - (i.e. blue, red, white, black, yellow) conventionally used to signify the five fundamental elements of the universe (i.e. metal, wood, water, fire and earth) in Han-Chinese folk beliefs - as the foundation of his paintings. The near-hysterical intensity of color, the convergence of each individual object or color, and the sharp color contrast together turn the painting into a dazzling spectacle as if all these elements were engaged in a noisy carnival of lights and colors. [6] Such a sense of dazzling is not merely an effect of color intensity or the artist's painting techniques. Instead, it derives also from the sight of the raging, twisted, cartoon-like figures or the monsters in traditional folk imagery, as well as the breathtakingly swelling, borderline-explosive images on the gigantic paintings as seen in works such as "Fire", " The Peach Blossom Village", and "Dou").

The disfigured and grotesque imagery, together with the over-crowded composition reveal Huang Chin-ho's brave attempts to fuse the spirit of Pop art with the visual experience of Taiwanese folk culture. Pop art seeks to break the close bonds between objects and their conventionally conceived meanings by way of freeze-frame, close-up, exaggeration, distortion, satire, etc., permitting us to break the usual patterns and to develop new ways of seeing.[7] What, then, was the "usual patterns" that Huang Chin-ho was trying to

break with his art? The answer is the mainstream social values which underpinned Taiwanese society in the early 1990s. To be more specific, what Huang set out to challenge was, politically, the vacuous China-centered ideology under the KMT rule; morally, to attack the hypocritical sexual morality of asceticism; socially, intellectual elites' nostalgia for an over-idealized past; and culturally, both the pro-China cultural policy and the modern Western urban consumer culture. Huang Chin-ho skillfully applies the weapon of Pop art to his examination of the most powerful taboos in Taiwanese folk beliefs. Those which have long been labelled as "superstitious" or "vulgar" or even "taboo" objects, such as sacred utensils, Taoist magic, and burial rituals, are now taking a giant stride onto the canvas. It should be noted here, far from simply reproducing these cultural symbols in an uncritically nostalgic fashion, Huang Chin-ho disfigures these images, and in so doing opens up a new critical vision of our society and culture.

III.

From the very beginning, this new critical vision has presented itself as a theater of visual violence armed with grotesque visual imagery. Such "aesthetics of violence" is constituted by a wide range of visual elements that the artist has long been associated with, such as bright colors or objects of grotesque shapes and bold composition, effectively turning the painting into a summon or even a spell, that forces the viewers to concentrate on the painting as if they were practicing rituals of evocation, allowing the viewers no space for indifference. This clearly separates Huang's art from the current trend of casual and superficial viewing which implies looking without comprehension. As the "subject" and "object" of viewing cross swords, it seems as though a battlefield typically seen in the "Dazzling Glove Puppet Show" was emerging from the painting. It is a battle not only between the aesthetics of the artist and that of the viewer, but also between the elegant, harmonious and leisurely aesthetics which has long been associated with classical Chinese and Western arts, and an alternative aesthetics characterized by exaggerated glitz and glitter.

What should be asked here is: did Huang Chin-ho break any taboo? I would point out two taboos here, which I see as two sides of the same coin. Whereas the first taboo Huang sets out to break is the external object or social phenomenon that people tend to avoid, the second is the inner darkness that one is most reluctant to confront. What are those taboos that invoke our utmost fear and disgust? I would argue that first and foremost would be the objects or phenomena which profoundly violate our intuition about how human beings would, out of inherent fear or hostility, fence off anything which appears unfamiliar, alienating or even aggressive to ourselves. In Huang's alternative aesthetics, the sense of intrusiveness is largely produced by the arsenal of bright colors, grotesque shapes and bold composition. The second source of such fear and disgust is the sense of repression caused by collective cultural beliefs. In Han-Chinese culture, these utmost taboos are often associated with our fear of death - fear of not knowing when Death or his executor may arrive and terminate all one's enjoyments (luck, success, longevity, happiness, and wealth). Huang guides the viewers into this taboo zone, for one has to first go deep into this horrifying territory before coming out of the unknown with better understanding and a sense of liberation. In addition, the dark side of the "self" that one is most reluctant to confront includes also the tendency toward self-deception when confronted with one's inability to deal with the threats posed in reality. Some of the common symptoms of this self-deceit include a tendency to subject oneself to an ignoble existence or to develop an inflated ego. The distorted images in Huang Chin-ho's paintings serve as a demon-exposing mirror, revealing a world aflame with desire to people who are too used to manufactured smiles, forcing them to see for themselves how they react to the hard truth then the distortion, self-contradictions and absurdity of their inner selves are exposed.

Let's begin with taboos associated with visual symbols of death. Huang Chin-ho's works are replete with funeral-related symbols from Han-Chinese culture. For example, the four pieces that make up the "Formosa" series are filled with characters typically written on ancestral tablets and magic charms, as well as funerary

objects for the deceased. Similarly, "Xiao-Ying-Cue" (aka Little Solid House) and "Dou" both heavily feature deformed images of elegiac scrolls, tombs, red-crowned cranes, and the God of the Ghost Month. Used as visual codes in a realist fashion or appropriated as "readymade" objects, or simply borrowed for the funerary implications of their colors or shapes, these images, when appearing in Huang Chin-ho's paintings, articulate the omnipresence of the shadow of death. Such a sense of insecurity can be seen to largely derive from the great fear of death deeply rooted in the collective psyche of the Han-Chinese population in general. From the agrarian society of the past to today's industrial society, these funerary objects, long treated as taboos in the Chinese folk culture, have continually renewed itself generation after generation, and served as a safety valve when the society is confronted by threats of marginalization.

These funerary objects habitually appear in sites of horrific devastation, and as such the visual signs of these objects, which encapsulate numerous historical traumas and memories of unbearable sorrow and loss suffered by various individuals, families and ethnic groups on this land, have become the key symbol and reminder of the greatest human tragedy. When faced with dictators and incompetent rulers, or in the thick of competitive battles of existence, the Taiwanese have long tended to develop a coping style of denial, wishfully thinking that the disappearance of these symbols of tragedy would automatically result in the disappearance of the traumatic experiences they signify. At the end of every burial ceremony, these funerary objects and symbols of great loss would be immediately discarded, or at least be placed at marginal territories, until the next occuring of tragedy. When a signifier from the system of (funerary) objects appears in a work of art, it points to a "signified" that is the memory or mental image of tragedy.[8] For a member of the Han-Chinese culture which has long tended to hide death symbols at the marginal areas, how can he/she not feel threatened and terrified when confronted with the reality that the visual signs of death taboos are now taking the center stage in the theatricality of Huang Chin-ho's art? However, once the viewers are willing to enter Huang's world of

images, they would soon realize that the signifiers in Huang's paintings, i.e. funerary objects, signify more than just burial customs of Taiwanese folk culture.

Huang Chin-ho's signifying strategy often entails tackling the viewer's tendency to deny, or escape from reality; in so doing, the artist compels the viewer to confront such weakness in humanity. It follows that once the viewer retains the ability and willingness to face the harsh reality, he/she will be liberated from the long-established habit of intuitively turning away from the sight of calamity or death and separating themselves from traditional and religious chains like a camel passively loaded with baggage. Instead, the viewer would be led to examine self-consciousness which is separable from these cultural symbols (of death or calamity), and subsequently create a new symbolic system. This changing process, which involves acts of "loading", "separation" and "rebirth", can be seen to echo Mircea Eliade's notion of religious symbolism, "*An essential characteristic of religious symbolism is its multivalence, its capacity to express simultaneously a number of meanings whose continuity is not evident on the plane of immediate experience.*"[9]

For example, in "Onward to Paradise", Huang Chin-ho attempts to articulate the non-traditional, non-realist and ambiguous by condensing traditional and realist images of (Taiwanese) folk culture. More specifically, he blends together images of stalky-built gods and scantily dressed, fleshy women performing in the strip show - an act of exorcism performed with theatrical gaudiness traditionally observed in Taiwanese folk religion - in an attempt to highlight the complex absurdity of humanity, i.e. being perfectly at ease with the ways one's swollen desire is distorted under prevailing social conventions. What is on display here is a "system of (funerary) objects" consisting of cleverly and comically set color accents, the long flag written with "Onward to Paradise" for soul-summoning, and the paper house to be burned as the offering for the deceased, and lotuses used for releasing souls from the purgatory, all of which are casually scattered around the background of the piece.

What, then, is the purpose of this painting? Is it, like a

天上流氓 Gansters in the Paradise 油畫 277x495cm 1990

wreath or an elegiac couplet, simply serves as a symbol of the funerary ceremony, or is there something deeper? What we can ask here is: can the second-order semiological chain continue to unfold here? Who is the person that the fleshy and immatronly woman in the painting trying to summon to the Paradise? Is it the headless man from whose body smoke continually emanates and prevails at the top of the painting? Or, is it the "Other" which is completely absent from the painting itself? It should be noted that the direction in which signification takes place varies and depends upon the viewer. Some may think that the characters on the soul-summoning flag, "The West", represent not the Paradise of the Buddhism but the Western world or any kind of colonial power. In this sense, it would follow that this piece, "Onward to Paradise", seems to signal the demise of the Western-influenced aesthetics and to announce the dawning of a new era for Taiwanese nativist art. On the other hand, some others may consider that the painting itself represents Taiwanese society's forgiveness and remission of the crimes committed by dictatorial colonial oppressors. How are we to interpret its symbolic meanings? Is it

that we inevitably fear and refuse to confront our own death? Or, are we simply cursing our enemies to death? Is it a dichotomy of "live (for me) vs. death (for you)" based on a self-centered preoccupation, or is it a more tolerant and compassionate mode of interpretation which entails, essentially, the honest confrontation of death? [10] Can we detect, from "Onward to Paradise", a spirit of "expiating the sins of the dead" that help us show compassion for the innocent and break the chains of vengeance and hate? All these different modes of interpretations cross paths at the signifying processes of the painting and create a common ground on which the Taiwanese spirit of "co-existence amid antagonism" holds.

IV.

The use of religious symbolism in Huang Chin-ho's painting serves a number of purposes. Not only is it to challenge our visual instincts as we are confronted with the death taboo, it also escapes from simply reproducing traditions in a pre-determined fashion. In other words, it not only break the long-holding pattern to catalyze the awareness of separation from the

太平街仔 Tai-Ping Street 油畫 1991

system, but also raises questions as to what to choose: the exclusive dichotomy, or a new approach that goes beyond such dichotomy and seeks a mutually inclusive mode capable of maintaining the dynamics of both parties, and at the same time delivers artistic creativity through disguise in a humorous fashion.

The composition of Huang Chin-ho's paintings are similar to traditional Taiwanese religious art (e.g.

temple paintings, embroiders, images of the Purgatory, funerary objects and the flamboyantly decorated stage) in the sense that they are often based on narratives of folk tales or historical stories. However, despite their similarities in colors, compositions and styles, they invoke rather different visual effects. Religious images tend to contain strong narratives, and their characters are often taken to epitomize the stories in which they

appear. It is worth noting here that despite varied styles by different folk painters, most viewers can easily recognize these characters in connection with the stories they represent, as long as they are familiar with the themes and plots of these stories, such as the morality or festivity themes in "The Romance of the Three Kingdoms", "The Investiture of the Gods", or "Journey to the West". Haung Chin-ho clearly intends to break the singular relationship between the signifier (i.e. the character) and the signified (i.e. the story). In Huang's paintings, although the subjects may first appear similar to characters of traditional religious paintings, clear differences will be identified as soon as they are examined closely.

A look at the notions of ghosts and spirits in Taiwanese folk traditions may help us understand how Huang Chin-ho develops such a playfully grotesque style by means of religious symbolism. The cosmological view of traditional Taiwanese folk beliefs divides the universe into three distinct realms: Heaven, Earth, and the Netherworld. These three realms are the abodes of, respectively, gods, humans, and ghosts/spirits.[11] However, in Huang's No. 1000 gigantic painting, "Onward to Paradise", there seems to be no signs of solemn-looking gods or their arm of celestial heroes from our folklore; neither are there the three Earth Gods that represent merit, wealth and longevity, which are often seen woodblock-printed in red on the paper money for the deceased, or the three courtly dressed gods that are traditionally known, respectively, to grant good luck, to give absolution, and to dispel misfortune. What we see in the "Paradise" as portrayed in Huang's painting, instead, are three disheveled gangsters in the middle of a "Cosplay" (i.e. costume play).

Are there "gangsters" in the Paradise, according to our folk beliefs? It is worth noting here that in the Taiwanese folk tradition, images of gods are often closely associated with the spectacle of the gathering of Eight Immortals, who mount the clouds and ride the mist to serve peaches of immortality. Such a portrayal of the celestial world seems to reflect firstly the hierarchical structure of our everyday reality, and secondly the aspirations of ordinary people to gain religious merit and ward off calamity by praying and

supplication. But do gods and other immortals really dress or act as we imagine they would do? Is it possible that they may act just like gangsters? While Huang Chin-ho accurately conveys the images of the ordinary folks at the lowest of the social strata - those who surrounds us on a daily basis, so familiar to us that we effectively forget their existence - the artist creates a new visual effect here by way of "costume-play". Besides, those cloud- or bubble-like balls, combined with temple folk paintings, traditional embroidery designs, as well as the increasing conflicts in Taiwanese society, become important accessories of the roaring image. Do they signal the presentation of bestowed fortune or boiling resentments?

Huang Chin-ho fuses his pre-1990's abstract-expressionist style with a close-up shot from a "bird's eye" perspective, and creates a large volume of cloudy scales. This significantly differs from the glittering style - one which can be seen epitomized in "Onward to Paradise"- that the artist has later adopted, demonstrating a clearly change in his use of color. With big heads and small torsos, the subjects, droll and bawdily-dressed, seem to gibe at the Taiwanese conventional image of gangsters, which tend to be muscular, ruthless, and amuck. The three dumb and comic characters could well be comedians who pass themselves as gangsters.[12] After all, who would associate such comical, unsophisticated drag queens with the solemn and refrained granddad of the celestial world (i.e. the Gods of "Luck, Prosperity, and Longevity" or the Gods of "Wealth, Heir, and Longevity")? Did Huang de-divinize those celestial beings by sneering at them and turning them into cross-dressing petty gangsters? Or did Huang in fact unearth the godly qualities in these marginalized characters? This painting is a parody which fused together the consecrated and the ambiguous.

The ambiguous nature of the visual signs can be seen to effectively undo the consciousness of time inscribed in the narrative structure of the folk symbols, which often derive from the plots or characters of historical tales and mythologies. The characters in the painting seem to show a sense of casualness and accidental humor of a show presenter. What, then, is the purpose of such mindless humor? Russian philosopher Mikhail

桃花鄉 The Peach Blossom Village 油畫 163x280cm 1993

Bakhtin has suggested, what can counter-fight the derisive sneer from harsh realities of the grim fate that lie ahead? In traditional folk cultures, humor and laughter are precisely the masquerade of horror, misery and alienation in our everyday life; isn't loneliness, absurdity or the occasional cranking of filthy jokes a great means of miming, ridiculing, denouncing and counter-fighting straight-faced authorities? Any act of loneliness is in fact filled with a mixture of self-entertainment, loneliness, helplessness and fret; it is at the same time a quasi-tragic counter-force and a valiant effort at liberation.[13]

Cultural critic Chiu, Wu-ter has noted that in "cross-talk"- a popular form of the traditional Taiwanese art of storytelling and singing - the loony and naughty performance of a nobody often contains colorful slangs and catchphrases. During the course of both the Japanese colonial rule and the KMT's authoritarian regime, such satirical modes of expression can be seen as skirting the borders of the law, as they continually tested the limits of freedom of speech. In the narratives characterized by in the ferocious power struggle

between main characters, the humor of the comical minor characters often effectively convey the moral lesson masquerading as entertainment, that "compassion is the greatest of all virtues; any kind of struggles can make one stronger".[14] Huang Chin-ho's humorous costume-play continues to accelerate toward a state of hysterical ecstasy. In his next two gigantic-sized paintings, Huang turns the comical figures into hideous monsters. As a result, the entire image of "Dou" (1994-1998) appears as if it was a heavy-metal-noise version of a contemporary burial song; what is raving before our eyes is a blazingly flamboyant and stormy image of the Hell. What Huang did not tell us, however, is "who" has the right to determine the laws of virtue and chastity, and in doing so, to condemn desire? Is it the bind police with a long, wet dripping tongue in "Dou"? Is it the rough-looking female gangster boss who wears sun glasses and holds a Five Thunder Summon Charm in "Fire" (1991-92)? Or, is it, in fact, the artist himself, or even the process in which we gaze at the canvas?[15]

Huang Chin-ho's humorous yet violent artistic style

cannot be seen as a kind of casual or de-contextualized form of conceptual collage. On the contrary, Huang's conceptual collage often entails intertwining of the layers of visual psychology, and causes an ambiguous "confrontational coexistence" as the viewer is establishing connections with the meanings of the visual signs. In the process of origin-tracing for the meanings of these visual signs, the viewer searches through personal memories for any imagery which may be remotely linked to these visual signs, only to suffer a sense of rupture, or even memory loss, when

realizing that the efforts were to no avail. The artist first astonishes and unnerves the viewer with the sharp contrast in the visual experience, and then leads the contentious viewer through a journey to trace the origin of the meanings, only for the viewer to get completely lost half way through. The isolated yet boastful visual signs fail to find a narrative counterpart, just like an erected penis which cannot find an organ anatomically corresponding to it. Immediately afterwards, the next blazing visual sign appears. Similarly, it repeatedly lures the viewer into the quest

閻 Dou 油畫 978x400cm 1994-1998

for the meaning, yet at the same time keeps the meaning infinitely suspended. It should be noted, however, that such ambiguity of the meaning does not make Huang's visual aesthetics in complicit with the sort of anarchic, de-contextualized collage which is constituted of simulacrum. Rather, these quasi-"ready-made" visual signs effectively highlight the ambiguity of the meanings. From Huang's transformation of the traditional visual signs, one does not perceive any continuity or consistency of an original meaning; instead, as signification is suspended, what arises is a sense of uncertainty that derives from an ambiguous state between the recessive and the eschatological. The anxiety, caused by the sense of uncertainly as just mentioned, compels the viewer to retreat to the visual stimulation caused by the splendid image, as if the latter could serve as a form of masturbation that would grant temporary sexual satisfaction. The uncertain anxiety and the temporary pleasure from masturbation create a kind of confrontational coexistence in a schizophrenic, masochistic fashion. Through the crowding and alienating effects of the composition,

such a sense of eschatology is taken to the extreme.

Also contributing to taking the sense of eschatology to the extreme is the antagonistic and contradictory characteristic of the composition of Huan Chin-ho's printings. To put it more succinctly, the contradiction presented in the composition of Huang's oil paintings is that while each of the over-crowded elements that constitute the bright-colored visual carnival is in fact isolated from each other. In other words, every compositional element is so closely attached to the other, yet the space which the element highlights is irrelevant to each other. This can be seen to deny the continuity which often characterizes religious paintings. Instead, it divides the image in a virtually violent manner, and in doing so, represses the narrative structure. What the viewer perceives, instead, is a sense of crowdedness, alienation, and rigidness. What parts Huang Chin-ho's works from traditional religious paintings is a strong sense of contradiction which lies

not only in the narrative structure of the visual composition, but also in the way in which the artist obscures the "sacredness" of the celestial beings in religious paintings. Or, it can be suggested, that the boundaries of these celestial being's sacred identities have been lost. What the painting features could be, in fact, gods, humans, demons, or any form of the embodiment of desire - only that the Taiwanese no longer perceive them as the powerful Holy Other. Instead, they now appear a series of seemingly inflated, shining monsters whose meanings cannot be identified, and who cast a sabre-rattling sneer at those visual signs of authoritarianism which have previously repressed libidinal desire.

In Huang Chin-ho's painting, one finds it difficult to identify a fair-minded and incorruptible judge. It seems that any characters in the painting can be gods or demons who dance in riotous revelry and cry a chorus of noises. The entire painting looks as if it was

天地父母 Saint Parents 油畫 72.5x91cm 2001

an endless drama, or a tale without a story. It seems that each of the characters wants to loudly tell his/her story, but doesn't want to listen to others, as if they had neither the time nor the space to do so, as all they can do is to relentlessly expand themselves in the limited shared space at the last moment. As a result, every character in the painting occupies a pivotal position, looking all splendid and fierce but deep down isolated and insular. Such "blazingness" is arguably the essence of Huang Chin-ho's unique visual aesthetics, which perfectly captures the state of collective hysteria that characterizes the Taiwanese: that is, on the one hand,

"the stubborn, never-say-die spirit and the ever-lasting utmost energy that everyone aspires for",[16] and on the other hand, the kind of bravado and twisted defense that one is forced to put upon when Taiwanese cultural subjectivity is under threat. Amid the blazing lights, one cannot help but laughing boisterously when confronted with the uncertain fate of tragic absurdity that lies ahead.

(This article was originally printed in February 2005, *Modern Art* No.118)

Notes:

1 I would like to thank Mr. Huang Chin-ho for providing the statement of the artist's thoughts and other materials related to his works. I would also like to thank Mr. Chiu Wu-te, whose work on Taiwan's "art of glittering" has been inspirational, and Professor Lin Tuan of Department of Sociology, National Taiwan University as well as Professor Tsai Yuan-lin of the Graduate Institute of Religious Studies, NanHua University for giving me invaluable feedback on the Workshop of Religious Studies, 2004. The notion of the "splendid" is borrowed from the film *Splendid Float* directed by Chou Mai-ling (2004).

2 See Yen Ying-chuan, 'The normative space and the pursuit of new knowledge: on the modern art of Taiwan during the colonial era', in *Contemporary Taiwanese Art in the Era of Contention*, Taipei: Taipei Museum of Fine Arts, 2004, pp. 10-41, and Yen Ying-Chuan (trans.) , *The Landscape and the Mind-scape: a Guide to Contemporary Taiwanese Art*（Part 1）, Taipei: LionArt 2001.

3 See Hsiao Qiongrui, 'Between radicalism and conservatism: revisiting the development of Taiwan's modern art in the post-War era ', in *Contemporary Taiwanese Art in the Era of Contention*, Taipei: Taipei Museum of Fine Arts, 2004, pp. 42-69; Hsiao Qiongrui, *The Colors of the Island: the Visual Culture of Taiwan*, Taipei, Tung-Da 1997, and Ni Tsai-Chin, *Artists ←→ Taiwan: on the Twenty Years of Taiwanese Fine Arts*, Taipei, Artist; Kuo Chi-Sheng (ed.) *Taiwanese Visual Culture*, Taipei, Artist, 1995.

4 Chen Rui-Wen, 'Cultural critique in artistic expression: starting with the consciousness of reality of contemporary Taiwanese social art ', Journal of Modern Art, No. 2 (1999) , pp. 5-28; Pan An-Yi, ' Contemporary Taiwanese art in the era of Contention ', *in Contemporary Taiwanese Art in the Era of Contention*, Taipei: Taipei Museum of Fine Arts, 2004, pp. 70-187; unfortunately this essay does not discuss the works of Huang Chin-ho.

5 Ni, Tsai-Chin, *op. cit.* p. 166

6 Chiu Wu-Te, 'Blazing and Fierce: on Huang Chin-Ho's Visual Aesthetics of Glittering ' in "Literature", *Taiwan Daily News*, 26th June 2003.

7 'Introduction ', Lucy Lippard (ed.) *Pop Art* (1968) . Chinese translation by Chang Cheng-Jen.

8 For detailed discussions on the notions of the "signifier" and "signified", see Roland Barthes, *Mythologies*, translated by Annette Lavers (New York: Hill and Wang, 2000) , pp.114-131.

9 Mircea Eliade, 'Methodological Remarks on the Study of Religious Symbolism ', *History of Religions: Essays in Methodology*, M. Eliade and J. Kitagawa eds. (Chicago : The University of Chicago Press, 1959) .

10 Chiu Wu-Te, *op. cit.*

11 Heterogeneity of the cosmic phenomenon is an important issue in the phenomenology of religion when dealing with the sacred space. The sacred space is heterogeneous; it is often divided into this world vs. the Underworld, the above vs. the below, the inside vs. the outside, the center vs. the margin, the Heaven vs. the Hell, etc. Such divisions signify a comic order which is related to, but different from the order of this world. Different cosmic zones are inhabited by different kinds of mythological figures e.g. Gods, ancestors, ghosts, deities, monsters, etc. See Mircea Eliade, ' Chapter 1, Sacred Space and Making the World Sacred', *The Sacred and the Profane*, trans. W.R. Trask (New York: Haper & Row, 1961)

12 Chiu Wu-Te, *op. cit.*

13 *Collected Works of Mikhail Bakhtin: On Rabelais.* Vol. 6. Trans. Li Zhaolin and Xia Zhongxian, et al. Shijiazhuang: Hebei Education Press, 1998, pp. 44-47.

14 Chiu Wu-Te, ' The magic world of the glittering drama', serialized in *Taiwan Daily News* from 24th June 2004; quotation from Chiu Wu-Te' manuscript, p. 12.

15 Wang Ching-ling, ' An introduction to Huang Chin-Ho's visual aesthetics', *Contemporary Artists*, Autumn 2004, pp. 80-1.

16 Chiu Wu-Te, ' The magic world of the glittering drama', serialized in *Taiwan Daily News* from 24th June 2004.

世俗之難

郭維國2005年的〈暴喜圖〉系列與其後作品

文／張晴文

微小的隱喻

第一次拜訪郭維國的住處和畫室。他和我約在捷運站的出口，開著一輛休旅車前來。他說：「車子是男人的玩具」，大概還帶著點夢想和滿足的意味吧。我一向覺得休旅車像是美滿家庭甚至過度甜蜜的象徵，一家人可以一起到任何地方的美好畫面，常常成為休旅車廣告的溫馨訴求。那是一種安全感。

公寓裡住著一家三口。郭太太正在廚房準備晚餐，我好奇地看看藝術家的住所，其實和一般的小家庭沒什麼兩樣。牆上掛著他和女兒的油畫，客廳的壁櫥上放著好多全家人一起出遊的照片。有些照片已經泛黃，但是笑臉還是一樣生動。排列著的照片是好多不同時候不同地點的旅遊紀錄，從照片裡小孩的年紀，以及大人的臉孔、身材變化，可以知道這是好多年來的美好回憶。不只是照片，事實上郭維國一家人本身就是不折不扣的快樂小家庭，或許支持他創作的潛在動力，就是這個安定的家。

〈暴喜圖〉這個系列一畫七年。郭維國說，這次的新作發表之後，或許會改變新的創作方向也不一定。七年的時間的確不短，回想第一次〈暴喜圖〉系列在竹圍工作室的展出，到此期間的些微變化，除了圖面上可以看到的技藝精進，一脈相承的題材之下，可以看見一位四十有五的中年畫家，如何從審視自己的身體察覺到自我的存在狀態。這樣說似乎太過抽象，不如說，從七年來的〈暴喜圖〉裡，可以見到他如何凝視自己的身體（家人也幫了不少忙），以及面對自己的生活、角色，他的快樂、痛苦，成就感以及困頓。

現世之歎

2002年，隨著展覽出版的畫冊〈暴喜圖〉裡，最末的部分收錄了郭維國的創作自述和年表。年表自祖父一輩寫起，詳述祖父、父親到自己，1881至2002一百年來的家族記事。這樣的敘述方式使我印象深刻，尤其是「1965，入三重埔聖育幼稚園」、「1972，國小五年級時，利用洗髮精空瓶自製一艘電動船轟動全校」、「1983，喜獲英國畫家法蘭西斯·培根（Francis Bacon）畫作資料深受感動，且因父親得食道癌，作品風格遽變」這些小事細節。

從這裡可以看出，家庭記事對於郭維國而言是重要的，並且，許多事情似乎早有因緣，所有的問題都有答案。談到家族於他的一些影響，他說：「家族裡的男丁，祖父、伯父、自己的父親，無論是生病或者意外總是早逝……」或許這成為他心中隱藏的壓力，「所以我努力認真地畫」，面對未知的魔咒，唯一的方法好像就是跟它拚了。

確實，從「1960，考取文化大學美術系。得來不易的求學機會，積極學習」，畢業之後歷經生意困難、因家生巨變，出國留學之事無法成行，到「1992，仲夏某日，吳天章與陸先銘來訪深談，對我在創作上多所期許與激勵」，終於決定回歸創作，1998年正式開始了〈暴喜圖〉的系列，這期間，郭維國重拾創作的興味與快感，從一張自畫像開始看到內在的自我，畫出超乎自己想像的面目，恐怕也是連當初的自己也深感意外的。

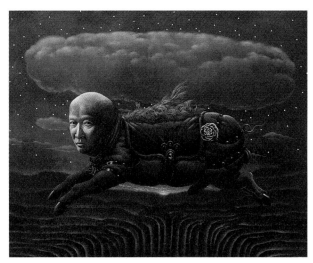

我在天空飛呀！飛！ I am Flying in the Sky 油彩、畫布 130 x 162 cm 1998　　　　暗夜玫瑰 Shadowy Rose 油彩、畫布 72.5 x 91 cm 2002

家族或者家庭情感，是看郭維國〈暴喜圖〉系列作品的一把鑰匙。一直覺得〈暴喜圖〉非常眞實，那種眞實除了因爲採用寫實的方法表露之外，更重要的，是展露了郭維國對於世俗的涉入與期待。這並不意味這些作品俗氣，而正是因爲它看來那麼努力地做到脫俗，而顯露出了那股世俗的味道，這種世俗感也讓〈暴喜圖〉有種笑中帶淚的現世之歎。

於是，在這回的〈暴喜圖〉裡，看到郭維國於家庭的自剖──對上一輩的情感、對自己的嘲弄，身陷親情輪迴裡的宿命和願望，他徹底反省，努力做好，這些對於一個中年男人而言似乎必備的責任感，也都在〈暴喜圖〉裡一一描繪。

塵世的味道

談到〈黃絲袍〉這件作品，郭維國說：「到了這個年紀，身邊的朋友們常常會有暗中較勁的感覺，比較事業的成敗，或者比較『五子』──金子、車子、房子、妻子、孩子」。他對這樣的比較不以爲然，於是將自己設計到作品裡面，想要嘲諷一下世俗的標竿。但是身在這樣的社會環境下，誰又眞的不計較呢（否則怎麼會拿這樣的題目來創作）？

〈黃絲袍〉的產生過程，就像是其他所有作品一樣，首先有了素描草圖，準備所需的各樣「道具」。因爲

寫實所需以及他的堅持，畫面中所有的元件都是依照實物來描繪。除了現成之物，他也會爲了尋找適當的材料跑遍各式商場，很多時候，「道具」還是自己動手做的。準備妥當，郭維國在自己的工作室裡簡單地安排場景，請他的妻子做攝影師爲他拍照。至於一些無法在現場準備的物件，他便上網搜尋圖像，重新組合至畫面之中，將此種種構成第二次的草圖。根據這張草圖加以不斷地修改，最後成畫。

創作的前置作業，超出了畫布以外的工作範圍。爲了張羅道具而搜盡相關物件，上網抓取圖像或者購物，找到需要的材料，在今天時空裡，從事寫實油畫的創作其實還是得世俗些的──網路也成爲不可或缺的資訊來源。畫到最後，畫裡的自己手上還拿著新鮮的i-Pod Shuffle，腳下踩的正是新購的休旅車。事實上，五子登科雖然不是很令人激賞的標準，但若眞要這麼俗氣地依此檢驗，郭維國也沒有讓自己拿了不及格的成績。

世俗以各種願望的形式附著在人生的每個關節，在郭維國的畫裡則變成一個個常被點名運用的符號。譬如木馬，譬如彩帶。又譬如黑傘、照片，或者翅膀。這些符號太常出現，以至於連郭維國本人都快要對〈暴喜圖〉系列畫作感到不悅。從1998年起至

黃絲袍 Yellow Silk Robe 油彩、畫布 200 x 138 cm 2005

今，〈暴喜圖〉幾經轉變，除了寫實技法的整體掌握更臻精熟，自身身體的形象從一開始的隱約顯現到後來的大方表演，那些不斷延續再用的符號，也成為辨識系列作品的絕對關鍵。在一向幽暗的畫面裡，紫紅或灰是基本色調。衣料、布幕或雲是柔軟的慰藉，針線是穿引。彩帶和花是紀念，翅膀是坐困愁城。傘和面具提供遮掩，傷口滴血，木馬總是哀傷。這些華麗的事物成為黯淡畫面裡特別亮眼的部分，並且帶著濃重的塵世味道，再度將〈暴喜圖〉與世俗牽連，不斷賣弄肢體的畫中人，成為世俗人生裡最賣力的演員。

勉力微笑

〈告別「暴喜」〉裡拉長了耳朵，打著傘回頭一笑的郭維國，車子後面拖拉了一具小棺材，裡面躺著一張蒼白的臉。路邊的計時器指著他的一生行跡，從出生到未知的死亡，指針指著現在，而創作〈暴喜圖〉的階段被他視為全盛時期一般，在鐘面上以紅色的線條標示。〈後花園的祕密〉這幅作品，郭維國把自己藏身在一條剖開的大魚裡，有著動物腳趾的浴缸裡是一顆血紅的心臟、彩色花朵附帶著黑白照片、披著厚重魚身的自己，以及牆上盤根錯節的樹根，所有的符號敲打著感官，超現實的場景安排在荒謬裡帶著一股耽溺的趣味。

最後一個系列的〈暴喜圖〉，更直接地也更急切地把沒有說完的心事，一次呈現。在2002年左右甚至更早的〈暴喜圖〉系列，畫面的鋪陳較為單純，而這一次的作品裡，郭維國將更多的物件安排在畫面之中，場景也有了轉變。閩南建築的殘跡，增添了哀榮過往的味道，老舊而線條剛硬的傳統建物輪廓，強行在畫面裡置入了荒魅的歷史感，有種回應家族情誼的意味。畫面中，每樣事物的安排大都有特定的意味，心臟、臍帶、骨與肉象徵著與親情的關

紅色相簿 Red Photo Album 油彩、畫布 130 x 194 cm 2004

紫紅豬的真情告白 The Confession of a Purplish Red Pig 油彩、畫布 130 x 194 cm 2006

聯，畫中人物攀附的豆莖或蕈柄，也有向父權依偎的含意。無論如何，對於上一代情感的投射，成為中年的郭維國需要審視與整理的內在情結。他曾說道父親在他心中總是個侷儻的讀書人形象，而母親從小就是嚴格要求自己與孩子們的鐵血管家。已逝的父親來不及成為他談心的對象，做為人子也為人父，中年孤兒是心境上的疲憊，化身成為〈暴喜圖〉裡每一張努力微笑的臉。

眞情告白

2006年的近作〈紫紅豬的眞情告白〉，郭維國在畫面中置入了多重的自我形象。這個多層次的展現，藉由他的畫筆在同一平面裡揭示出一個個不同的「郭維國」或者「自己」。過去的一幅作品，飛行的紫紅豬，圓胖的身形下，有著一顆灰色頭顱，即是郭維國的五官模樣。這件作品或許可以視為一幅自畫像，將自己表達為一隻飛行中的、紫紅色的小豬。而這幅滑稽的畫像，在〈紫紅豬的眞情告白〉畫中成為展覽室裡的作品之一，掛在牆面上的紫紅色豬，與展場裡的郭維國斜眼對望，而畫面中的那隻小豬彷彿現身說法，正在接受記者的採訪，說著自己才是眞正的紫紅豬，手上還拿著郭維國面貌的頭套。

郭維國當然不是紫紅豬。無論紫紅豬與郭維國的影像在畫面裡究竟糾集成什麼樣錯亂的關係，拿著畫筆的郭維國，如何選擇以這樣的方式表達對自己的幽默玩笑，則是更讓人玩味的問題。

這幅作品所呈現的提問方式，容易讓人聯想到科舒斯（Kosuth, Joseph）〈一張與三張椅子〉的習題，責問物像與意義之間的認識關係，以及究竟誰比較接近「眞實」或者具正當性。在這裡，如此排比的方

告別「暴喜」 Farewell to "Diagram of Commotion and Disire" 油彩、畫布 140 x 230 cm 2005

式並無意追尋科舒斯的意義遊戲，而更迂迴地接近
郭維國「談論自己方式的展露」，或者爲〈暴喜圖〉
一系列創作所下的註腳，畫中所畫的像極自己的畫
中人物僞裝成自己再除去面具宣稱一個關於不是自
己的宣言而那個像是自己的人物看著這一幕再度被
自己畫出來，終究，郭維國以最寫實的手法畫出最
像自己卻最隱密最虛幻的那一面，最後，這一個被
看見的自己或許才是郭維國願意示人的底線，也是
對他而言，對他人剖析並表露自身最抽象的眞實，
最不具意義的意義。

世俗的包袱或是〈暴喜圖〉一再前進的驅力。未曾
想過竟可以這般放膽去說的那些，關於自己的過去
與未來最高的機密，隱藏在如接龍遊戲一樣的〈暴
喜圖〉裡。接龍，就是按著既定的順序規則，盡力
把老天發給你的牌，用最聰明的方式打完這一局的

遊戲。郭維國用七年的時間接續，在無可避免的世
俗徹底衰敗之前，他已經準備回收快樂與寬慰。世
俗聽來讓人不快，但它無疑是最難應付的基本課
題。

（本文原刊於2006年6月，《現代美術》第126期）

Secular Regrets

on Kuo Wei-kuo's "A Diagram of Commotion and Desire" Series

Chang Ching-wen

A Minor Metaphor

On my first visit to Kuo Wei-kuo's home and studio, we had arranged to meet at the exit of an MRT station. Kuo then came in a SUV and drove me to his apartment. In a tone that brimmed with satisfaction and dream-fulfillment, the artist said, "a car is a man's ultimate toy." I've always seen the SUV as a token of family life or exaggerated happiness - after all, that is indeed the warm message that commercials have always tried to get across by portraying a family traveling everywhere in the vehicle. In other words, a SUV has come to symbolize a sense of security.

Living in the apartment are the family of three - the artist, his wife and daughter. While Mrs. Kuo was preparing for dinner, I looked around inside the apartment with curiosity, but found it of little difference from other ordinary family homes. Hanging on the wall were his and his daughter's oil paintings, whereas the living-room cupboard was filled with snapshots from family holidays. Some photographs had faded and yellowed, but the smiles they showed remained as bright as ever. These photographs helped to record the trips that the family had taken at various times and places. From the changes in the child's age or the adult's face and figure, one could tell that those images represented sweet memories of a long time span. As a matter of fact, they are indeed a typical happy nuclear family, and probably Kuo Wei-kuo's main source of motivation and artistic inspiration.

The series, "A Diagram of Commotion and Desire" was created over the span of seven years. According to Kuo, he was considering a shift in creative direction after this series. Seven years was by no means a short time-span. Looking back upon the time when "A Diagram

of Commotion and Desire" series was first exhibited at the Bamboo Curtain Studio, and comparing it with how it turns out right now, we may discover that although the theme has remained intact, slight changes have been developed during the course of the seven years. These changes include, to name a few, the improvement in the artist's techniques, and the ways the artist, approaching 50 years of age, has observed his inner self through examining his own body. Such descriptions might be too abstract. To put it in another way, it can be suggested that from the painting series, "A Diagram of Commotion and Desire", one can see how, during the course of the seven years, the artist, blessed with much help and support from his beloved family, has gazed upon his own body and looked closely at his life, roles, happiness, anguish, accomplishments, as well as times of hardship.

Secular Regrets

The artist's statement and a chronicle of his life were included at the end of the exhibition album for "A Diagram of Commotion and Desire" (2002). The chronicle began with Kuo Wei-kuo's grandfather, and described in detail the three generations of Kuo's family spanning from 1881 to 2002: his grandfather, his father, and the artist's himself. I was deeply impressed by this narrative, especially the small details such as "1965: beginning formal schooling at Sheng-Yu pre-school", "1972: leaving the entire school in awe by making a mechanic ship with an empty shampoo bottle as a fifth-grader", "1983: acquiring, and being deeply moved by, materials relating to the works of British painter Francis Bacon", "Sudden changes to my artistic styles due to father's illness (esophageal cancer) ", etc.

我的心毛毛的 My Mood is Misgiving 油彩、畫布 97 x 291 cm 1997-98

One can easily see from these details that family has always held a unique place in Kuo Wei-kuo's heart, and that karma seems to play a certain role in many affairs, as though solutions to all problems had already been pre-determined. When talking about his family influence, he said, "all the males in my family - my grandfather, my uncle and my father - were either ill the whole time or deceased prematurely. " Perhaps this has become the hidden source of pressure for the artist: "that's what has driven me to hard work. " Confronted with the seemingly hereditary curse, perhaps the only way to deal with it is to fight on with all his might.

Indeed, from these entries, "1960: being admitted Department of Fine Arts, Chinese Culture University. A hard-earned opportunity for higher education and vigorous learning ", "After graduation, my plans for further studies abroad were halted due to a sudden financial crisis in the family", "1992, on bright summer day, Wu Tien-chang and Lu Hsien-ming paid me a visit and kindly offered me plenty of support and encouragement regarding my artistic career", "1998: Launching A Diagram of Commotion and Desire", we can see Kuo Wei-kuo's enthusiasm and joy at returning to art practice. A self-portrait was the starting point of all this: it is from here that Kuo began to see his inner self, and to create something beyond his own imaginations - a result he could not have foreseen.

Understanding this close family tie is the key to decoding Kuo Wei-kuo's "A Diagram of Commotion and Desire" series. I have always found "A Diagram of Commotion and Desire" extremely real. This sense of" real-ness" does not simply result from the realist approach in which the work was executed; more significantly, it is because the work honestly reflects Kuo's thoughts and desires of the worldly affairs. Nevertheless, this does not mean that Kuo's works have become meretricious because of these personal concerns. On the contrary, it is precisely because the artist strived too hard to pursue unworldliness that the work inadvertently exposed the meretriciousness. Such a sense of meretricious earthiness has also rendered "A Diagram of Commotion and Desire" a bittersweet lament over our earthly world.

We can therefore see, from "A Diagram of Commotion and Desire", Kuo Wei-kuo's self-analysis of his family - his feelings toward the elderly, his self-mockery, and his struggles between fear for the hereditary fate and wishes for life. He made serious soul-searching and strived for perfection. All these, as well as a great sense of responsibility habitually associated with a mid-age man, can be seen portrayed in "A Diagram of Commotion and Desire" with all honesty.

The Taste of the Earthly World

When talking about the "Yellow Silk Robe", Kuo Wei-kuo said, "At this stage of a man's life, friends tend to secretly compete with each other on career

achievements or on 'the five winners of life': money, cars, houses, marriages, and offsprings. " Disapproving of this sort of competitions, Kuo made it a subject of his artwork in an attempt to mock these conventional notions of personal achievement. Nevertheless, living in a society like this, who can honest say he/she doesn't care? Even the artist himself must have cared enough to make it a subject of artistic endeavor.

The creative process of making "Yellow Silk Robe"was no different from that of making other pieces: the artist first drafted a sketch and then prepared the necessary equipments. As Kuo insisted on absolute realism, all the elements in the painting were painted in accordance with the actual objects. Aside from using existing materials, Kuo also acquired suitable materials from markets and shopping centers everywhere. On many occasions, he even had to hand-make the equipments. Once all had been prepared, Kuo then rearranged his studio and asked his wife to act as a photographer. He also often acquired images of certain objects which had been unavailable onsite, and

incorporated these images in the painting to make the second draft, which was subsequently mended and developed into the final work.

The pre-production preparation often exceeded the work one has to put on the canvas in scope. To be able to handle all these details - retrieving images from the internet or shopping for materials – a realist painter seems to have no choice but to be more earthly, because in today's world, the internet has become an indispensable source of information. In the end, Kuo found the subject of his painting, i.e. himself, holding a brand new iPod Shuffle and driving a new SUV. One may find the"five winners" a rather distasteful set of criteria for personal achievement. However, if we were to measure one's personal achievements by such an earthy, meretricious standard, we can't say Kuo Wei-kuo has done too badly, can we?

Earthiness weaves into all areas of one's life in various forms of wish and longing. On the other hand, in Kuo Wei-kuo's paintings, it is articulated through a wide range of symbols, such as the hobbyhorse, ribbons, the

後花園的秘密 The Secret of the Rear Garden 油彩、畫布 170 x 280 cm 2004

black umbrella, the photograph, or a pair of wings. These symbols appear in the paintings so frequently that even the artist himself has become increasingly uneasy. Since 1998, "A Diagram of Commotion and Desire"has undergone several rounds of transformation. The artist's command of the realist painting techniques has developed into maturity. Changes can also be seen in the ways in which the imagery of the artist's own body evolved from a faint and gleaming shadow to a full-blown performance. Moreover, those repeatedly employed symbols have also become a key characteristic of this series. The often-dusky image is tinted with laky or gray shades. Threads and needles sew together soft comfort provided by fabrics, curtains or clouds; ribbons and flowers are the dearest keepsakes; and the wings signify [a man] walled in his own worries. The umbrella and the mask provide the shade for the bleeding wound, while the hobbyhorse is forever sorrowful. All these dashing objects shine in the gloomy image and convey a profound sense of earthiness that once again associates "A Diagram of Commotion and Desire"with an earthbound spirit. Endlessly showing off his body, the man in the painting is veritably the most conscientious actor in the play of our earthly life.

A Forced Smile

In "Farewell to a Diagram of Commotion and Desire", long-eared Kuo Wei-kuo, holding an umbrella in his hand, turned his head with a coquettish smile on his face, whereas the car drags along a small coffin in which lies a pale face. The timekeeper on the roadside chronicles the life story of Kuo Wei-kuo from birth to the unforeseeable future death. When the indicator points to the present moment, where the creation of "A Diagram of Commotion and Desire"is considered a summit of Kuo's career, the area is marked with a red line on the clock face. In "The Secret of the Rear Garden", Kuo hides himself inside of a giant gutted fish. Placed inside of the bathtub with animal toes are a red-colored heart, flowers of various colors, the artist himself carrying the heavy body of a fish, and the twisted roots and intricate gnarls hanging on the wall. All these symbols strike our senses as the surreal scene exudes a sense of indulgence amid its absurdity.

The final series of "A Diagram of Commotion and Desire"pours out the artist's inner thoughts in a more straightforward and hasty manner. In fact, the 2002 series of the "A Diagram of Commotion and Desire", or the series before, had a simpler composition, as opposed to the current series which places more elements in the image and makes changes to the settings. Ruins of the Southern Hokkien-style architecture added to the painting a sense of nostalgia for past glories. With a rigid outline, these old traditional buildings force upon the image a sense of history and forsakenness, as though it was reflecting a family heritage. Every element in the painting has certain connotations. For example, the heart, the umbilical cord, the bone and flesh signify family ties, whereas the man clinging on the beanstalk or the mushroom stem seems to signal attachment to patriarchy. In any case, these visual signs can be seen to project the artist's close bond with the last generation, which became the inner sanctum that called upon Kuo's monitoring and analysis at his mid-age. He mentioned once that his father had projected the image of an archetypal free-spirited intellectual, whereas his mother had always been a strict and self-critical "blood-and-iron" homemaker. With his father deceased, Kuo never had a chance to enjoy a heart-to-heart with him. Now a father himself, the mid-age, parentless man turns his mental exhaustion into every labored smile in "A Diagram of Commotion and Desire".

A heart-filled Confession

In his recent production, "The Confessions of a Purplish Red Pig" (2006), Kuo Wei-kuo placed multiple images of the self at the center of the painting. Through the artist's paint brush, such multi-layered articulation reveals, in one image, all the different variations of "Kuo Wei-kuo" or "the self". In a past piece, A Flying Purplish Red Pig, the chubby man with a grey skull was based on the complexion of the artist himself. This piece, which featured a flying purplish red piglet, could perhaps be seen as a self-portrait. However, in the content of "The Confessions of a Purplish Red Pig", this comical painting, i.e. A Flying Purplish Red Pig became one of the paintings shown

縫合 Sewing up 油彩、畫布 91 x 117 cm 2002

in the exhibition room. Appearing on the wall, the purplish red pig exchanged looks with Kuo Wei-kuo through crossed eyes in the exhibition room, and the piglet in the painting was being interviewed by journalists, saying he was actually the REAL purplish red pig while holding a Kuo Wei-kuo face mask in his hand.

Of course Kuo Wei-kuo is not the purplish red pig. No matter what sort of twisted relationships may derive from the encounter between the images of the purplish red pig and of Kuo Wei-kuo in the painting, why Kuo, with a paint brush in his hand, chose to crack a joke at himself in such a humorous manner, remains an even more intriguing question.

The way in which this painting poses questions reminds one of Joseph Kosuth's "One and Three Chairs "(1965), which enquires into the epistemological relationships between the image and the meaning, pondering which one should be closer to the "truth" and thus gives more legitimacy. The juxtaposition within Kuo's painting was not meant to follow Kosuth's signifying play. Instead, it was closer to Kuo Wei-kuo's characteristic "self-revealing by talking about himself"- an act which can also be seen as an exposition of Kuo's " Diagram of Commotion and Desire" series. The subject of the painting that bore a striking resemblence with the artist first disguised himself as the artist before taking off the mask to claim that he was not the artist, only for the artist-lookalike to see it all and put it on canvas. After all, Kuo Wei-kuo has revealed the most private and illusory aspect of

原子小金剛的救贖 Redemption of Astro Boy 油彩、畫布 97 x 194 cm 2006

himself in the most realist way. In the end, this version of himself, visible to all, marks the bottom-line of what Kuo Wei-kuo is willing to expose about himself. For the artist himself, in the process of revealing and analyzing himself in front of a public audience, this is also the most abstract reality, as well as the most meaningless meaning.

Such worldly burdens are indeed the driving force behind "A Diagram of Commotion and Desire". All the things Kuo Wei-kuo never could have thought he would let out, i.e. the ultimate secrets about his past and future, are concealed in "A Diagram of Commotion and Desire"like a game of solitaire, of which the logic is essentially to play the cards randomly dealt to one following certain rules and orders, in an attempt to win the game in the most intelligent way possible. Kuo Wei-kuo took seven years to continue the game, and was prepared to withdraw all happiness and comfort before the inevitable earthiness fell into decay. The term"earthiness" may sound distasteful, but is in undoubtedly the most

fundamental issue confronting everyone, and one that is most difficult to deal with.

(This article was originally printed in June 2006, *Modern Art* No.126)

築虛爲實的生活暨美學實踐者——許雨仁

文／王嘉驥

許雨仁（b. 1951）素來有作素描筆記的習慣。這種隨筆的記錄，不僅僅以圖畫顯形，同時也有大量的文字心得筆記。晚近，他在一篇〈創作自述〉當中，正面提到了素描之於他個人創作的重要性。許雨仁指出，「素描的目的不在於畫技演練」，其更重要的意義還在於「自由」與「解放」，以「發掘『眞實我』」，並「發展『個性我』」。對許雨仁而言，素描作爲一種敏銳的直覺活動，同時也可以看出畫者是否具有「格物致知的習慣」，是否具有「從凡物中發展想像的能力」。通過不間斷的素描活動，許雨仁同時也發現，「有一些圖形似乎隱藏在本我心之中」，而且是在他「無意識／無目的的塗寫活動中，就會自然自動地出現」。[1] 因此，素描的作用，除了是對於外在物質世界的一種反思與造形想像，同時，也是一種自我挖掘與認識的過程。而許雨仁對於素描的這種認識，在一定程度上反映了他曾經在1970年代師事李仲生（1912-1984）的影響。

黃翰荻是最早討論許雨仁創作的藝術評論者。早在1985年，他已經注意到許雨仁素描筆記中的文字記錄，具有「一種生硬童駿的奇美」。透過許雨仁的筆記，黃翰荻看到了他創作意識中「不同於常」的幾種重要特質。黃翰荻對許雨仁的觀察指出，「對於現代人所誇持自詡的科學文明，他彷彿存懷著某種強烈的反抗意識，意圖回到另一原始樸拙甚至近於魔力符咒的變形世界……像一個活在現代社會中的原始住民，他所擁有的心靈和官覺都是我們這些摩登人物所失落的。」不但如此，黃翰荻還在許雨仁的作品當中，看到了一種令他動容的「強勁而不受

外在風潮、流派影響的藝術生命力」，而這種「原創性」的特質，則是「發生自台灣鹹澀貧瘠的角陬」，而且難能可貴地「不見此地常帶的地域偏狹」。[2]

然而，頗具反諷的是，儘管黃翰荻在許雨仁的繪畫當中看到了一種原生於「台灣鹹澀貧瘠的角陬」的罕見原創特質，許雨仁卻沒有例外地也在1970年代末期以及1980年代期間，趕上了1978年台美斷交之後的一波美國移民潮。就在1980年代幾度赴美的期間，他逐漸認清了移民生涯原是一場失落夢的嚴酷現實。許雨仁在筆記當中，記下了自己在美國期間，庸庸碌碌以推銷珠寶維生的心頭點滴：「整天在D.C.、Virginia、Maryland的高速公路、鄉間小路上轉來轉去，爲了生活，爲了建立一條獨立的經濟路線……兩眼盯著Jewelry Stores……內心裡忘掉了自己，只有在睡覺前退回到自己，又被惺忪的雙眼帶到另一個沈靜、掙扎的世界裡！」在這些文字底下，他更以「被打包的人」和「在車內奔跑的人」自侃，並畫下了自己被捆縛在方盒之中，以及被羈束在車內的素描圖案。[3]

原本懷抱著期待的美國夢，最終證實是一場心靈的失落之旅。許雨仁毅然於1990年偕妻子連同在美國出生的幼子返台，從此專意於藝術創作。同年，他以油畫形式，畫下了一幅〈這是我去過最大的城市〉（1990）。畫中以近乎素人童稚的反透視手法，表現了自己曾經爲生活而奔波其中的紐約市夜景。畫中一部比例明顯過大的汽車，背後襯著紐約的摩天大樓，彷彿騰駕在橫跨畫面的布魯克林大橋上。這不但是許雨仁個人的紐約生活回憶，更是他在素描筆

立在石堆的自畫像 A Self-Portrait on a Heap of Stones
130.5 x 97 cm 1989

樹上長著白花 White Flowers on the Tree 130 x 89 cm 1990

記中所描摹的「在車內奔跑的人」的具體寫照。

也在稍早的1989年，許雨仁曾經畫下一幅更大的〈立在石堆的自畫像〉。此一畫作彷彿是許雨仁早先在素描筆記中所留下的「被打包的人」的另類變化。作為一幅自畫像，他幾乎將自己的頭像釘在十字架上，而十字架則是佇立在堆滿土石的盆景之中，予人一種黯黑的廢墟感。這幅自畫像的面容肅穆近乎哀戚，彷彿是對自己生命某一階段的墓誌銘。藉著此一畫作，許雨仁顯然已經表露出離美返台的意向。

返台之後的許雨仁，一方面維持簡樸的生活，同時，也拜台灣藝術經濟在1990年代前期勃興之賜，再度積極創作，並以繪畫維生。從1990年至1995年

左右，他曾經畫下大批的油畫作品。這些作品幾乎沒有例外地表現了一種黏稠密實的畫面塊壘感。在沈甸甸的畫面當中，許雨仁油彩的色調多半顯得幽暗、沈滯、鬱悶且不流動。就主題而言，主要以花卉、城市、自然風景、或是與個人成長記憶相關的鄉土回望為主。在視覺上，這些油畫確實形成了黃翰荻所言的一種如沙、如鹽、如乾草，如枯枝的混雜效果。[4]而這種畫面的質理，多少反映了許雨仁對於台南家鄉——包括空氣、地質、以及自然視野——的懷舊記憶。

在造形的處理方面，許雨仁刻意將外在世界具體而明確的物質形體模糊化與朦朧化，使其變形為一種帶著曖昧、斑駁，或甚至抑鬱的心理素質。而此一回歸渾沌原始的企圖與形象特質，儘管是黃翰荻在

海狂衝著土 海輕細著山 海輕推著沙 海輕吻著石
海輕吻著土
海重擊著石 海猛射著沙 海吞食著山 海是造景者!!!
2006「海洋書畫」系列 "The Ocean" series

1985年的文章當中，早已提及的一種觀察，或甚至是許雨仁本人曾經在素描筆記中表明希望追求的藝術目標，然而，就在經歷了1980年代美國夢的幻滅之後，許雨仁或許更能體會到，資本主義城市文明對於人性可能造成的扭曲、斷裂與斲喪吧！⁵就此而言，回歸渾沌的原始，或許也可以看成是許雨仁在文明的創傷之後，意圖藉繪畫自我療癒的一種過程。⁶

1996年，許雨仁首度以水墨創作舉辦個展。⁷相較於他在油畫中慣常使用的沈厚、密實、堆疊的畫面處理，許雨仁的水墨畫風則顯得空白清淡許多。事實上，許雨仁早年在國立藝專（今之國立台灣藝術大學）美術科的藝術教育，即是以國畫作爲主修。只是出人意表的是，許雨仁在畢業製作時，卻由於畫風的表現過於不正統，偏離主修老師所要求的傳統路徑太遠，幾乎使他無法順利畢業。許雨仁這種對於既有師承與傳統的叛離，或企圖自闢門徑，自然也預示了他日後刻意所有不同的水墨觀點。

出於形式的自覺，以及對於傳統「僞飾」的不滿，許雨仁的水墨筆風顯得與衆不同，甚至完全不在傳統之內。儘管許雨仁的水墨與油畫作品的面貌迥異，然而，其根柢卻都很注重痕跡感。不管是油彩或是筆墨，許雨仁都偏好它們在畫布或紙絹上運行的痕跡。許雨仁的水墨作品偏好細筆的運用，每一次蘸墨和運筆的過程，都給人一種惜墨如金的節儉感。而且，每一次的運筆，都是在墨汁枯竭了以後，才又蘸墨；同時，每一次補蘸墨汁以後，都是重新另起線條，而不對既有的線條進行補筆的動作。再者，由於他在1990年代期間所使用的棉紙纖維較粗，觀者都很容易可以看到墨線在紙上拖曳、轉筆與留白的效果。⁸來到晚近幾年，許雨仁有時改以絹本創作，但仍堅持單色水墨的形式。極爲不同的是，他的運筆更明顯地轉爲片段而不連續，如此，形成一種看似斷斷續續的虛線連接風格。同時，隨著運筆更加地純熟，許雨仁對於畫面的處理，也變得更爲綿密，筆墨的密度更高，畫面空間

的層次也更具玩味與變化。

相較於他在油畫中所展現的工業廢墟感，以及意圖回歸精神原鄉的心靈創傷感，許雨仁的水墨創作反倒凸顯了一種山水造境的自由想像，同時，配合詩性的文字書寫，使其畫作更具文學性。從1996年之後，許雨仁確立了回歸水墨創作之路。在自創一格的景致與風格之中，他的水墨越來越有一種清雅秀麗的雋美質感。除了以山水為主體，他也經常在畫面之中描摹日月的光輝或神祕的光芒照射，這些都使得許雨仁的水墨越顯輕盈透明。

從1996年的水墨個展迄今，許雨仁的水墨風景仍有不同與差異。就形式而言，1990年期間的作品似乎較強調人為的形式構成，而且，畫面呈現大量的留白，因此，畫面的二維性、幾何感與極簡特質相對也較為鮮明。再者，儘管水墨的技法風格與油畫南轅北轍，然而，其主題內涵與油畫中所見的關於城市與台灣自然環境的議題，卻仍舊有著高度的連續性。所不同的是，許雨仁的油畫呈現較強的心理感傷與文明廢墟感，而來到水墨作品之中，則是留下了大量的空白、荒涼與枯渴感。一反傳統山水繪畫隱居避世的主題，以及以山水作為胸中丘壑的意境表達常態，許雨仁的水墨卻時而可見裸露的水泥鋼筋，以及因為偷工減料而頹圮剝落的建築廢墟，這種反浪漫的特質也是對於當代環境現實的觀照與省思。就此而言，許雨仁在1990年代期間的油畫與水墨，固然面貌極為不同，形式美學也頗為兩極化，然則，兩者卻都直指相同的城市議題，而且都是對於台灣當代社會嚴重失根與喪失原始純真的懷鄉哀歌暨評論。

多年以來，許雨仁不但以清簡樸實度日，將物慾降至最低，同時，他也持續保持戶外寫生的記錄習慣。他更時而駕車野營至台灣的自然山林之中，選擇與天地一同作息。而花東的山海景色，更是他時而提及的寫景對象。或許也因為這樣，許雨仁近幾年來的水墨作品，展現了較多的自然寫生景致——晚近他以〈海洋書畫〉（2006年）為題的系列作品，即

水已留過去了 水已靜止了 水已翻轉了
想起了那靜山空水 已是個不盡的水水

91

是其中一例。[10]儘管以自然景觀的寫生作爲創作的基礎，許雨仁這批水墨作品卻明顯看出與傳統山水繪畫佈局的淵源。此與許雨仁稍早在1990年代期間的表現，已有不同。

值得指出的是，除了過往以來特殊而獨創的幾何形式之外，許雨仁的山海景觀大抵延續傳統水墨的畫幅格局，亦即以中堂或長條的垂直掛軸爲主。就構圖而言，許雨仁的山海形式也明顯巧合於傳統常見的幾種形態，譬如：鳥瞰式的平遠構圖；中峰鼎立式的巨碑式構圖；以及近岸眺望遠山的一河兩岸式構圖。似乎可以看出，隨著個人獨特筆墨的建立與成熟，許雨仁也逐漸找到了能夠與水墨山水傳統匯流並進的妥協共榮之路。

類似於他對油畫的造形邏輯，許雨仁的水墨形象也採取了將山海形象簡化、概念化、或甚至風格化的手段。較不同的是，許雨仁水墨作品中的幾何感更爲鮮明。不但如此，許雨仁筆下的山海意象，也與文人山水繪畫的傳統有著一定程度的類似性──兩者都剔除了在地景點的特殊性，而成爲永恆化的山海意象。這種去除了時間的偶然性，不再具有明顯四季感，也沒有確切日夜的山水或山海景象，最終已接近於一種純粹的空間結構。

來回觀照許雨仁自1990年代以迄於今的創作歷程，其意義不外心靈原點的回歸。從刻意維持粗衣礪食的清貧生活，到創作上不斷追求回返原始之路，許雨仁的生活原則與創作早已合而爲一。而許雨仁對於水墨所抱持的創作觀念，也早已不是風格的刻意形塑或建立。他畫中斷斷續續且如虛線若實的中鋒墨線，更像是一種儉樸生活態度的實踐。循著一筆一畫逐懸而緩慢地堆築建構，許雨仁如今歸返到至簡至樸至拙的創作。這種築虛爲實的美學，既是一種風格，更是一種生活。　▋

（本文原刊於2006年8月，《現代美術》第127期）

註釋：

1 引文出自許雨仁個人網誌，參閱許雨仁，〈創作自述〉，〈http://www.wretch.cc/blog/yu4444/5993229〉網頁。

2 黃翰荻，〈我所知道的一種藝術樣本──許雨仁作品初探〉，《許雨仁》（台北：漢雅軒，1991），頁21。

3 引文見於許雨仁的素描筆記，圖版參閱《許雨仁》，同上註，頁7；亦可參考林中坡，〈建構而後茁壯──許雨仁生命的内在指標〉，見於《許雨仁1993：原動──潛遊在文明的廢墟》（台北：漢雅軒，1993），頁30。

4 參閱黃翰荻，〈我所知道的一種藝術樣本──許雨仁作品初探〉，同註2，頁21。

5 許雨仁在1985之前的筆記中寫道：「我只是想徹底揭開原始作畫的方法，現代及古典的技法總是以一種爲飾的方式在向前推進，我卻想一步一步的往回走。」參見黃翰荻，〈我所知道的一種藝術樣本──許雨仁作品初探〉，同註2，頁22。

6 有關許雨仁回歸「原始」的意圖及其以「城市」爲題創作的關係，亦參閱王嘉驥，〈編織現代城市傳奇──我看許雨仁的「城市」畫作系列〉，見於《許雨仁1993：原動──潛遊在文明的廢墟》（台北：漢雅軒，1993），頁2-3。

7 展覽地點是在台北漢雅軒。

8 亦可參考王嘉驥，〈水墨畫最荒涼的預言──許雨仁一九九六個展〉，《中國時報》1996年12月8日第19版（「人間副刊」）。

9 參閱王嘉驥，〈水墨畫最荒涼的預言──許雨仁一九九六個展〉，同上註。

10 許雨仁2006年〈海洋書畫〉系列作品，可以參考許雨仁個人網誌上所提供之圖片：〈http://www.wretch.cc/album/album.php?id=yu4444&book=10〉。

被遺忘海海邊邊的梯梯田田 久遠的立立石石守護著
海洋吹著感動的風在快速裡忘懷 水田裡的雲對無聲唱天空的雲
剩下的雲暫時遺忘人世間的糾糾纏纏
2006「海洋書畫」系列 "The Ocean" series

雲裡還有石 水裡還有土 霧裡還有壩 雲雲霧霧裡擁
有著…山水靜靜
2006「海洋書畫」系列 "The Ocean" series

Building the Real from the Ground Up

On Hsu Yu-jen's Aesthetics and Philosophy of Life

Chia Chi Jason Wang

Hsu Yu-jen (b. 1951) has long used sketch as a means of visual note-taking to complement with large amounts of texts. In a recent statement, Hsu discusses the importance of sketch to his creative practice, "the purpose of sketch is less to do with improving my drawing skills than to do with attaining self-liberation, and in so doing unearthing my true self and developing my own personality and characteristics."[1]

For Hsu Yu-jen, sketch - an activity essentially involving artistic intuition - also serves as a touchstone of one's creativity, showing whether one is able to achieve enlightenment by studying the nature of things, or to unleash imagination from simple and ordinary affairs. Hsu also discovers, through his constant practice of sketching, that some images which seem to be long hidden in the mind can be automatically drawn out

許雨仁畫室一景 Corner of Hsu Yu-jen's Studio

from the unselfconscious and aimless acts of scribbling. In this sense, it seems that sketching not only reflects one's imagination of the external material world, but also acts as a process of self-discovery. And Hsu Yu-jen's approach to sketch can be seen, to a certain extent, to reflect the influence of his mentor in the 1970s, Lee Chung-sheng (1912 - 1984).

Huang Han-di is the first art critic to have systematically discussed Hsu Yu-jen's art works. As early as 1985, he had noticed the "raw and innocent charm" of the textual records in Hsu's visual notes. Huang Han-di sees in Hsu Yu-jen's notes several distinguishing characteristics of Hsu's artistic ideals: "he (Hsu Yu-jen) seems to be deeply defiant against contemporary scientific civilization with which modern men and women have prided themselves. As such, he seems to be attempting at a return to the state of pure simplicity bordering a disfigured world of magic, as though he

was a primitive man living in modern civilization. But in fact, Hsu possess a sort of mind and sense that we who live in the modern world have lost forever." Not only that, Huang Han-di is also deeply moved by Hsu Yu-jen's enduring artistic vitality which is "so powerful that it goes beyond the influence of any artistic trends or styles." Hsu's strong sense of originality, according to Huang Han-di, derives from "the far corner of poverty-beset Taiwan". But commendably, Hsu's art shows "no sign of insularity often seen on this land. "[2]

Ironically, however, despite his rare sense of originality which arose from the "far corner of poverty-beset Taiwan" as Huang Han-di had suggested, Hsu Yu-jen joined the massive wave of immigration to the United States in the aftermath of the severance of diplomatic relations between USA and Taiwan, only to be forced to wake up from the American dream after several visits to the States in the 1980s. He wrote in the notebook

一堆水泥 Cement 120 x 162 cm 1994

thoughts on living a mediocre life as a jewelry salesman in the United States, "For the whole day I was either speeding on the highway of D.C., Virginia and Maryland or zigzagging through the country snake lanes - all this just for securing some financial independence. I lost myself whenever I was staring at the jewelry stores. It is only in the brief spell before I fell asleep, being taken to another world of endless silence and struggles, that I could get myself back again." Underneath these notes were some drawings of himself as a man confined in the box, and a man trying to run inside of a car.[3]

The American dream Hsu had long nurtured turned out to be the journey of a lost soul. In 1990, Hsu Yu-jen returned to Taiwan with his wife and American born young son to concentrate on art practice. In the same year, he created an oil painting entitled "The Biggest City I Have Ever Set Foot on", depicting, in an anti-perspective approach that highlighted the innocent, kiddish charm of an uncoached man, the night view of New York where he had struggled to make ends meet. The painting features a disproportionately large car with the Empire State Building of New York in the background, as if the car was running across the Brooklyn Bridge in the painting. It not only represented the artist's memories of life in New York, but also served as a gritty portrayal of "the man running in the car" as he had drawn in the sketch book.

Earlier on in 1989, Hsu Yu-jen had painted "A Self-Portrait on a Heap of Stones" - a painting larger than "The Biggest City". "A Self Portrait" seems to be a variation of "the man in the box" from his sketch book. In this "self-portrait", Hsu virtually pins his own head on the cross, which is stood on a heap of stones, effectively conveying a dark atmosphere of decay. With a solemn, virtually mournful look, the self-portrait seems to serve as an epitaph of a certain phase of the artist's life. Clearly, Hsu Yu-jen has expressed, through this painting, his intention to leave the States and return to Taiwan.

Hsu Yu-jen maintained a simple life after returning to Taiwan. Meanwhile, he began practicing art again. Thanks to the boom in Taiwan's art market in the early 1990s, he was able to make a living by painting. During the first half of the 1990s, Hsu produced a large quantity of oil paintings which were, almost without exception, characterized by a sense of compression and density. By using dark, stagnate and depressing colors, the heavy impasto of the painting surface often features subjects such as flowers, cityscapes, natural scenery or personal memories, creating what Huang Han-di calls an "interweaving effect of patterns" as if blending together the visual appearances of sand, salt, hays, and deadwood.[4] The texture of the paintings can be seen to somewhat reflect Hsu Yu-jen's nostalgic sentiments for his hometown Taiwan, including its air, geology, and natural scenery.

In terms of his treatment of the images, Hsu Yu-jen deliberately blears the concrete materials of the physical world to create an ambiguous, mottled, or even gloomy feeling. It is worth noting that as early as 1985, Huang Han-di had spotted, in an essay, this unique quality which appeared to suggest an attempt at a return to the primitive chaos. In fact, even Hsu himself had stated in his sketch notes that a return to the primitive innocence would be his artistic ideal. Nonetheless, it had to wait until Hsu had the first-hand experience of urban capitalism and finally woke up from the American Dream that he would realize the full scale of the distortion and damage it could do to a person.[5] In this sense, Hsu's art, which indicates an attempt at returning to the primitive state, can perhaps be seen as a healing agent in the aftermath of his frustration and defeat in the urban jungle.[6]

In 1996, Hsu Yu-jen had his first ever solo ink-painting exhibition.[7] Compared to his oil paintings which were often characterized by the solid and condense images, Hsu's ink-and-wash paintings were a lot lighter. In fact, Hsu had been an ink-painting major when studying in the National Taiwan Academy of Arts (today's National Taiwan University of Arts). However, he nearly failed the graduation exams due to his "unorthodox" approach to ink-and-wash painting. Hsu's rebellion against "the orthodox" or "tradition" can now be seen to indicate his intention to develop a new approach to ink-and-wash painting in later years.

Hsu's keen awareness of the artistic form and discontents toward the mannerism of the traditional approach led him to develop a new and distinguishing form of ink-and-wash painting - to an extent that it was completely beyond the confines of the traditional approach. Despite the fundamental differences between his ink and oil paintings, both forms demonstrated Hsu's meticulous attention to the texture. To be more specific, Hsu seems to constantly foreground the traces of his brushstrokes on both the paper (for ink-and-wash paintings) and the canvas (for oil paintings). When performing ink-and-wash paintings, Hsu Yu-jen preferred creating thin lines with thrifty use of ink. Every stroke was applied with minimum amount of ink. It is worth noting that in Hsu's ink-and-wash paintings, each brushstroke would last until the ink was exhausted from the brush; a fully-inked brush was used strictly for starting a new stroke only, and never for mending an existing line. In addition, the rougher-textured paper Hsu used during the 1990s allowed the viewers to see clearly how the artist dragged and rotated the brushstroke or how he created the margin.[8] In later years, Hsu began to paint on the silk, but insisted on still practicing singled-colored ink painting. What has clearly changed, however, is that Hsu began to repeatedly paint quasi-dotted lines in his works. Meanwhile, as his brushstroke techniques reached maturity, Hsu resorted to fine brushstrokes to create denser composition and greater variations in the spatial arrangement.

Far from his oil paintings which are often characterized by an dark aura of the industrial ruin or melancholic nostalgia for the primitive state, Hsu's ink-and-wash paintings tend to foreground a sense of free-flowing imagination in the shaping of the landscape which, combined with lyrical written notes, adds to the paintings a touch of poetry. From 1996 onward, Hsu has established his career as an ink-and-wash painter. His unique style in ink-and-wash painting entails elegant and graceful appearance and, in particular, lightsome and limpid quality created by a combination of key elements of traditional landscape paintings (i.e. mountains and waters) and glints of sunlight or moonlight or a veil of mysterious aura.

Since the 1996 exhibition, Hsu's ink-and-wash paintings have evolved in some ways. In terms of the art form and style, Hsu's 1990's pieces seemed to focus more on artificial construction and tended to leave large blank areas, effectively highlighting the two-dimensionality, geometricity, and minimalism of these paintings. It should be noted that despite their fundamental differences in art styles and techniques, Hsu's oil paintings and ink-and-wash pieces display considerable similarities in the sense that they all deal with Taiwan's urban and environmental issues. Nevertheless, while Hsu's oil paintings often convey strong sentiments and a profound sense of decay, his ink-and-wash paintings, often characterized by a large blank area, tend to articulate a sense of bleakness and despair. Contrary to applying popular elements of traditional ink-and-wash paintings (e.g. reclusion themes, or imagery of the mountain and water which symbolizes one's inner landscape), Hsu Yu-jen's ink-and-wash pieces often depict sights of steel bars sticking out from reinforced concrete, or ruins of buildings that collapse as a result of faulty construction. The "anti-Romanticist" tendency of Hsu's paintings can be seen to reflect the artist's deep concern about contemporary environmental issues.[9] It can therefore be suggested that despite their contrasting aesthetic styles, Hsu Yu-jen's 1990s oil and ink-and-wash works, which often address urban issues, serve as a form of social commentary on the alienation and uprootedness of Taiwan's contemporary industrial civilization, as well as the artist's nostalgic sentiments for lost innocence.

Over the years, Hsu Yu-jen has lived a simple life and reduced his material wants to the most basic level. Meanwhile, he has maintained the habit of sketching outdoors and taking visual notes. He even occasionally drives into the woods to camp for the night just to feel the connection with nature. The mountain-and-sea views of Taiwan's East Coast are among Hsu's favorite sketching venues. This probably explains why Hsu's ink-and-wash paintings of the recent years are mostly landscape sketches, with "The Ocean" series (2006) being the most prominent example.[10] Although the series is largely based on sketches, influence from traditional ink-and-wash landscape paintings can clearly be seen in the pieces included in this series,

particularly in terms of the basic shapes of their composition. This marks a clear sign of difference between Hsu's recent works and his 1990s pieces.

It is worth noting here that aside from the unique and original geometric shapes which Hsu has long employed for his works, these recent landscape paintings, featuring mountain-and-sea views, largely preserve the basic layout of traditional ink-and-wash paintings, i.e. long, vertical wall scrolls. In terms of the composition, Hsu's mountain-and-sea themes can also be seen to coincide with the style of traditional ink-and-wash landscape paintings in terms of the basic elements and formats employed, such as the bird's-eye-view composition, the monumental composition, or the river-and-banks composition. One can see, from the development of Hsu's works, that as he reached maturity in both artistic style and brushstroke techniques, Hsu Yu-jen seems to also have found a way to harmonize and complement with traditional ink-and-wash landscape paintings.

Adopting a similar compositional pattern to his oil paintings, Hsu Yu-jen's ink-and-wash pieces tend to be minimalist, symbolic, or even personalized in artistic style. However, his ink-and-wash paintings seem to be more geometric in their scopes. Besides, Hsu's works share similarities with traditional Chinese ink-and-wash paintings in the depiction of the mountain and the sea, as they tend to eradicate site-specificity in pursuit of a purified and eternalized image of the mountain and sea. With no distance of time, changes of seasons, contingency of events, or clear distinction between day and night, these mountain-and-sea views are purified into an art form bordering a geometric spatial structure.

As we examine Hsu Yu-jen's creative trajectory through the 1990s and the recent years, we can discover that what underlies Hsu's creative thoughts and energy is none other than a desire to revert to the primitive state of mind. Hsu's life and art have mirrored one another, as the artist has long maintained an austere and simple lifestyle, and meanwhile pursued purified primitivism in his art. It should also be noted that Hsu Yu-jen's artistic thoughts for ink-and-wash paintings are derived from his reverence for nature, rather than a deliberate quest for personal style. The inconsistent, near-dotted ink lines in his ink-and-wash paintings can be seen to reflect his simple philosophy of life. Slowly building his world with delicate brushstrokes, Hsu Yu-jen now lives a life filled with simple pleasure of art. Capitalizing on the building of the real from the ground up, Hsu's unique aesthetics is more than an art style; it is, in fact, a way of life.

(This article was originally printed in August 2006, *Modern Art* No.127)

Notes

1. Quoted from Hsu Yu-jen's weblog. See 'The Artist's Statement', 〈http://www.wretch.cc/blog/yu4444/5993229〉.

2. Huang Han-di, 'An artistic sample I know of: on the works of Hsu Yu-jen', *Hsu Yu-jen*, Taipei: Hanart TZ Gallery, 1991, p. 21.

3. Quotes from Hsu Yu-jen's sketch notes. For illustrations, please see Huang Han-di, 'An artistic sample I know of: on the works of Hsu Yu-jen, ' *Hsu Yu-jen*, Taipei: Hanart TZ Gallery, 1991, p. 7. See also Lin Chung-po, ' Established and exuberant: on the inner landscape of Hsu Yu-jen's life, ' in *Hsu Yu-jen 1993: Wandering around the Ruins of Civilization*, Taipei: Hanart TZ Gallery, 1993, p. 30.

4. Huang Han-di, *op. cit.*

5. In a note book Hsu Yu-jen kept prior to 1985, he wrote, "I just want to thoroughly unearth the primitive painting methods. At a time when conventional techniques - both the modern and the classical - continually push on, I just want to move backwardly step by step." See Huang Han-di, 'An artistic sample I know of: on the works of Hsu Yu-Jen, ' *Hsu Yu-jen*, Taipei: Hanart TZ Gallery, 1991, p. 22

6. For materials dealing with the motifs of Hsu Yu-jen's works, particularly with regard to the artist's longing for "returning to primitivism" and the urban themes, please see Jason Wang Chia-chi, 'Weaving the modern urban legend: my thoughts on Hsu Yu-jen's 'Cities' series, ' in *Hsu Yu-jen 1993: Wandering around the Ruins of Civilization*, Taipei: Hanart TZ Gallery, 1993, p. 2-3.

7. The exhibition was held at the Hanart TZ Gallery, Taipei.

8. See also Jason Wang Chai-chi, 'The bleakest prophecy of the ink-and-wash painting: on Hsu Yu-jen's 1996 Solo Exhibition', in p. 19 (Philology), *Chinatimes*, 8th December 1996.

9. See Jason Chai-chi Wang, 'The bleakest prophecy of the ink-and-wash painting: on Hsu Yu-jen's 1996 Solo Exhibition', in p. 19 (Philology), *Chinatimes*, 8th December 1996.

10. For illustrations of Hsu Yu-jen's"The Ocean "series (2006), see the artist's weblog 9. *Ibid.*
〈http://www.wretch.cc/album/album.php?id/=yu4444& book =10〉

海是命生原處 海海生生 海海死死 透過海洗盡一切
肉身是水
跟著海走完我的過程 讓一切回到海
2006「海洋書畫」系列 "The Ocean" series

那天，她抓到了雲

陳慧嶠的創作與生命之旅

文／秦雅君

有些人的一輩子就像是一個星期日的下午，這個下午並不是完全難以忍受，只是悶熱、無聊與不適。他們流著汗，不停發著牢騷。他們不知道該作些什麼，整個下午只留給他們瑣碎厭煩的記憶。然後突然間一切都過去了，夜晚降臨了。—唐望[1]

1961年，人類學家卡羅斯·卡斯塔尼達（Carlos Castaneda）為了研究的需要，結識了印地安巫士唐望（Don Juan），在追隨唐望的十年間，他經驗了一系列全新的知識領域。唐望陸續教導他如何成為獵人、成為戰士，以致成為巫士的方法，而這一切的學習都必須要從「抹去個人的歷史」開始，因為只要翻轉了這套我們習以為常的描述方式，世界自然會以全新的面貌在你面前展開。唐望故事對於藝術家陳慧嶠來說有特殊的意義，這一點，既表現在她的思想上，也反映在她的作品裡。當企圖瞭解或描繪有關這位藝術家的一切時，顯得有些荒謬的是，我還是得從敘述一個個人歷史的方式開始說起……

懵懂之際

台灣從事當代藝術領域工作的人，不認識陳慧嶠的大概不多，這除了她藝術家的身份之外，更重要的或許是作為伊通公園「負責人」的角色。認識她的人多半都叫她「嶠」。

因應著我採訪的需求，嶠用很短的時間為我回顧了她的個人歷史，很令人驚異的是，即便是時空久遠的往事，她經常還能描述到十分細節的部分，這或許與她一向有寫日記的習慣有關。

嶠是阿嬤帶大的小孩，入學的時候只會講台語，老師說的話她都聽不懂，所以她什麼都不會，只喜歡畫畫。小學、國中，她都主動要求媽媽讓她學畫畫，高中則進入祐德中學美術實驗班。一路上來，老師都覺得她畫的好，高中畢業那年，正好是國立藝術學院（現台北藝術大學）第一屆招生，老師自作主張幫她報了名，但嶠並沒有去考，雖然她對自己的術科還算有信心，但一個連考高中都得靠猜題的人，要通過大學學科考試簡直是天方夜譚，她跟老師說：「你不要作夢了。」

離開校園之後，嶠的第一份工作是在宏廣動畫公司的著色部門，一待就是兩年多，最後決定離開是因為覺得自己像一具行屍走肉，也看不到未來。後來她在幼稚園教過美術，也在花店上過班，多數的工作期間都不超過三個月。這段時間的她，經驗著青春期的苦悶，懵懵懂懂地膠著於夢想與現實之間。

1986年2月28日是個特別的日子。當時嶠又掙扎著是否要辭掉工作，那一天她和朋友去逛春之畫廊，看到一群人圍著張永村在問問題，身上帶著自己插畫的嶠，忖度著是否也可以拿作品給這個「藝術家」看看，猶豫良久，進出了畫廊三次，終於鼓起勇氣走上前去。沒想到張永村看了，竟轉身招呼其他藝術家也過來看，當時在場的有林壽宇、莊普、賴純純等，結果只有莊普有反應，他問道：「你的作品可以收藏嗎？」這個經驗實在令人驚喜，雖然此時的嶠對「藝術」或「藝術家」究竟是什麼毫無概念，但因受到鼓勵所產生的自信，似乎令眼前的可能性更明晰了一些。一直到很後來，嶠才發現，莊普之所以想要買那件作品，是因為想要「把」她身

旁的女性朋友，那張畫裡的主角正是那位漂亮女孩。嶠大笑著講起這件往事，就算是個美麗的誤會吧，這卻正是她踏上藝術之路的開端。

從那次經驗開始，嶠與莊普建立了亦師亦友的情誼，回應嶠對學習的渴慕，莊普建議嶠到SOCA [2]去上課。SOCA當時集結了一批觀念新穎的藝術家，包括賴純純、莊普、盧明德等人都在那裡授課，同時也經常舉辦座談會，介紹一些前衛的藝術觀念與形式，包括空間、媒體、錄影、裝置等等都是經常討論的內容，對於當時以繪畫為主流的台灣藝壇，頗具挑戰／挑釁的姿態。

在SOCA上課期間，嶠像塊海綿般拼命吸收這些陌生的知識，同時也在課堂上結交了許多朋友，當時一起跟著上莊普的課的還有劉慶堂、黃文浩等人，在嶠的敘述中每每以「我們這一班」來代表。他們共同學習，也集體創作，對藝術的熱情高漲到即便SOCA已經結束經營後，仍維持著定期聚會的習慣。

當時幾個人經常流浪在東區的幾家咖啡廳，一面聊創作，一面觀察時下最流行的空間，嶠說：「我們那時候每一個人對藝術的情操是蠻強烈的喔，只是很抽象，在那個年紀，對藝術充滿了嚮往，你不懂它，但它對你是聖光，你覺得距離它很遙遠，卻有一個很崇高的理想在那邊，也是因為這樣大家才聚在一起。當然裡面也有一些戀情在發展，也是這樣才能扣在一起那麼久。」基於這個背景，使得這群人可以激烈辯論到吵架的地步，卻還堅持著對話，也因為揉合了理想與情感這兩項要素，使得這個小團體的維繫得以超越現實的考驗。

後來因為從事攝影工作的劉慶堂要找工作室，他們也就跟著一起找空間，最後落腳在伊通街一棟三層樓的建築，於是在1988年9月，「我們這一班」終於過渡到了一個安定的所在——「伊通公園」。

與伊通公園並行的創作發展

曾經有許多人在不同的時空裡，描述或定義過伊通公園——一個空間、一個場所，一個流動的藝術團體

……，其中我覺得湯皇珍的敘述頗為貼切：「在我的觀察裡，這個『圈子』或大或小，可大可小，無可名狀，有人是坐陣打卡一年到頭在那兒（如劉慶堂、陳慧嶠），有人是勤於走動，有人是定時出現，有人是偶而突襲，但是彷彿『伊通公園』總是安著一枚磁石，很自然就有一些人便禁不住地聚集過來。」[3]伊通公園的確是個「圈子」，這個圈子以固定的空間、終年坐陣的劉慶堂與嶠，以及勤於走動的一群（流動的）人口，維持著這個圈子的磁性，吸引著同時也拒斥著他們的藝術同行，以型塑一個若隱若現的「伊通」風格。這個圈子裡的個別成員也藉由其行動，包括勤於走動、對話、創作……，回應或保障被含納在這個圈子裡的權利。嶠是這股磁性的核心之一，而她也受到自身以外的磁性所深深牽引。

在SOCA的那段期間，嶠的學習不外乎材質、色彩、空間的訓練，到了伊通公園開始營運以後，也就嘗試用現成物玩一些可能。在這些實驗中，她很喜歡的一件，用的是一個作紙的西班牙人不要的廢木框，當時大家正在進行空間的訓練，試圖將平面上的空間思索，發展到實際的環境中，她把這個呈銳角三角形的廢木框釘在牆角，一個小空間就出現了。當時能想到這樣做她還挺得意的，沒想到有一個傢伙看到了，邊說著：「如果這樣呢？」同時把橫在底部的一根木條，推移到牆角，小空間瞬間多了一個層次，這個人就是魯宏。那個動作讓嶠楞在當下很久，雖然頗覺自尊受損，但她還是承認人家比她更聰明。嶠覺得跟這群人在一起最爽的就是，討論事情的時候，他們經常可以超出她的經驗、想法與能力，當她願意欣然接受時，這些都成為她的養分。

1989年，嶠如願去了法國遊歷，在當地遇到聖誕節，她應景地利用線作了一張卡片，打開時，線會在平面上創造出一個小空間，結果那小東西有很多人想買。既然用了線，嶠隨後想到應該要穿針，既可利用它來貫穿線，同時也可作為支撐空間的工

未來是一點點水在你的眼裡 Future is a Drop of Water in Your Eyes　1997

具。關於材料的選擇與應用方式，經常就是這樣接連發展出來，後來幾乎成為嶠的標誌之一的「插針的玫瑰」，也是在類似的背景下產生。乾燥的玫瑰、針都是身邊的材料，嶠於是考慮著，花很美麗，但似乎還應該再多一點什麼，玫瑰原本帶刺，那麼把刺刺在花上似乎更直接一些，便拿起大頭針插在玫瑰花上，插了一朵，覺得挺好看的，便一路插下去。後來這個形式單元反覆出現在她的作品中，或成為小小的立體雕塑，或裱褙在壓克力與不踑鋼畫框裡，或散落在大型玻璃桌面與木質地板上，形成一件空間裝置。在材質延展的過程中，她同時也進行著作品狀態的延展。

泅泳於材質之間

認識了莊普這群人後，嶠很自然地就不再畫畫了。回應著這群頭角崢嶸的藝術家們所提倡的嶄新觀念，嶠在似懂非懂的情境下開始學習應用各種材料。人們在繪畫裡，看到的經常是一個模仿的世界，例如藉由顏料模仿各種材質，或在平面上企圖模仿空間，而其成就的評估則常在於與逼真的程度。那麼，如果想要畫一朵玫瑰，何不直接展示一朵真實的玫瑰？如果想要畫一個空間，何不直接製作一個真實的空間？當材質以其原本的面貌或內涵而被採用，當再現的形式不再僅限於平面，創作的自由度與可能性顯然大大提升了。

在歷數自己創作發展的過程中，可以發現，嶠談論最多的是材質的問題，從材質的選擇、材質的組合，以至材質的接合等等，顯然在她的作品裡，材質不再僅僅是一項媒介或工具，它們本身就是一項重要的內容。此外，它們的遇合，所試圖再現的並非真實世界的任何片段，而是一種性靈的狀態或嚮往，它既不屬於現實，也不屬於非現實，或許更接近於一個「夢境」，在這神秘領域的探測過程裡，較少理性上的揀選，更多的是直觀與經驗的相互證成。

在嶠的作品中，常見的針與線原本是被固定在紙漿上，漸漸地，她開始覺得紙的感覺不太對，於是想找一個更協調的材質，後來就換了棉花。在作品〈默照〉中，她企圖表現隱藏的針，當針往內插在棉花裡時，不細看幾乎無法察覺，僅藉由針頭的金點給出暗示，棉花上方纏繞著細密的銀蔥線，其纖維的質感與其他材質有所呼應，最後則藉由針頭與銀蔥線對光線的反射達到最後的統合。在這裡她極力追求的是一種協調的視覺意象，卻讓那頻密的刺痛感發作在觀者的意識之間。

1997年，嶠覺得用針已經用的差不多了，思索著有什麼另外的可能，遂試圖操作一種用針來複製針的概念，她用電繡在軟絨布上繡出一根一根細針，之後再把它裱成平面作品（〈未來是一點點水在你的眼裡〉、〈雨追著雨下著雨〉、〈跌落的聲音〉三連作）。整組作品使用的都是線，但在視覺上看到的卻

睡吧！我的愛　Then Sleep, My Love...　1998

睡吧！我的愛（局部）　Then Sleep, My Love...（detail）

是針，而這些形象上的針卻又是由真實的針所製作出來的，來來回回，頗有一種在視覺與意識之間反覆辯證的趣味。

後來，嶠又找到了一種人造的短纖維絨布取代了棉花，而這一路下來的實驗，最令人印象深刻的一件大概是1998年的〈睡吧！我的愛〉，在一張形式簡單的雙人床上，覆蓋著潔白柔軟的枕頭與被單，呈現出一種令人忍不住想立即倒臥在上面的那種舒適感，趨前卻發現絨布裡密密地埋藏著尖銳的細針……

1995年，嶠推出自己第一個個展「脫離真實」，地點當然在伊通公園。在這次的展覽中，她大量使用了不銹鋼、玻璃、壓克力，並且第一次嘗試用水。那次的經驗是一場硬仗，因為沒有自己的工作室，所以多件作品都預備在展場直接組裝，再加上不同的材料分屬不同廠商提供，因此包括各項局部的尺寸以及組裝的程序等等，都需要事前精密的計算與規劃。最終，當我們在空間裡感受到的是一個極其光潔平整的極簡氛圍，隱而未現的卻是無可計數的計畫與繁複瑣碎的工序。

第一次個展還帶著一些緊張，到第二次個展的時候，嶠顯然心臟強壯了許多。第一次個展花了三十幾萬，1997年個展「懷疑者的微笑」，整個成本拉高到九十幾萬。展出作品中的幾座大型玻璃缸，不僅在製作上十分昂貴，在裝置上也涉及組合、承重、配電等等複雜的技術問題，直到展覽開幕前一天晚上，嶠還自己拿著美工刀一刀一刀刮除填補縫隙的矽膠突出物。以一個沒有太多實質收入的藝術家而言，她在這些作品的實驗上，一方面要承擔作品是否能如預期般完美的實現，另一方面也要承擔不斷堆高的成本如何吸收的問題。不過僅僅為了滿足自己究竟能做到什麼程度的慾望，她敢於承擔這樣的風險。

在嶠的創作過程中，總要經歷密集的腦力與勞力耗損，我想，那絕對稱不上有趣的不厭其煩，對她而言顯然是達到那些如夢境般的呈現的必要儀式。

知識的煉金術

從嶠每每為展覽或作品所寫的文字，可以看出她追

求一種密度很高的思索狀態，多數圍繞在關於生命、藝術、真理等命題，以及如何洞悉或觸及它們的各種行動，彷彿只是因為碰巧是個藝術家罷了，於是她用作品來記錄相關的過程與成果。

從國中開始，嶠就對神秘主義一類的事物充滿興趣，包括夢境、星座、神話故事等等，但當時她對這些材料之間的共通性渾然未覺。一直到進入青春期，開始談戀愛了，因為遭遇到與對象缺乏共同語言的問題，促使她開始進行大量的閱讀，從存在主義的小說、心理學、禪宗、哲學、星座……，一路追蹤下去。後來認識了魯宓，他翻譯了一系列的唐望故事，每一本嶠都把它看完了。小時候的嶠很不喜歡讀書，因為不知道學習那些內容有什麼用處，等到她真正需要的時候，再去讀這些東西，理解的狀況便截然不同了，伴隨著她的成長與歷練，這些知識扎扎實實地埋入了她的心智，同時也勾引出永無止盡的好奇與追索。

回想當年沒有嘗試念大學這條路，嶠一方面覺得或許也好，可以免除學院訓練的包袱，但另一方面，在與眾多高學歷的同儕相處之際，她不是沒有過自卑的情緒，而這項負面的感受，在大量的閱讀經驗之後，獲得了相當的彌補。長時間的累積過後，她不敢說自己真的懂了什麼，但確切有了更多的自信，也越來越能接受自己；此後任何的匱乏都不再是一種阻礙，而只不過是一個猶待彌補的部分。

在卡斯塔尼達的著作中，巫士唐望不只一次提到所謂的「八個點」：「我們可以說，每個人都與生俱來八個點。其中兩個，理性及言語，是所有人都熟悉的。感覺總是模糊而似曾相識。但只有在巫士的世界中，一個人才能充分認識作夢、看見與意願。最後在巫士世界的邊緣，他會遇到最後兩個點。這八個點造成他的完整自我。」[4]

$$\nearrow \text{feeling} \searrow \qquad \nearrow \text{Tonal}$$

$$\text{reason} \rightarrow \text{talking} \rightarrow \text{dreaming} \rightarrow \text{will}$$

$$\searrow \text{seeing} \nearrow \qquad \searrow \text{Nagual}[5]$$

嶠曾經在1997年個展「懷疑者的微笑」及2006年個展「此時此刻」中，分別製作過以這八個點為基礎的作品，其中細微的變化，就是她不同時期領會的映照。相隔十年，再度與這觀念性的圖式重逢，顯示出嶠在其知識煉金旅程中的反芻經驗，在廣泛駁雜的涉獵過後，她頗有一種原來不過如此的豁然開朗。

訪談的過程中，嶠顯然很難把這些經驗化成簡單的語言讓我領會，而我在唐望故事系列極其片段的閱讀中，可以看到的是其要求從抹除個人的歷史開始，不斷努力發掘感覺、作夢與看見等直觀世界的內涵與力量，而這些在理性世界中經常被壓抑或貶抑的領域，正是引領我們走向未知世界的通道。就像我們經常不以為意的「作夢」，在巫士的修煉過程中，便是一項力量的來源。嶠說：「我每天都作夢。」

那天，她夢見她抓到了雲

每個人一定都有作夢的經驗，但大概很少人會很篤定地說自己每天都會作夢，嶠習慣在日記裡紀錄夢境，所以她對自己的作夢以及夢這件事情，有著高度的關注與自覺。當認知到自己的生命經驗裡，每天都要被夢打擾，累積下來有很長的時間是活在另一個世界裡面，這一點讓嶠很難不去追究它的道理。她不太相信佛洛伊德的那套分析，幾乎所有的結果都落到與性有關的解釋，事實上，從嶠對佛洛伊德的星座的研究，發現他正具有做出那套分析的傾向。

最終，嶠有一套自己的解釋，在這裡她相信某種輪迴之說，或許是一個過去世的你自己，在夢裡不斷給出暗示，喚醒你的記憶，提示你在這一世還有些什麼未完成的功課。在清醒的時刻有理想上的夢想，在入睡的時刻有實際的夢境，嶠的生命軸線大多落在這兩條交纏的路徑之上，而她渴望在這一鍋濃稠的物質裡攪出一個清明的狀態，這也是在她作品裡不斷呈現出的一種精神想望。

嶠曾經三度作了類似的夢，在夢中她抓到了雲。前

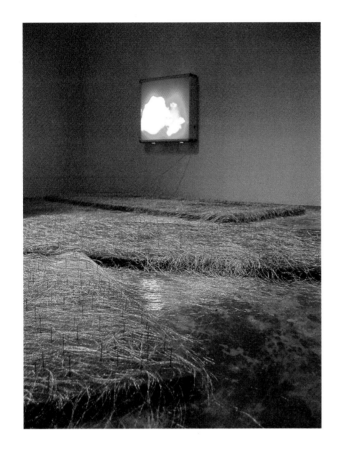

那天，我抓到了雲！ That Day, I Held Clouds in My Hands！ 2002

兩次，雲到了手裡，變成像是絲綢般的東西，最近的一次，則變成一團白色、有彈性，像霜一般的物質。這與自己作品的樣態極其接近的三次經驗，讓她懷疑自己是否有自戀狂。對此，好友劉慶堂給出了一套解釋，他認爲雲是自由的象徵，抓取的動作則是權力的展現，因此這個夢境反映的是嶠內心對自由的渴望，後來嶠在自己的命盤裡的確也看到類似的傾向。不過，這一切顯然沒有所謂的正確答案。

雲的意象經常出現在嶠的作品裡，如1995年的〈作夢與作夢者〉，她用燈箱將藍天白雲的影像鑲嵌在不踤鋼立方柱體的表面上，到了1997年的〈在我之中在我之外在空間的空間裡〉，那藍天白雲則被壓在幾個量體驚人的玻璃缸底部，缸裡灌滿了清水，澄淨的像是幾個大冰塊，觀者或覺得那雲伸手可及，但一行動隨即發現並非如此。1998年的〈別把夢吵醒，也別把夢踩醒〉，雲的意象終於脫出了平面，也

脫出了影像，眞眞實實地充塞在空間裡，散落在白色棉花中的白色乒乓球，則暗喻了宇宙的想像。2002年，顯然肇因於那個打擾了她數次的夢境，嶠作了一件〈那天，我抓到了雲〉，如同夢境中的經驗，那雲如銀絲般流淌在一根根豎立的細針之間。

無論從嶠的夢境或是從她的作品上，我都覺得那雲或許更像是生命裡最終極的一個秘密，她渴望揭開最後的謎底，卻只能在夢裡獲得實現，然而，夢境卻也給出一種希望，讓這個永恆的追求獲得延續的力量。

此時此刻

2006年，嶠獲邀在台北當代藝術館推出個展，最初她覺得腦子一片空白，不知道要作些什麼，當時只覺得很喜歡「此時此刻」這個字眼，於是就從這個後來作爲展覽名稱的詞語開始，一點一滴地把心裡的東西召喚出來。

在這個展覽裡，嶠回溯了自己對於星座興趣的起源。小時候，她記得曾在某一個夜晚裡她對阿嬤說，星星掉下來了，她想要去抓星星，阿嬤說那是火金姑，她還想那明明是星星，並考慮著它們既然會發亮那一定是燙的，就用扇子去撲，結果只留下那是否真是星星的一片狐疑，卻還不願意打破那個浪漫的想像。一直到長大以後，才知道那真的就只是螢火蟲罷了。可以抓到星星的夢碎了，但這一路下來，她卻從未放棄用各種方式去攫取那些難以掌握的對象。在個展「此時此刻」中，嶠即用作品〈銀塵〉再現了那個童年記憶裡最純淨的星空。

嶠說這是她最放鬆的一次展覽，過去作品多少有一種要與人對話或挑戰的味道，但這一次她只想作她自己，作她想要表達的情境。過往曾經在她作品裡出現過的許多元素，都回來了，卻不再被侷限在於任何框限或疆界之中，嶠想讓她的意識與作品徹底地溢出理性範圍之外，她很高興自己終於可以這樣百無禁忌地去實踐一個只為了美麗的展覽。

在作品〈古老的感覺〉中，可以看到她在地板上種滿了大型的薊花，這來自嶠2005年前往格蘭菲迪（Glenfiddich）酒廠駐村時的經驗。當時她在蘇格蘭滿街都看到那種花，整株都長滿了刺，令人難以親近，但花朵的部分卻十分柔和，到了繁衍的時節，便會如棉絮般隨風飄散。嶠覺得這花似乎比玫瑰更加吻合自己，它天生已經渾身是刺，因為隨處可見，所以一點也不嬌貴，本身兼具了韌性與柔美兩種極端的特質，在在契合嶠所喜愛的一些質性。在蘇格蘭展出時，她便以印有薊花圖案的布做為創作材料，也才意外的發現它原來是蘇格蘭的國花。對嶠而言，蘇格蘭之行，從預期語言不通而不願前往，到處處發現一種似曾相識的熟悉感，以及能夠不藉由語言與人達到心有靈犀的溝通，那種不能解釋的狀態讓她印證了宿命的存在。嶠說，那個感覺很好。

嶠曾在作品中援引唐望所指出的八個點，但在她所演繹的圖示中，中心點卻總是落在「愛」與「夢」，對她而言，愛與夢既是名詞也是動詞，是需要用不斷的行動去企及的一種狀態。在「此時此刻」之中，嶠盡情釋放她的直觀與感性，卻用一個理性的載具來述說這個內在的回憶，當這兩個平行的世界終於在她的作品裡重逢時，似乎也預告了另一個旅程的伊始。　∋∈

只有對這輝煌生靈的熱愛，才能給予戰士精神的自由。而自由便是快樂，便是效率，便是在面臨絕境時的灑脫自在。這是最後的一課，總是留在最終的時刻，最孤寂的時刻。當一個人面對他的死亡與孤獨時，只有在這個時刻，這一課才有意義。　—唐望[6]

（本文原刊於2007年10月，《現代美術》第134期）

註釋

1. 卡羅斯·卡斯塔尼達（Carlos Castaneda）《力量的傳奇》（Tales of Power），魯宓譯，台北：方智出版社，p.354。
2. SOCA現代藝術工作室，由賴純純於1986年所創辦。
3. 湯皇珍〈伊通的形成1991-1992　不是公園的「伊通公園」〉，http://etat.com/itpark/gallery/index-itpark.htm
4. 同註1，p.124。
5. 〈回顧八個點的圖〉，未發表，p.2。
6. 同註1，p.354。

古老的感覺 Ancient Feeling 2006
內在的回憶與銀塵 The Inside Memory and the Silver Dust 2006

The Day She Caught the Clouds

The Creative Art and Life Journey of Chen Hui-chiao

Chin Ya-chun

"Men for whom an entire life was like one Sunday afternoon, an afternoon which was not altogether miserable, but rather hot and dull and uncomfortable. They sweated and fussed a great deal. They didn't know where to go, or what to do. That afternoon left them only with the memory of petty annoyances and tedium, and then suddenly it was over; it was already night" — Don Juan[1]

In 1961, anthropologist Carlos Castaneda came to know an Indian mystic called Don Juan as part of his research work. In the ten years he followed Don Juan, Castaneda experienced many completely new things. Don Juan taught him how to be a hunter, a warrior and even ways to become a sorcerer. However, learning all these things required that he started by "eliminating his own history", because as soon as we overturn the descriptive methods we learned to be normal, then the world naturally presents itself as something completely new and different before our eyes. The story of Don Juan has a special relevance to artist Chen Hui-chiao, a fact that can be seen in her thinking and is reflected in her work. Whenever we attempt to understand or depict something to do with the artist, what is perhaps most ridiculous is that we must first start by describing her own personal history.

A Time of Innocence

Pretty much everyone involved in the field of contemporary art in Taiwan knows Chen Hui-chiao. This is partly to do with her identity as an artist, but even more importantly her role as the individual in charge of "IT Park." Many of the people who know Chen just call her "Chiao."

In accordance with the request I made as part of the interview, Chiao briefly recapped her personal history for me. What was really surprising was her ability to describe in great detail things that happened a long time ago, which is perhaps connected to the habit of writing a diary.

Chiao was brought up by her grandmother and was only able to speak Taiwanese, which meant she couldn't understand a word the teacher said when she first went to school, which meant she couldn't do anything expect paint which was her favorite subject. At both elementary and junior high schools, she actively asked her mother to let her study painting. At senior high school she joined an experimental art class at Yuteh High School. From the very beginning Chen's teachers were impressed with her paintings, and the same year she graduated from senior high school was the first year students were enrolled at the Taiwan Academy of Arts (today's Taipei National University of the Arts). Chen's teacher decided to help her enroll but she never took the entrance examination, because despite her confidence in her art work, for someone who had only managed to get into senior high school by guessing the answers, the idea that she might gain admission to university by examination was just too unbelievable. She told her teacher: "You must be dreaming."

After leaving school, Chen's first job was in the Coloring Department at Wang Film Productions, where she stayed over two years. She only finally decided to leave after coming to think of herself as an automaton and being unable to envisage the future. She went on to teach art in a kindergarten and also worked in a flower shop, but many of the jobs she did lasted no

longer than three months. During this time Chen Hui-chiao experienced many of the ups and downs of youth, and found herself somehow caught between her dreams and reality.

February 28, 1986, was a very special day in the life of Chen Hui-chiao. On that day she was struggling with whether to quit her job when she and a friend went to visit "Spring Art Gallery". Whilst there they noticed a group of people standing around Chang Yung-tsun and asking questions. Chen just happened to have some of her own illustrations with her and was wondering whether she should ask this "artist" for his opinion. After trying to make her mind up for what seemed like a long time and even leaving the gallery three times, she finally plucked up the courage and walked up to him. Unexpectedly, after looking at her pieces Chang Yung-tsun turned around and called some of his artist friends over to take a look, including Lin Shou-yu, Tsong Pu, Lai Tsun-tsun etc. The only one who responded was Tsong Pu who asked: "Are your works available for collection?" This experience was a pleasant surprise for Chen Hui-chiao, and although at that time

she had little, if any, idea about what constituted "art" or "an artist," the self confidence such encouragement gave her seemed to make the possibilities in front of her a little clearer. Only later did she discover that the reason Tsong Pu wanted to buy her work was that he was interested in the female friend she was with, who also just happened to be the central figure in the painting in question. Chen Hui-chiao always finds the telling of this particular story especially amusing and even thought it was an exquisite misunderstanding. It also marked the first step she took on the road to becoming a real artist.

Beginning with that experience, Tsong Pu became both a teacher and a friend to Chen Hui-chiao. Knowing of her thirst for knowledge and passion for learning, Tsong suggested that Chiao take classes at SOCA [2]. At that time, SOCA was a meeting place for artists with new ideas, and classes were given by individuals such as Lai Tsun-tsun, Tsong Pu, Lu Ming-te etc. At the same time, regular seminars were held introducing certain avant-garde artistic ideas and forms including regular talks on spatial, media, video and installation art etc.

空中的火焰（三連作）　Fire in the Air （3 pieces）　1997

For a contemporary art community focused on painting such as that that existed in Taiwan at that time, such discussions were both challenging and inspirational.

During her time attending classes at SOCA, Chen Hui-chiao was like a sponge, absorbing all the unfamiliar learning she came into contact with. She also made friends with many of the other classmates. Students who attended Tsong Pu's classes at the same time included Liu Ching-tang, Huang Wen-hao etc. When discussing the experience Chiao often talks of "our class" – they learned and produced art together. Indeed, their passion for art was so great that even after SOCA closed they still continued to meet regularly.

At that time several people wandered the cafes of eastern Taipei, talking about art but also observing the latest and most fashionable hangouts. Chen Hui-chiao recalls: "Every one of us had strong feelings about art those days, but they were very abstract. At that age we were full of yearning about art. We didn't understand it but it was still a light leading the way forward. It felt very distant but lofty and sublime, and it was that which brought us all together. Of course lover

relationships were developing as part of this process, which was why we were together so long." On the basis of this background, this group of people would debate passionately to the point of argument and yet keep talking, exactly because their relationships were a mixture of idealism and passion, making them a group that stood the test of real life.

Later, Liu Ching-tang was looking for a studio for his photography work and everyone else helped out searching for the right space, finally finding a three-story building on Yitung Street. In September , "our class" finally found its own place "IT Park."

Creative Developments That Parallel IT Park

Many people have at different times sought to depict or define IT Park as a space, a venue, or a fluid artistic group etc. I would say that the words of Tang Huang-chen have proven to be nearest to the mark: *"To my mind, this "group" can be large or small, describable or indescribable. Some of us were there all year round (such as Liu Ching-tang and Chen Hui-chiao), others were more on the move, some appeared regularly and others on occasion. But in any case,*

"IT Park" always proved itself to be a magnet to which some people felt themselves naturally drawn." [3] IT Park certainly was "a group" – one that had a fixed space, two full time gatekeepers – Liu Ching-tang and Chen Hui-chiao – and a more mobile population, the combination of which maintained the magnetic appeal of the group, that attracts but also repels fellow artists, to craft an almost indiscernible yet distinctive "IT" style. The individual members of this group also utilized its actions, including mobility, dialogue and creativity, as an echo or way of protecting the rights that came with membership of the group. Chen Hui-chiao is one of the central members of "IT Park"; its magnetism and she have been guided by a force that exists external to her own being.

During her time at SOCA, Chen learned about materials, color and space. After IT Park Gallery was up and running, she played with finished items as well as the possibilities they represented. As part of these experiments, one of her favorites was one in which she used a wooden frame disposed of by a Spanish person who makes paper. At the time everyone was practicing using space, attempting to develop graphic spatial and thinking into the real environment, Chen Hui-chiao nailed this sharp cornered triangular wooden frame into the corner of the wall, creating a small space right there. She was pretty pleased with herself for having thought of that, until someone else said "How about this?" taking a piece of wood from the bottom of the frame and pushing it into the corner, immediately

在我之中在我之外在空間的空間裡 Within Me, Without Me in Space, Within Space 1997

adding a new layer to the small space – That was Lu Mi. That one act froze Chen in one spot for a long time, and despite feeling somewhat insulted she still had to accept that this was an even smarter idea. Chiao maintains that the best thing about being with such a group of people is that whenever discussing things, ideas are thrown around that go beyond her own experience, imagination and capabilities. Whenever she was open to such ideas they proved vital sustenance to her own creative development.

In 1989, Chen Hui-chiao fulfilled her ambition to visit France and spent Christmas there. Especially for that occasion she made a card out of thread which, when opened, created a small space of a two dimensional surface. This proved so popular that pretty soon people were asking where they could buy it. Having already used thread it occurred to Chiao that she could also make use of needles to direct the thread more precisely but also as a tool to support the space. Indeed, decisions as to the selection and application of materials often developed in this way, and the "Pin Rose" that has since almost become synonymous with Chen Hui-chiao actually came from a similar series of eventualities. Dry roses and needles were always close at hand. Chen Hui-chiao considered that although the flowers themselves were beautiful, they seemed to lack something. Roses naturally have thorns and having the thorns in the petals seemed a little more direct, so Chen took a pin and stuck it in the rose. After finishing one she decided that it looked so beautiful she just kept going. Since that time this formalistic unit has repeatedly appeared in her works, sometimes as a small three dimensional sculpture in its own right, mounted in an acrylic and stainless steel picture frame or spread over the surface of a large glass table and wooden floor, to form a spatial installation. Whilst exploring and expanding the use of materials, Chen Hui-chiao also extended the state of her works.

Searching for the Right Materials

After getting to know Tsong Pu and the other artists, Chen Hui-chiao naturally stopped painting. In response to the debates between these artists and the brand new concepts over which they argued and sought to promote, although Chiao sometimes had only the slightest of understandings, she began to learn more about material applications. In painting, what people most often see are images of a replicated world, such as the use of colors to copy the effect of certain materials, or attempts to recreate space in two dimensions, with an evaluation of the artist's achievement often determined by how realistic a work appears. But if one wants to paint a rose then why not directly display a real rose? If one wants to paint space then why not directly create a real space? When the original form or meaning of a material is used, when the re-presented form is no longer restricted to two dimensions, creative freedom and possibilities are greatly enhanced.

If we look at the development of Chen Hui-chiao's own distinctive style, then what is noticeable is the way in which she often discusses issues relating to materials, whether the selection, combination or mixed use of materials etc. Clearly in Chen's work materials are no longer just a medium or tool, but rather an important content in their own right. In addition, what their chance meeting is meant to re-present is not any segment of the real world, but rather an emotional state or need. Such pieces are neither real nor unreal, which perhaps makes them closer to a "dream state." As one explores this magical arena, there are relatively few rational choices to be made and rather more interlocking direct views and experiences.

In Chen Hui- chiao's art, the frequent appearance of needles and thread was originally fixed in pulp. Gradually, she started to feel that the feel created by paper was not exactly what she was looking for, so she started searching for a better suited material and later changed to cotton. In the piece "Silent Light", Chen attempts to express hidden needles, so that when the needle is inserted into the cotton it is almost impossible to detect without looking very carefully. She uses the golden point of a syringe needle as an allusion, with fine silver thread wrapped around the upper part of the cotton, the texture of the fiber corresponding to the other materials. Finally, Chen uses the way a syringe needle and the silver thread refracts light to achieve the ultimate combination of elements.

At this juncture she actively seeks a more coordinated visual images, but also allows the concentrated sense of pain to take hold in the consciousness of viewers.

By 1997, Chen decided that she had pretty much done everything that could be done with needles, so she began to consider different possibilities, including an attempt to replicate needles using needles. First she took an electric embroidery machine and embroidered needles into a piece of soft cotton flannel, which was then mounted as a two dimensional work the three pieces "Future is a Drop of Water in Your Eyes" "Raining, Chasing Rain, Falling Rain" and "Sound Falling." The entire work uses thread; but visually speaking, what a viewer sees are needles, and these image needles are made from real needles. Looking back and forth, the work is infused with a sense of repeated dialectic between visual appearance and meaning.

Later, Chen Hui-chiao discovered a short manmade fiber flannelette to replace the cotton variety. The most striking piece to come from this experiment to date has probably been "Then Sleep, My Love…" (1988). In this piece, a formalistically simple double bed is covered with a pure white soft pillow case and duvet cover, creating such an enticing sense of comfort that visitors are almost compelled to lie down and experience it for themselves. It is only when they take a step forwards that it becomes clear that the flannelette is filled with sharp needles.

In 1995, Chen held her first solo exhibition "A Separate Reality", naturally enough at IT Park. In this exhibition, Chen made major use of stainless steel, glass, acrylic, and for the first time also experimented with water. That experience was difficult because at that time she did not have her own workshop, so many of the pieces were actually prepared and assembled in the display area. Added to this is the fact that different materials were provided by different plants, including various partial dimensions and assembly processes, which required precise calculations and planning. Ultimately, the space created an extremely simple atmosphere of cleanliness and order, although what remained hidden were the countless plans and complex processes that underpinned the exhibition.

Chen's first solo exhibition came with a lot of excitement and tension, but by the second time she was a lot more relaxed and much stronger. The first solo exhibition cost over NT$300,000 to organize, whereas the 1997 solo exhibition "Smiles of the Skeptic" cost as more than NT$900,000. Several large glass urns amongst the display items were not only extremely expensive to make, but when it came to installation also involved complex technical problems relating to assembly, weight, power supply etc. Indeed, even the night before the exhibition opened, Chen Hui-chiao was still to be found wielding her own craft knife and making the final arrangements. For an artist with not much of an income to speak of, the burden resulting from her experimentation with these works was doubled, as she had to not only realize her original vision of perfection, but also deal with the problem of the ever expanding costs. Despite this, Chen was determined to find out the extent to which she could express her passions just to satisfy herself, and that gave her the necessary courage to take on the related risks.

The creative process of Chen Hui-chiao involved a great deal of focused brainpower and labor, a bothersome pastime that I cannot imagine is any fun at all. This process is clearly an absolutely essential ritual for the artist in the creation of her dreamlike pieces.

The Alchemy of Knowledge

From Chen Hui-Chiao's writing about her exhibitions and work, it is immediately clear that her art involves a degree of intense reflection, much of which revolves around issues such as life, art and truth. They also relate to a variety of activities on how to better understand or come into contact with these ideas, almost as if she was an artist by accident, and it is because of this that she uses her art to record related processes and results.

Beginning at junior high school, Chen Hui-chiao has been fascinated by all things associated with mysticism, including dreamscapes, astrology, mythological stories etc, but at the time she never recognized the common nature of these materials. It was not until later youth when she fell in love that finding herself and her partner spoke different languages, Chen started to read more, from

existentialist novels to psychology, Zen Buddhism, philosophy, astrology etc. She later met Lu Mi and he translated a series of stories about Don Juan that Chen greedily devoured. As a child, Chen had not liked reading books because she could not see the relevance of the book contents to her life. However, it was a whole different story when she did read something only because she needed to. This approach accompanied her as she grew, the things she learned firmly implanted in her heart, but also simultaneously mapping the bounds of a boundless curiosity and desire to explore.

Looking back upon her decision not to study at university, Chen Hui-chiao feels that the decision has its pros and cons. On the one hand, it was a right thing to do because it frees her from the baggage that would unavoidably come with academic study. On the other hand, it has often left her feeling inferior and insecure, particularly when she socializes with her highly educated colleagues. Fortunately, after immersing herself in books, those sorts of negative feelings are greatly diminished. After long term accumulation of experience, Chen Hui-chiao would still not venture to say that she has any great understanding of things, but she certainly has more self-confidence, and is increasingly able to accept herself for who she is. In future, a sense of lacking will never again be an obstacle, just something waiting to be researched and understood.

In the writings of Carlos Castaneda, warrior Don Juan mentions the "Eight Points" more than once: "*We can say that everyone possesses eight points from birth; two of these, reason and language, we are all familiar with. Feeling on the other hand is always unclear yet seemingly familiar. However, it is only in the world of the sorcerer that one can truly understand dreaming, seeing and will. Finally, on the periphery of the sorcerer's world he encounters the final two points. These eight points constitute his complete self.*" [4]

$$\nearrow \text{feeling} \searrow \qquad \nearrow \text{Tonal}$$
reason \rightarrow talking \rightarrow dreaming \rightarrow **will**
$$\searrow \text{seeing} \nearrow \qquad \searrow \text{Nagual}^{[5]}$$

In her 1997 solo exhibition "Smiles of the Skeptic" and 2006 solo exhibition "Here and Now," Chen Hui-chiao produced works based on these eight points. The minute changes the artist makes are a reflection of her different understanding at different periods in her life. A new encounter with these conceptual annotations a decade later highlights the artist's reflective experience as part of her journey into the alchemy of knowledge. The broad and heterogeneous subjects touched on during this journey have made Chen a much more open-minded person that she was.

During my interview with her, Chen Hui-chiao clearly found it difficult to put these experiences into simple language in a way that I could understand. What I found from reading sections of the Don Juan stories was that we are demanded to start our exploration by eliminating our personal history in order to work constantly to uncover feelings, dreaming, seeing and other contents and strength from the intuitive world. Moreover, realms that are often suppressed or devalued in the rational world are vehicles leading us into an unknown world. Just as we often absentmindedly "dream", whereas in the training of the sorcerer this is a source of power. Chen says: "I dream every day."

On That Day, She Dreamed She Held the Clouds in Her Hands

Everyone has dreams but very few of us would say with such absolute certainty that we dream every day. Chen Hui-chiao is in the habit of recording her dreams in a diary, which is to say she is particularly interested and self-aware of her own dreams and dreaming itself. On coming to realize that her own life experiences were being interrupted by dreams each day and that when added up she was spending a very great deal of time in a completely different world, Chen found it impossible to not look into the subject in more depth. She failed to be persuaded by Freudian analysis and explanations that all seemed to be connected in some way to sex. In fact, having looked into Freud's star signs, Chen Hui-chiao discovered that he was of a particular disposition to undertake that kind of research.

Finally, Chen came up with her own explanation. At

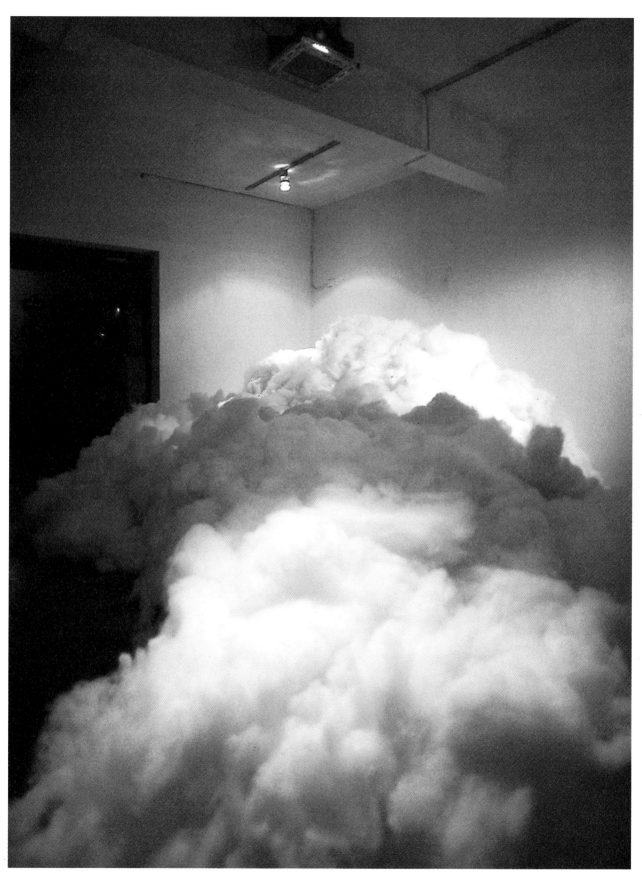

別把夢吵醒也別把夢踩醒　Never Shout or Trample the Dream Awake　1998

this point, she believes in certain ideas of reincarnation, or that perhaps dreams are the ways in which our selves from earlier lives constantly seek to give us hints or awaken memories, reminding us of things that we have yet to do in this life. When awake we have rational dreams, when asleep the dreams are real. Chen Hui-chiao's life has, broadly speaking, revolved around these two interlocking paths, and she still desires to craft from this a clear state of mind. This is reflected in the spiritual yearning always evident in her art.

On three separate occasions, Chen has dreamed of capturing clouds in the palm of her hand. In the first two, as she grabbed the clouds they became something like silk, but in the most recent dream, the clouds were transformed into a white, elastic frost-like substance. These three experiences approximated very closely to her own work and caused Chen to worry she might be a Narcissist. Close friend Liu Ching-tang offered an explanation, suggesting that the clouds symbolize freedom and that as such the act of grabbing them is an expression of power. In this interpretation the dream is a reflection of Chen Hui-chiao's inner desire for freedom. Later, Chen identified a similar tendency in her own chart of astrology, but even then there is no correct answer to such musings.

Cloud images often appear in Chen Hui-chiao's work. In "The Dreamer and the Dreamed" (1995) she used a light box to inlay the image of a blue sky and white clouds on the surface of a stainless steel pillar. In "Within Me, Without Me in Space, Within Space " (1997), the blue sky and white clouds are squashed under several surprisingly heavy glass vats, each one being filled with water. These are pure and clear like large ice cubes and whilst viewers might feel this is a cloud that can be touched as soon as they reach out a hand they find it is not. In "Never Shout or Trample the Dream Awake…" (1998), the cloud imagery is finally detached from the two dimensional and images, to be really truly squeezed into a space, the white ping pong balls liberally spread amongst the white cotton alluding to imaginings of the universe. In 2002, clearly having been bothered by the aforementioned dream, Chen produced "That Day, I Held Clouds in My

Hands!" In that dreamlike experience, the silver wisps of cloud float in between a sea of pins.

Whether we look at Chen Hui- chiao's dreams or work, I tend to feel that the clouds perhaps better resemble the ultimate life secret. She desires to find an answer to this final puzzle but can only find reality in dreams. Moreover, dreams also offer hope, infusing this eternal pursuit with continued strength.

Here and Now

In 2006, Chiao was invited to give a solo exhibition at the Museum of Contemporary Art, Taipei. Initially, she could think of nothing and really didn't know what to do – all she had was the phrase "Here and Now" which she quite liked. That became the starting point and the title of the exhibition, followed by ideas from the heart which followed one by one.

In this exhibition, Chen traces the origins of her interest in astrology. As a little girl she remembered one evening saying to her grandmother that a star had fallen to earth and she wanted to go and look for it. Grandma said that it was just a firefly, but the young girl continued to think it was obviously a star. She also considered that given the stars shone so brightly they must certainly be so hot that they needed putting out with a fan. Ultimately all that remained was the doubt as to whether that had been a star or not, but still she remains unwilling to undermine what for her is such a romantic image. Only when she grew up did Chen find out that what she saw were just fireflies. Despite losing her dream of catching stars, she has yet to give up on the idea of using various methods to capture objects or targets that are difficult to catch or control. In the solo exhibition "Here and Now" Chen replicates the starry night sky of childhood memories in the piece "The Silver Dust".

Chen has said that this was the most relaxed she felt for any exhibition. In the past, to a greater or lesser degree, her works had sought to either establish a dialogue with, or challenge viewers. On this occasion, she was just being herself and expressing situations she wanted to express. Many of the elements that had appeared in her earlier piece reappeared but were now no longer restricted by boundaries or borders. Chen

Hui-chiao wanted her consciousness and works to go far beyond the realm of reason, and she was especially delighted at finally being able to show an exhibition designed only to show untrammeled beauty.

In the piece "Ancient Feeling", Chen covers the floor in large thistles. This comes from her experience as a resident artist at the Glenfiddich artists' village in Scotland in 2005. It was whilst there that she saw streets decorated with that particular flower, covered in thorns and therefore difficult to get close to, though the flowering part of the thistle was always extremely soft and delicate, so when it came time to propagate it would float in the wind like so much weightless cotton. Chen believes that the thistle is a closer approximation of her own character than the rose is. She believes herself naturally surrounded by thorns from birth - a combination of the extremes of gentles softness and durable hardness, some of the characteristics she happens to like. When showing her works in Scotland, Chen chose to use cloth decorated with thistle prints as her creative medium before discovering that it is the national flower of Scotland. For Chen, her trip to Scotland, from her unwillingness to go based on the expected difficulty of communicating, to discovering a strange sense of familiarity wherever she visited and the ability to communicate or achieve a meeting of the minds with people, not dependent on language, and that indescribable state of mind that made her believe in the existence of fate. She describes that feeling as "unbelievable."

Chen has quoted the eight points of Don Juan in her works, but if we look at the annotations she has developed then the central point is always a focus of "love" and "dreams." For her, love and dreams are both a noun and a verb, a state of mind that can only be realized through constant action. In "Here and Now," the artist gives free rein to her intuition and perceptions but still used a rational vehicle to this "Inside of Memories". When these two parallel worlds finally collide in her works, it seems to speak to the beginning of a long journey.

"Only the love for this splendorous being can give freedom to a warrior's spirit; and freedom is joy, efficiency, and abandon in the face of any odds. That is the last lesson. It is always left for the very last moment, for the moment of ultimate solitude when a man faces his death and his aloneness. Only then does it make sense." — Don Juan [6]

(This article was originally printed in October 2007, *Modern Art* No.134)

Notes

1. Carlos Castaneda, *Tales of Power*, translated by Lu Mi, Taipei: Fangchih Publishing, p.354.
2. SOCA Modern Art Workshop was founded by Lai Tsun-tsun in 1986.
3. Tang Huang-chen "IT Park Gallery was founded in 1991-1992 not 'IT Park' " http://etat.com/itpark/gallery/index-itpark.htm
4. Op cit 1, p.124.
5. Chen Hui-chiao "Look back the Eight Points", p.2°C
6. Op cit 1, p.354.

你可以死兩次，我會在之前趕去。
訪李國民

文／游崴

一

李國民住在八里的舊公寓，原本的廚房被拿來當成工作室，流理台上放了暗房用的放大機，一旁堆疊的雜物，看來不太有收納的打算，客廳的書櫃還是最近才新買的。我以爲他剛搬來不久，他笑說不是，「五、六年有了」。

陽台沒有欄杆，望出去就是淡水河。「那時周杰倫就躺在陽台邊上，我拍他。背景原本還看得到家樂福什麼的，我光圈一開，把淡水河拍得像塞納河。」李國民抽著煙，「之後我就不再拍人像了。」

在攝影界打滾十幾年的李國民，是有理由厭倦一些東西。今年威尼斯雙年展台灣館「非域之境」（ATOPIA）裡，李國民的作品裡不見人影，全是家屋空間，從寶藏巖、樂生療養院到空軍一村。照片裡的房間塞滿了日常用品，幾乎不用刻意強調，洋溢著的物質性已先一步擄獲了我們。沖印成大尺幅的燈箱片看來是必須的，只因爲每個人總不免臉貼著照片，細節又一個細節地看，辨別場景背後的身世。物事極其日常，乍看無奇，卻又彷彿無奇不有。房內無人，卻處處充滿人跡。

景框裡，是一整個生活世界。「我關心的是，我爸爸與媽媽的藝術世界是什麼？他們需要藝術嗎？我們對於當代藝術的認知與他們的生活世界有什麼不同？我如何說服他們，關於我的藝術是什麼？」李國民連番問道。

二

這些都與李國民在眷村的成長經驗，若有似無地牽連在一起。他的童年在桃園龜山鄉陸光二村渡過，「我小學時的音樂老師許元慶寫了一首大家都能琅琅上口的歌《我的家庭》。我家門前有小河，後面有山坡。山坡上面野花多，野花紅似火……便是我們村子的寫照。後來這些野花被鐵皮取代，小河裡已不見田雞，下課時，在回家路上的田地烤地瓜的景象，已不復見。田野間的農舍，一間間變成了粉肝紅色的二釘掛牆面。」

李國民說起故事，「我對陸光二村的最後一瞥，大概是十年前，只記得，彷彿經歷大地震般，黃色怪手經過，記憶中的黑瓦房與檜木樑柱應聲倒下，從門窗探出頭，竹籬笆與大樹也嗚呼哀哉。小時候的記憶從此只剩下幾張穿著開襠褲的黑白照片。」

童年場景隨著都市更新而消失，李國民對攝影的興趣則從初中開始持續至今。他記得父親有一套沈重的老式135mm單眼相機，鏡頭是螺紋式的，鏡外環還有皮革的那一種。「當時，揹著相機是軍官騷包的標準配備。從那時候開始，我就迷上了攝影了。」

桃園振聲中學電子科畢業的李國民，獨自一人摸索攝影，在1990年代進入攝影界後繞了一大圈，從人物、服裝到商品攝影，甚至連婚紗都拍過。後來因緣際會進入《雅砌》雜誌擔任攝影編輯，開始接觸了建築領域，拍過無數台灣建築師的作品，目前，他依舊是台灣專業建築攝影界最頂尖的攝影師。即便收入過得去，但由於家中15年前曾被倒會，留下了上千萬的債，李國民至今仍在幫忙家裡償還債務，「如果家中沒有債務，我可能到30歲時還會是個小混混吧。」他說。

透過鏡頭，李國民幾乎是冷眼旁觀台灣1990年代以來建築空間的發展，看到的荒謬與美學上的革新等量其觀，他佩服新一代建築師把廁所從一個陰暗角落，變成一個可以思考的浪漫地方，也曾親眼目睹億萬豪宅中俗不可耐的金馬桶。「我拍過無數的台灣住宅空間，但至今仍搞不懂，台灣的建築怎麼會如此超現實？」

厭倦了將淡水河拍成塞納河的奇技，李國民同樣厭倦了總是拍那些不沾灰塵的新建築，「我好奇這個空間『之前』到底是什麼？」李國民說。他開始關注起挖土機尚未鏟平一切之際，空間裡的故事。

三

幾年前，李國民與友人展開了一個名為〈台北租屋〉的計畫，拍攝了數十位台北租客的房間，他們都是李國民認識的藝文圈朋友，包括林宏璋、大塚麻子、前濁水溪公社的「左派」（蔡海恩）等人。李國民並不諱言是受了都築響一（Kyoichi Tsuzuki）〈租賃宇宙〉（Universe For Rent）裡東京租屋空間的啓發，李國民覺得可以用自己的專業，來進行台北的在地版本。李國民用「租借欠還送」五個字來詮釋這個小宇宙，唸起來像是口訣。

〈台北租屋〉在李國民眼中，還只是個生澀的起點，他自承在概念上還沒有想得很清楚。但如今看來，已然具備了他日後攝影作品裡所隱含的人類學與城鄉研究的向度。「我們通常對城市的想法，都是從飛機上，用一種鳥瞰的方式，從外面來看。」李國民設想的是另一種，「有沒有可能換個角度，從裡面來看一座城市？」

2006年，李國民以寶藏巖駐村藝術家的身分，走訪寶藏巖居民的家中，拍攝了一系列的室內攝影作品。就在我們習慣於在福和橋上不帶感情地瞥視這塊位於台北城邊緣的聚落，對李國民來說，這個攝影行動是記錄，也是另一種發現。

「寶藏巖其實就是台灣的縮影，它有各階層地位的人，也是個臥虎藏龍的暗角。」李國民不諱言，寶藏巖勾起了他小時候在眷村的回憶。在他眼中，這裡還是一個物事豐富的玄妙之地。他引述了一段記事：

九月，中煒尋獲木杖一只，上等木材，杖上握把，

劉班長 神明廳，寶藏巖 Squad Leader Liu, Shrine, Treasure Hill 2006年9月

劉班長 廚房，寶藏巖 Squad Leader Liu, Kitchen, Treasure Hil 2006年9月

年輕夫妻闔家歡，橋仔，北竿　Young Happy Family, Ciaozai, Beigan

小雨，閣樓，鐵板，南竿　Drizzle, Attic, Tieban, Nangan

為銅製梅花三弄紋案。一日，風吹斷落，露出彈簧，蹦出「尚方毒藥」一罐。又一日，國民、幸均、中煒，於門前大樹下，暢談寶藏巖大事，時正入秋。忽間，地上湧出無味清泉數分鐘。驚訝，不信邪，又湧數分鐘。心中想，再次則靈，又噴湧數分鐘。之後，再未重現湧泉。

以自由攝影師為正職的李國民，並沒有像一些藝術家如葉偉立、吳語心等長駐寶藏巖進行創作，反倒是他的工作室後來成為吳中煒及一些學生們的混跡之地，而惹來不少非議。當時，寶藏巖正努力朝向「寶藏家園＋藝術村＋國際青年旅舍」三合一的理想邁進，2006年底，寶藏巖修繕改建動工在即，藝術家陸續遷出。李國民、陳幸均、吳中煒與學生們則因為不滿文化局對於寶藏巖的願景及作法，而成為留下來抗爭的一群異議份子，他們堅持居民在產權上的正當性，希望能保持聚落原生的有機面貌，而非把寶藏巖當做另一個標案招標出去。「我很怕它又變成另一個建成圓環，或第二個華山，變成又一個藝術文化產業。」李國民說。無奈抗爭行動未果，事隔近一年，李國民與陳幸均如今談起此事仍顯得氣憤，立場也未有改變。

從駐村創作到佔屋抗爭，李國民的寶藏巖經驗伴隨著衝突與爭議，卻也形塑了他接下來創作脈絡。他開始有計畫地以攝影為手段，紀錄台灣在現代化進程中可能將消失的聚落場景。不久前，他與陳幸均才去馬祖走訪南竿、北竿，拍攝當地的聚落，同樣是120mm的正片，同樣是充塞日常雜物的室內空間。談到他們在一戶人家的二樓臥室牆上，發現了謎樣的花紋與文字，李國民顯得很興奮。

四

「這是整個寶藏巖的心臟！」李國民秀出作品，場景是「劉班長」屋裡的挑高夾層。四方形的天井，區分出上下兩個空間，瞇著眼看來，有點像是一顆被剖開的果核。你無法想像裡面竟可以塞進這麼多東西，它們全是劉班長經年累月撿來的。「這種堆積了數十年的記憶，我只能用數大壯觀來形容，一棟花錢請藝術家都佈置不起來的現成物」，李國民說，「對我而言，是相當充滿國際性的地方記憶，足以成為一間獨立的貧窮美術館。」

但是，作為「寶藏巖的心臟」，這場景憑什麼？我問李國民。因為它看來那麼飽滿，飽滿到有種死亡的感覺，那麼像是種數學性的排列，那麼無章法卻自成章法……李國民試著用某種現象學式的接近，還混合了一些形式主義的判準及文學性的描述，來捕捉他的感覺，像是在分析一座迷宮。「它太順暢，順暢到無法一眼看穿。」他最後吐出這句話。

沒有人能否認，我們多少耽溺於李國民作品裡那些──以他的說法來講──飽滿、順暢、自成章法的，物的小宇宙。他對所謂的美感並不避諱，但這裡的美感卻是有政治功能的。景框裡被凝結住的時態狀似永恆，但由於他的攝影總意圖趕在現代化進程開始生效之前，先一步切進去做些什麼，以至於，反而附帶了一種行動上的急迫性。因為總在場景消逝之前進場搶拍，我們並不意外，這些照片在李國民心中，其實都是遺照：

我拍攝寶藏巖唯一的動機，其實就是在她消逝之前，為她留下美麗遺照──漂漂亮亮的死，死給你看，看。……透過攝影的隱喻，表達我作為一個寶藏巖公民，對於眼前事物即將面臨消失的積極抵抗，也基於納稅人對政府的信任，及對於台灣的建築美學，提出一些回應。

在這段由李國民給我的文字回應中，「死給你看，看」的兩個「看」字為他的原意，並非贅字。李國民試圖以照片中的被拍攝客體──寶藏巖──為主體，對著照片前的理想觀者一邊吶喊著「我死給你看！」，一邊進行著曖昧的邀請：「來看吧！」。

這個文字上的小機關，對大多數觀者而言，或許僅止於藝術家一廂情願的巧思，但多少透露了李國民是如何同時從行動與文件兩方面，來看待攝影這一回事：它不只是一個「趕在舊聚落在形將死亡之際用快門喊卡」的攝影行動；它同時也透過「憑弔遺

照」的衍申義，讓攝影成爲一種可以透過文本來體會的眞實死亡。〈你可以死兩次〉（You Can Die Twice）是李國民這次在威尼斯雙年展的作品系列名稱。他沒忘了提醒我，在展場中，這些燈箱片是如何「就這樣躺在那裡發光」，宛若漂亮的屍身。

五

「照片本身的死亡意義，與它的再生呈現，其實就是一種非常劇烈抵抗的聲音。攝影，其實就是一種相位移的運動。」李國民說。

李國民似乎有意把巴特（Barthes, Roland）給我們的「攝影之於死亡」的隱喻，並置在台灣現代化進程所造就的另一些死亡（包括物質文明、生活方式、社群關係等）周邊來互相援引的打算。但究竟這裡面包含了何種行動與文本之間在美學上的辯證？若以李國民目前數量稀少的自述，及有限的作品系列來推敲，可能還不太清晰。我發現李國民自己也常站在觀者這邊，還在試圖理解自己的作品。我覺得這並非壞事。

但作爲攝影行動，李國民持續記錄即將消失的聚落，想法倒是越來越清晰。在這點上，他目前在創作上的伴侶，台大城鄉所畢業的陳幸均扮演了重要的角色。問到未來的計畫，李國民說他們打算找機會去太平洋上的島國土瓦魯（Tuvalu）。

土瓦魯是哪裡？

「那裡是全球溫室效應下，第一個將被淹沒的國家」，陳幸均補充說道，「我們想在它消失前趕過去。」ᴮᴱ
（本文原刊於2007年12月，《現代美術》第135期）

上：兒時六歲發燒之子，寶藏巖
A 6-year-old Fevered Boy, Treasure Hill
下：台灣駐中國情報員之宅，寶藏巖
Mansion of Taiwanese Secret Agent in China, Treasure Hill

註釋
1. 本文中所有引用文，均引自我與李國民在2007年10月初透過
電子郵件所進行的訪談紀錄。

You Only Die Twice I'll Catch up with You Beforehand
Interview with Lee Kuo-min

Yu Wei

I

Lee Kuo-min lives in an old apartment building in Bali, Taipei County. What was originally the kitchen has been co-opted for Lee's studio. The kitchen counter holds a photo enlarger and a pile of other stuff that he doesn't intend to sort through. The bookcase in the living room was just recently purchased, and I thought he had just moved in not long ago, but laughing he said, "...no, about five or six years already."

Out on the balcony, which had no railing, I could see the Danshui River. Lee Kuo-min stood there smoking, "I took a picture of Jay Chou when he was lying on the edge of the balcony. You could still see Carrefour and other stores in the distance, when I released the shutter the Danshui River became the Seine. I didn't take any portraits after that."

After gadding about in the photography world for more than a decade, Lee is understandably tired of some things. At this year's Venice Biennale, Lee's photography in the Taiwan Exhibition "ATOPIA" didn't contain any figures, but were all rooms of houses, from Treasure Hill to the Lo-Sheng Sanatorium and the No. 1 Air Force Community. The rooms in the photographs are stuff fulled with everyday objects, and it hardly needs to be emphasized that their material quality grabs our attention right off the bat. It seems enlarged transparencies are necessary only because everyone wants to get up close to the photographs to make out all of the details and distinguish the world behind the scene. The things in the photographs are very common place, and at first glance are nothing unusual, but it also seems that every possible rare and eccentric thing is included. There are no people in the pictures, but there are traces of people everywhere.

There is a complete world framed in each scene. Lee asked, "I am concerned about what my mother and father's art world is like. Do they need art? What is the difference between their everyday lives and our understanding of the contemporary art world? How can I make them understand my art?"

II

These photographs seem to be involved with Lee's experience of growing up in the Military Dependents' Village. Concerning his childhood spent at the Luguang Village in Guishan Township, Taoyuan County, Lee said, "When I was in elementary school, my music teacher Hsu Yuan-ching wrote a widely known song called My Home. The lyrics go 'There is a brook in front of my house and mountainside behind. There are many wildflowers on the mountain, and red wildflowers look like fire.' This is just like a portrait of our village. Later, these flowers were replaced with sheet-metal settlements and the frogs in the brook disappeared. The scene of baking yams on the road that I saw walking home from school can never be repeated. The farmhouses in the fields all became buildings covered with fatty-liver pink tiles."

Lee told this story, "My last glimpse of Luguang Village was probably ten years ago. I only remember that it seemed like it had suffered a huge earthquake when the yellow backhoe shoveled everything away. I remember the sound of the juniper wood frame and black tile roofed houses collapsing. Poking my head out of a window, I saw that the bamboo fences and big trees would all be lost forever. What I have left over from my childhood memories are a few black and white photographs of me wearing open-seat pants."

Scenes from childhood follow the rise and fall of cities. Lee Kuo-min has been interested in photography since junior high school. He remembers his father had a very heavy, old style 135mm single lens camera. The lens was threaded, so it could be screwed onto the camera and was in a leather case. "At the time, a camera was standard equipment for officers who liked showing off. Ever since then I've been crazy about photography."

Lee graduated from the electronics department of St. Francis Xavier High School and figured out photography on his own. After he entered the photography world in the 1990s, Lee moved in a wide circle from portrait, fashion to commercial photography, and even did some studio wedding portraits. Later when he assumed the position of editor at *ARCH Luxury* Magazine, he came in contact with the architecture world and photographed the work of countless local architects. He is still Taiwan's top architecture photographer today. Even though his income is pretty good, his family owes more than ten-million (Taiwan dollars) due to the bankruptcy of an investment club some fifteen years back, and Lee continues to help them make good on this debt. Regarding this, Lee has said, "If my family didn't have this debt, maybe I still would have been a hooligan when I was 30."

Through his lens, Lee Kuo-min was a detached observer of the architectural developments and innovations in Taiwan in the 1990s, granting equal status to both the absurd and beautiful. He admired how the new generation of architects transformed the bathroom from a dark corner to a romantic room where people ponder their lives, and also witnessed first hand the pomposity of installing golden toilets in millions of stately homes. Lee said, "I've photographed countless residential spaces in Taiwan, but even today I still don't understand how Taiwanese architects manage to be so surreal."

Just as he is weary of making the Danshui River look like the Seine in photographs, Lee is also tired of photographing those sterile new buildings, "I am curious about what these places were before." he has said. He's started paying attention to the places that the

construction workers haven't flattened with their shovels yet, and the stories that these places have to tell.

III

Several years ago, Lee and a friend launched a plan called "Taipei Rentals", photographing dozens of rented apartments. The tenants were all people that Lee had met in his art circle, including Lin Hong-john, Asako Otsuka, and the former member of Loh Tsui Kweh Commune, "leftist" Tsai Hai-en. Lee quite candidly stated that he was inspired by the Tokyo rental space of Kyoichi Tsuzuki's "Universe for Rent", and believed he could use his own professional skills to carry out a version of this in Taipei. Lee used the phrase "rent, borrow, owe, return and send" to explain this mini universe, which sounds like it could be a slogan or chant.

Lee sees "Taipei Rentals" as merely a rough start, and acknowledged that the ideas haven't been thought through clearly. However, the project already possesses the anthropological, building and planning themes of Lee's later photographic works. Talking about alternative concepts for his work, Lee says, "Our ideas usually come from an external, bird's eye view of cities while we are flying over them in an airplane" but, "is it possible to change one's perspective and see a city from the inside?"

In 2006, Lee Kuo-min was a resident artist at Treasure Hill. While there, he interviewed residents and created a series of photographs of interiors. Even though we are accustomed to only casting an unemotional glance at this small village on the periphery of Taipei when crossing the Fuhe Bridge, in Lee's opinion his photography serves as a document as well as a means of discovery.

"Treasure Hill is actually a microcosm of Taipei. It has different social classes and also quite a bit of hidden talent lurking in its dark corners." Lee has said that Treasure Hill brought back some of his memories from childhood, and in his estimation it was a materially rich and mysterious place. He cited a section of his journal:

September, Chung-wei found a stick, high quality

鐵皮工兄弟，大廳，橋仔，北竿 Iron Worker Brother, Lobby, Ciaozai, Beigan

鐵皮工兄弟，主臥房，橋仔，北竿 Iron Worker Brother, Main Bedroom, Ciaozai, Beigan

wood, the stick has a bronze handle, in the pattern of three plum blossoms. One day, the wind broke the stick, revealing a spring, out leapt a can of Shangfang poison. Another day, Kuo-min, Hsing-jun and Chung-wei were all under the big tree in front of the door, discussing the situation at Treasure Hill, autumn was coming. Suddenly some clear spring water came up through the ground for a few minutes. I was astonished, I couldn't believe it, it continued to well up for a few more minutes. I thought that if it happened again then I would believe it, then again it spurt forth for few more minutes. Later, the spring didn't appear again.

As a freelance photographer, Lee was not at all like the artists Yeh Wei-li and Wu Yuh-hsin who had been making art at Treasure Hill for a long time. On the contrary, Lee's studio became a meeting place for Wu Chung-wei and a few students later on, which aroused a lot of criticism. At the time, Treasure Hill was working to integrate their three in one plan of "treasure home + artist village + international youth hostel." At the end of 2006 when Treasure Hill was about to start renovating, all of the artists moved out. However, Lee Kuo-min, Chen Hsing-jun,, Wu Chung-wei and the students became dissenters, deciding not to move but to stay and protest the way the Taipei City Department for Cultural Affairs was handling the situation at Treasure Hill. They insisted that the department honor property rights of Treasure Hill residents, hoping they could maintain the organic features of the original way of life in the village and not let it become another case of giving it out to the highest bidder. Lee said, "I was really afraid that it would become another Chien-Cheng Circle, or the second Huashan, becoming part of the arts and culture industry." Admittedly, their protest didn't result in much. After almost a year their position hasn't changed, and Lee Kuo-min and Chen Hsing-jun still get angry when they talk about this situation today.

From a resident artist to a protesting squatter, Lee Kuo-min's Treasure Hill experience was accompanied by disputes and controversies, but also formed the context for his next series of artwork. He started his plan of using photography to document village scenery in Taiwan that was in danger of being lost in the process of modernization. Not long ago, Lee and Chen Hsing-jun visited Nangan and Beigan townships in Matsu to photograph villages, making the same kind of 120mm transparencies of rooms filled with everyday items. When talking about the mysterious looking patterns and words discovered on someone's second floor bedroom wall, Lee seemed to get very excited.

IV

"This is totally the heart of Treasure Hill!" The setting in this photograph by Lee is the interior of Squad Leader Liu's loft. The square skylight divides the upper and lower spaces. Squinting my eyes, it looks a little like the pit of some cut-open fruit. It is hard to imagine how he stuffed so many things inside here, and it's stuff that Squad Leader Liu had collected over the years. Lee said, "These are accumulated memories from the last ten years, I can only use grand terms to describe this stuff. This is a ready-made scene that even an artist on a commission couldn't set up. I think it is a very international kind of local memory, and enough to constitute an independent art museum of poverty."

Still, I asked Lee what his statement "the heart of Treasure Hill" is based on. "Because this image is so full, and fullness has a feeling of death, then it seems like a kind of mathematical permutation. It doesn't look at all systematic, yet it has its own organizational system." Lee tries to use a certain kind of phenomenological approach, and adds in some formal standards and literary descriptions to capture his feelings, and so it is like analyzing a labyrinth. He said at the end, "It's too smooth, so smooth that it is impossible to see it all in one glance."

No one can deny that we more or less revel in Lee's little universe of things, with its fullness, smoothness and unique organization (to use the artist's own words). He doesn't avoid so called aesthetic feelings, but here aesthetics carry out a political function. The camera frames a scene and time is concentrated into moment for eternity, but because his intention is always to capture a time before the modernization process starts--to jump in a step ahead before anything is done--there is an urgent call for activism inherent in his work. Because there is always a rush to take the picture before the scene dies away, we can be sure that

these photographs are like funerary portraits in Lee' mind.

My only motive in photographing Treasure Hill was to create a beautiful funerary portrait before it died away, to show you a beautiful death, so Treasure Hill can show you. As a citizen of Treasure Hill, I wanted to actively protest the disappearance of the things that I saw with a photographic metaphor, and also respond as a taxpayer who has expectations for his government and Taiwan's architectural aesthetics.

In this written response, the second "show you" isn't superfluous. Lee is trying to take the subject of his photograph, Treasure Hill, and give it it's own voice, a voice that will shout at the audience, "watch me die!" and also the equivocal invitation, "look at me!"

Where most of the audience is concerned, perhaps the little mechanism in these words will only amount to wishful thinking on the part of the artist, but it more or less still shows us how Lee sees photographing this situation from both perspectives of activism and documentation. This is not only activist photography that hopes to capture the dying moment of a village with the click of the camera shutter, but it also turns the photograph into an experience of a genuine death, by extending the meaning of a funerary portrait. Lee named this work "You Only Die Twice "and exhibited it at the Venice Biennale. He didn't neglect to remind me how these light boxes "lay there glowing" like beautiful corpses at the exhibition.

V

Lee said, "The significance of the death and rebirth of the photographs themselves is actually the voice of fierce resistance. Photography is actually a kind of displacement movement."

It seems like Lee was using Roland Barthes' metaphor of photography as death, and juxtaposing it with a few of the deaths that Taiwan accomplished during its modernization process (including the death of its material culture, lifestyle and social relationships) in a mutual quoting arrangement. However, what kind of aesthetic dialectic exists here between action and documentation? If we use Lee's limited amount of artwork and rare statements about what he does to

ponder this question, perhaps the answer is not very clear. I discovered that Lee himself often stands on the side of the audience and tries to understand his own work. I don't think this is necessarily a bad thing.

However, Lee's sustained documentation of villages about to perish makes his point of view as an activist photographer increasingly clear. On this point, his current creative partner, Chen Hsing-jun, a graduate of Taiwan University Graduate Institute of Building and Planning, plays an important role. When I asked Lee what he has planned for the future, he said they are looking for an opportunity to go to the Pacific island nation of Tuvalu.

Why Tuvalu?
"It is the country that will be submerged first due to global warming," Chen Hsing-jun said, "we want to go there before it disappears."

(This article was originally printed in December 2007, *Modern Art* No.135)

Notes

1. All quotes in this article are taken from an email interview the writer conducted with Lee Kuo-min in early October of 2007.

眞正的吳天章，就是吳天章？

試窺吳天章的視覺意象[1]

文／王鏡玲

青春的魅影啊！你這逃亡者，死得過早。可是你不曾逃避我，我也不曾逃避你，因爲我們同樣地無辜與不忠啊[2]。─尼采

第一次看見吳天章〈春宵夢〉系列的作品時，記憶竟不自覺地倒流，來到一場喪葬儀式將盡的情景。暗夜裡，那座混合日式巴洛克和閩式建築的紙糊「豪宅」張燈結彩、亮麗熱鬧，預告著透過銷毀自身的物質性，去換取死後無盡財富的應許。豔光四射下，紙糊「豪宅」正中央立有一幅黑白遺照，相片裡那位過世的「豪宅」主人，毫無表情卻又充滿表情地注視一切。

這張遺照藉由被拍者確實存在過的事實，召喚出死者肉身生命終結後，另一種活現在「死亡」想像中的「臨在」感。那逝去卻又被召喚回來的「死亡」想像，拆穿那誤以爲被喪葬儀式安撫完成的「死亡」恐懼，以及難以言喻的對於死者「再現」的排斥、騷動與著迷。原本已經「不在」人間的主人透過遺照，比活著更「活現」、更具威脅地凝視著每一道交會的目光。羅蘭・巴特(Roland Barthes)曾說「攝影召喚瘋狂」[3]，在藝術家吳天章作品的視覺意象中，所召喚出的可見物質性中，那不可見的「驚異」與詭譎，不正是瘋狂的深處嗎？同時透露出瘋狂「噴張」與「收驚」的分裂張力。

一、返回記憶僞裝的起點

藝術家必須創造結構，利用這結構來捕捉現實、重構現實，而不只是反映現實。─作者[4]

〈四個時代〉是1987年解嚴之後，吳天章從〈傷害症候群〉那些帶有表現主義、直接暴露國族暴力與災難記憶的圖象敘事，轉爲政治強人／獨裁者的肖像畫風格。這一系列政治人物的肖像畫，讓吳天章過去戒嚴時期所擅長的黨外雜誌政治漫畫，以及融合大型看板與壁畫風格的構圖形式進入新階段。在這階段吳天章對肖像畫的使用，已經展現了日後常見的視覺曖昧感：一方面貌似互相拉扯、對立，另一方面再往更深處探索時，卻又模糊了對立的界線，進入互相掩護、爾虞我詐的和諧。

在政治強人的肖像畫系列，吳天章展現了三重意象上的曖昧關係。第一重是運用巨型尺寸的視覺效果，結合傳統帝王與祖先肖像畫、電影看板以及戒嚴時期政令宣導看板的風格，在展覽場上表達出空間上的「大」、「壓迫感」與「霸氣」。第二重是以人民血肉堆疊的傷亡意象，作爲象徵帝王威權的「龍袍」[5]。這兩重視覺意象，引出了第三重的曖昧感，那就是吳天章不只是企圖揭露強人作爲歷史災難的加害者，同時也表現出對於英雄主義「一將功成萬骨枯」的愛恨交織[6]。像這樣誇張的巨型油畫墓誌叢林的展示，既像揮別政治獨裁陰影的莊嚴告別式[7]，也同時表達出小人物惡搞戲謔的阿Q寫照，亦即，與其無力與獨裁者鬥爭而挫敗絕望，不如在強人背後扮鬼臉、塗鴉、瞎攪自爽一陣[8]。

在1980年代末、1990年代初台灣社會風起雲湧地擺脫戒嚴時代文化、建立新的主體意識之際，吳天章透過〈傷害症候群〉和〈四個時代〉以其紀念碑與漫畫塗鴉交融的誇張油畫風格，保存、拆解、釋放了舊時代政治暴力的肅殺之氣與集體傷害的症狀；

並從以暴制暴的封閉式集體意象內部，找到向外伸展的欲望出口。吳天章從油畫媒材，轉向攝影與手工藝結合的媒材，走進更深的、被塵封的「我」的傷害記憶內裡，製造出另一種「我正在說謊」的「偽裝之真」。從藝術家所創造的時間結構中，捕捉與重構私密感與距離感：那無法成為「自我」與無法滿足「自我」的傷害，以及透過創作將更深更久的「痛」，從被虐的「痛」，轉為享受的「痛」，以及釋放「痛」的笑意。

在那時，渴望透過影像來表達創意的吳天章，遭遇了理想與現實的掙扎。如何可以製造出畫面的真實感與戲劇張力、又不需要真的出外景、找一堆演員和工作團隊、背負龐大的影像製作花費呢？機靈的吳天章想起導演黃明川所說的「限制在那裡，美學就開發到那裡」。吳天章試著以小搏大、以假造真、以「沙龍照」的攝影棚代替舞台、電影城或外景拍

攝，窮則變、變則通的吳氏「假假」美學在此誕生了。「假假」矯飾的精神狀態一剛開始來自吳天章創作前期物質條件貧困的寫照，藝術家也透過切身物質困窘的現實提煉，借力使力，創造出比現實生活裡所充斥的粗糙、急就章、廉價的贗品文化，更「以假亂真」、更囂張而驚豔的「假假」精神狀態。

吳天章並不走紀實攝影企圖「如其所是」地呈現被拍攝對象，以攝得最自然面貌的路線。相反地，他以編導方式全面介入拍攝的畫面，從角色扮演、服裝、道具、佈景皆出自自己之手。畫面中的人物都向著鏡頭，卻看不見眼神，看似裝模作樣，卻又似高深莫測。吳天章刻意營造的「沙龍照」風格，不只再現「記憶」與「記錄現實」，同時藉由製造「過剩」的記憶，來「堵住記憶」。

記憶不斷地在虛實難辨的往返運動中，進入更深而

蔣經國的五個時代 Five Eras of Chiang Ching-kuo 1991

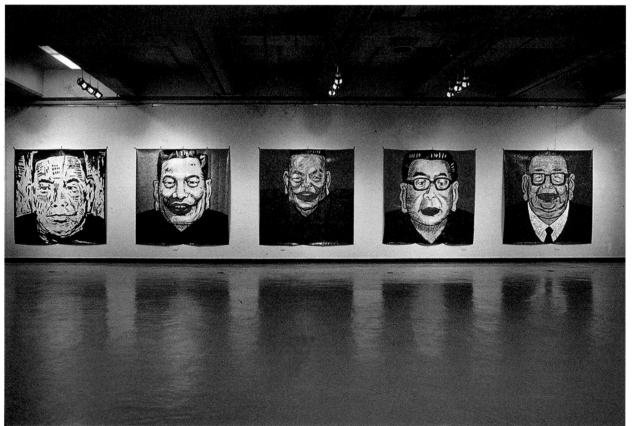

難以重返的失落。在失落的臨界點上，激起了創造「過剩」記憶的欲望，讓那段一去不返的記憶不斷地「滿」出來。「決定的瞬間」被吳天章退回到1960年代或更早，那段藝術家追憶似水年華的時光，以及創造「記憶」的靈感源頭。透過戀物癖般鉅細靡遺地重構「那個」時代的衣服款式、布料材質、體態、音樂、傢俱、佈景、擺設、與情慾…，邀請觀者進入那個已經被遺忘、卻似曾存在過、具有相當遙遠時差、卻又有點熟悉感的時代。

這種帶有顛覆性的復古「現場」模擬，並不是把「攝影」視為拍攝當下、為所拍攝的「那個生命」定格作證。吳天章藉由這些虛構的影像，引導觀者去凝視那個曾經活現過、卻一去不返的時代靈光(aura)[10]，讓觀者也跟著這些虛構影像，像拿著手電筒進入心靈的地窖內，一起窺視那個被塵封時代的內在肌理。不過，吳天章導引我們前往的並非真正的那個具體、曾經存在過的歷史往事，而是來到更遙遠、壓抑更久的偽裝記憶入口；那分不清真假，彷彿向內封閉的記憶殘骸，又像向外擴散的欲望想像窗口。

這種返回真假難辨的記憶起點的視覺意象，透過肖像攝影寫實的表現形式，將欲望的動力與民間信仰的「靈魂不滅」或「魂魄」相結合。自我意識無限延伸的想像，讓可見的「陽世」欲望延續到不可見的「陰間」，延伸到無止盡的生生世世輪迴的想像，彷彿愛憎癡狂的鬼魂不斷地透過「遺照」而「陰魂不散」。透過「形而上」的心理想像與「形而下」肖像攝影寫實表現的雙管齊下，時間差所形成的「舊」時代「老靈魂」魅影崇崇。這種集體潛意識的聯想，塑造了一般受到華人民間宇宙觀影響的觀者，看見吳天章的影像作品時「毛骨悚然」的「攝魂」驚訝─牽動超自然、形而上、「靈界」禁忌象徵體系的不安或恐懼。但這種陰森卻又在藝術家的幽默、矯飾佈局裡，感到誇張、戲謔、與「玩假的」的安全距離。

二、以「沙龍照」的「不真」來「逼真」

影像的本質完全在於外表，沒有隱私，然而又比心底的思想更不可迄及，更神秘[11]。─羅蘭·巴特

「假假」矯飾特質一直被視為吳天章主要創作風格。吳天章個人的看法是：「假假」的氣質來自台灣統治者所造成的那種粗糙、可替代、無長久經營的流亡心態；常民文化裡，也經常濫竽充數、以假亂真。透過一再凸顯這些假假矯飾的「形而下」風格，吳天章創造了一種虛／實交替狀態的「偽裝」曖昧性。我們約略可從時代反差以及階級意識兩方面，來捕捉吳天章在虛實交錯的「沙龍照」創作意象裡，來自社會現實面的創作因素，以及藝術家加以轉化的線索。

首先，就時代反差而言，沙龍攝影具有傳神的時代特質。這種時代特質是台灣從農業、手工業的生產勞動社會，過渡到以大量機械化生產的「現代化」社會的寫照。被吳天章經常「定格」的這段1960年代，是吳天章個人念茲在茲的青春時光，也正是美國自1950年代到1960年代中期，視台灣為東亞冷戰時期的重要據點，對台灣挹注了巨額資金的時期。美援穩定並改善了當時台灣財政與基礎建設，也讓台灣依附於美國的經濟體制之下。1960年代政府開放外資，鼓勵投資的政策，讓私人企業與外國資本結合，促進工業化，帶動經濟快速成長。受美國為首的跨國外資主導，台灣變成製造廉價輕工業產品的加工出口區，中小資產階級和工人階級人口逐漸增多[12]。

這時期的農業發展因為政策往工業化發展的轉移而逐漸衰退。大量人口離開農村，進入工廠成為工人，離開過去大家族定居式、和農作物、自然生態關係密切的生活形態，進入都會化、功能化、機械化、他鄉變故鄉式的生活。那時國民教育逐漸普及，識字、接受西式現代世界觀的人口逐漸增加。經濟生產方式的逐漸改變，越來越多人從農業時代的作息與宇宙觀，逐漸接受資本主義經濟體系下與機械為伍的勞動生活形態。原先以地域性自給自足

為主的手工製品經濟消費模式，也被工業化大量複製的商品與跨地域消費模式逐漸取代。

在那時從日本或中國大陸接受攝影訓練的攝影家，早已陸續在都市裡開設相館，台灣報章雜誌裡的攝影照片數量開始擴增。六〇年代起電影娛樂更加普及[13]，電視進入家庭、產生了新的大眾視聽傳播文化[14]，透過機器來傳播知識與休閒娛樂的形式，逐漸取代過去面對面、親身參與的活動。過去農業時代認為攝影「攝走真魂」[15]、視照相機為巫術法器的排斥心態，也逐漸被都市裡越來越多接受機械用品的人們捨棄。人們接受相機不再具有形而上的靈力，使用相機來快速記錄生活中的重要事件，拍照逐漸成為家庭生活儀式的一環。從這時期起一方面相片取代了傳統肖像畫，成為祖先親族遺照最主要的媒材，另一方面相片也成為那時代的年輕人，記錄那段青春歲月的重要見證物。

但是在這段相機逐漸普遍化的工業化時期，卻由於當時政治戒嚴環境箝制了藝術創作理念，以致於台灣在那個經濟力改善、攝影活動開始蓬勃發展的時代，一般社會上所流行的只是無關社會現實、符合官方「正確」、「安全」尺度下的沙龍照文化。官方的打壓讓當時一般大眾對攝影的了解，停留在「只有沙龍攝影那樣的照片才是攝影」[16]。在那個整體經濟尚未脫離貧乏、求溫飽的時代，走進相館拍照，對一般人而言並不是一件平常事，反而像出席正式場合或是扮裝表演。因此，正襟危坐的儀態下，正是幻想自己宛如重要人物，被鏡頭留下以茲紀念的虛榮。盛裝打扮、矯情造作，讓新興的機械科技所帶來的扮裝儀式，剎那間滿足一般人變成大人物的幻覺。

另一方面，就階級意識的反差心態上，為何要裝模作樣、虛張聲勢呢？難道不也意味著，明知無法真正企及那些「上流」階級強勢、炫耀的名利，但是輸人不輸陣，透過模仿讓外表上乍看旗鼓相當，甚至更亮眼、囂張來扳回一成。這種阿Q精神外人看來是嗤之以鼻的「作假」，對於被拍者卻是以假當真的

虛榮。既然無法快速而獨立地創造新價值，那何不投機地仿效，來自我發洩、自我欺騙、自我嘲諷。這不也是弱勢者無法或無能面對與強權者競爭時，不想長期被傷害與否定、甚至被消滅，所翻轉出來、求生存與求虛榮的變相文化性格嗎？

這就是吳天章的視覺意象所凸顯的精神狀態，但吳天章不只是展現這兩重的過往「沙龍照」心態。吳天章更進一步地製造了沙龍照不會出現的情慾體態（例如上彩妝的陰柔水兵陽具勃起若隱若現、妙齡女子撫胸自慰），並加入了「遺照」與「告別式」的視覺聯想（例如假花圈、喪葬「戴孝」的記號）。弔詭的是，我們就在一再揮別的「告別式」與一再偽裝的沙龍照中，看見了那無法捨棄、難以偽裝的真實感。吳天章透過製造「失去」，來激起「擁有」的欲望，透過「不真」來找尋隱藏或失去的「真實」，而「失去」與「偽裝」竟然變成最真實的「我」的生存狀態。

至於那些作品中的人物刻意被遮的雙眼，是強化「傷害」與壓抑靈魂的寫照？用來擺脫原先那個「我」的另種易容術或偽裝面具？還是透過遮蔽的陰暗，來看見那肉眼不可見的世界？誰知道呢？一旦畫中人卸下蝴蝶結、眼鏡、花朵…開光點眼了，他們又會看見怎樣的世界呢？

在那些肖像照裡，吳天章吐露著對於受挫者、邊緣者、陰錯陽差無法成為台面主角者的戲謔、嘲諷、憐憫、慰藉與救贖的曖昧情愫。透過密閉的「攝影棚」、虛擬造假的佈景、裝模作樣的「身份」轉變，攝影宛如魔術一般，讓主角暫時脫離現實弱勢的身份，進入夢幻新角色的扮裝遊戲。這種快速決定的瞬間，卻製造了「真的發生過」的假象，為主角的幻想與虛榮做了不懷好意似的偽證。

誰在乎那位肖像主角究竟是誰呢？假假真真，或許每一位都隱含藝術家的自我投射以及現實社會的縮影。像是杜斯妥也夫斯基（F. Dostoevsky）小說筆下的主人翁，從雙重或多重的自我分裂式中，折射出

不安、焦慮、亢奮、自大、自卑、自閉又放肆的精神狀態。從「他是誰？」變成「我是誰？」，從自我分裂中發現自圓其說。這已不是分辨誰真誰假的標準答案式的問題了，而是為何從偽裝、造假、虛擬、造作的手法與佈局裡，可以讓人看見一種逼現本真的驚豔。

這些「把青春泡在福馬林」的偽裝沙龍照[17]，不只是一場面對時代創傷、原地打轉的強迫症，反而已經被時代帶向前、仍不住回頭反顧，然而回顧的也不是過去，而是藝術家對於慾望「對立並存」(ambivalence)的幻見(fantasies)。吳天章並沒有完全進入機器時代，他的另一半自我卻還眷戀著「前世」的手工業時代。藝術家迷戀逝水年華的一切——那尚未被機械科技取代的舊時代手工質感，作品的肌理處處可見「絨布交織金蔥布和亮珠的光芒，彷彿蕩漾著黑黯的心靈所滲出的一種幽幽的『情慾』感」[18]。「以人喚物」、「以物喚情」的戀物私密關係，透過數位攝影科技之助，吳天章讓那些被工業社會給遺忘殆盡的舊物件靈光，得以音容宛在。

在數位攝影科技的畫面製作手法裡，不同時空的因素可以任意地影像合成在同一畫面上，製造虛擬的「決定性瞬間」。在虛擬的影像世界裡，任意進行所有可見元素的重新拆解與合成。這似乎提供了所有可見元素「等值現身」以及「無限合成」的機會。但是人對於影像的好惡，絕對不是等值的，影像關鍵不在量的多寡，而在於價值的高低。總是有些影像令人格外癡迷，像那種介於永恆與虛無之間不忠善變的情人，而吳天章一再追逐的就是這樣的影像奧秘。

吳天章並沒有被目前無根式、包山包海、快速量產的影像泛濫洪流淹沒，而是企圖進行唐吉軻德式的「攝影」精神的再發現，讓「照片影像能夠再『啟動』攝影術剛發明時，所帶給人們『僵魂』疑慮的那種驚異感。」[19]這位藝術家像忘了喝孟婆湯的轉世靈魂，一邊轉身想留住上個世代的舊愛慾海浮沈，另一邊又迫不及待地投入煥爛繽紛的新歡勾引，在藝術創作轉世蛻變的旋風裡，吳天章已經同時把自己捲往深不可測的過去與不可知的未來了。

三、穿梭情慾的臨界線

攝影提供了「偽証」的錯覺，即便是一張泛黃的老照片依然能喚起神秘的精神召喚，照片中的人物依然「音容宛在」。—吳天章[20]

相機和視覺最大的差異，在於相機可以將事物外貌「定格」，但是人的視覺做不到。有趣的是，雖然視覺辦不到，但人的記憶卻辦得到。所以攝影的影像宛若「超現實」的現實，也像再現心理官能症的癥狀，再現那些被固著的過往記憶。試想，哪種記憶可以強大而持久地盤據、一再重現？甚至被禁制壓抑，也不惜夢裡變形現身呢？恐怕就是最令人愉悅著迷的吸引力，以及那避之唯恐不及、具威脅性、毀滅性的記憶了。追求快樂不顧生死，與自我防衛、保存的機制，一直都是情慾在表露與壓抑時的基本盤。

探索情慾的主題在台灣社會向來是一個比政治戒嚴的打壓，更嚴廣卻也更尷尬的公共議題。對於藝術家帶有「性」意涵的創作題材，經常被評論者從私領域的獨白，拉向公眾性的告白。評論者往往藉由將「性」相關的藝術表現「公眾化」或「污名化」，來將「性」去勢、納入管理，或者變成策略性操弄，來逃避面對「性」議題時，論述者自我檢視的尷尬，以及觸犯社會禁忌時的疑慮。

帶有「性」意涵的主題是吳天章九〇年代中後期重要的創作方向，加上遺照／喪禮相關的視覺圖象的挪用，將情慾表達帶向了挑戰死亡禁忌的雙重火線。第一重挑戰觀畫者洞察到「性」的偽裝後，和道德界線之間的張力[21]。第二重則挑戰了觀者對死亡禁忌的「褻瀆」式性幻想，所勾引出既恐懼又吸引的曖昧情愫。吳天章對「死亡」禁忌的挑戰，面臨當時藝術市場的現實考驗時，藝術家也不得不謹慎地低調、偽裝，將虛與實的臨界線拉得隱晦曖昧。

吳天章在〈夢魂術〉自述裡有一段話，傳神地點出

了他在〈春宵夢〉時期對情慾意象的看法：

男子與夢境中的「女人」交歡，但女子其實是男子心中「內我」（anima）的外射，是男人潛意識中的「女性本質」，滿足男子的生物性慾望和心理性慾望，對其未受到異性青睞的孤寂提供潛意識的「補償作用」。

「女性」體態在〈戀戀紅塵II──向李石樵致敬〉以男扮女裝現身。藉由變成「異」性的想像，產生自我分裂的勾引與佔有欲，分裂的自我在交媾的幻想中重新合而爲一。情慾並不止於自我幻想，也和情慾對象關係密切。情慾對象往往不只停留在單一個體之上，在「這」一個「白玫瑰」與「另」一個「紅玫瑰」[22]、「又」一個「x玫瑰」的引誘中，自我徘徊在忠誠與背叛之間，既期待又怕受傷害，既是意猶未盡卻又無限空虛。

藝術創作總是以有限自我，去揭露那一個又一個彷彿無限的「他者」。這種創作中多元分裂與統合的欲望，也正是人性／獸性／神性／魔性衝突與超越之所在。只是藝術家也看見了現實越界的侷限，暗室裡那位動作猥瑣又帶點搞笑的扮裝者，又走回畫框內，等待一次又一次越界的機會。這件〈戀戀紅塵II──向李石樵致敬〉，以機械式的重複永遠地進行：「走出→自爽→折返」的宿命，直到電力消失或機具故障。

從〈春宵夢〉系列到〈戀戀紅塵II──向李石樵致敬〉的裝模作樣、正襟危坐的猥褻體態，以及遮蓋在眼鏡、眼罩、假花、假珠寶裝置下，似笑非笑、故做神秘的表情，似乎挑起另一種暗潮浮動、欲蓋彌彰的踰越快感。吳天章不走劍拔弩張的對立風格，他總是用僞裝、作假、遮掩的曖昧手法，來作爲緩衝對立、隱藏自身的手段。吳天章不直接掀底牌、撕破臉，總是帶有演戲、扮裝般的虛實難辨的戲劇感，來逃離非此即彼的二元對立式的表態。在劇照般的影像調度上，吳天章這一系列「庸俗化」「贗品風格」交雜著：一邊挑逗、挑釁、猥褻，另一邊嘲

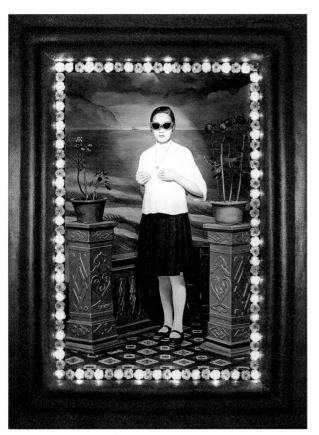

春宵夢 II Dreams of Past Era II 1995

戀戀紅塵 II 一向李石樵致敬 Unwilling to Part from Worldly Life II 1997

135

諷、偽裝、戲耍的情慾收放，讓各憑本事的看官，好好享用性幻想／性冷感、迷戀／反感／迷惘吧。

〈春宵夢〉裡「女子」的體態相當耐人尋味。有的扮成時髦閨秀／少婦，有的像娛樂界或性產業的一姐。貌似時髦又端莊的古典淑女，擺出了正經八百又引人遐思的撫胸動作；而豔麗妖嬈、帶有「風塵」味的熟女一姐，則擺出附庸風雅的悶騷貴婦狀，還有貌似心事重重的「女子」，眼和嘴卻可以長出開合的人造花朵。再看到材質的拼貼手法上，大部分〈春宵夢〉系列的畫框上都綴滿了亮麗的人造花圈或閃閃發亮的燈泡，更具戲仿喪葬「告別式」裡綜藝團的視覺效果。細看照片甚至還有刻意套色沒對準，戲仿廉價印刷的粗糙質感（〈春宵夢 I〉）。「假假」「矯飾化」的告別式「告別」的是什麼呢？是藉由告別「正式」的道德，以便勾引出那不在場的、被壓得深深的對於敗德禁忌的破壞嗎？期待與「死者」交媾——那種既吸引愉悅、又害怕被懲罰毀滅的「褻瀆」感嗎？

如果這些肖像照帶有遺照的意涵，那麼現代化科技文明並非只是以機械來取代宗教向度裡的情感。相反地，透過科技將想像「影像化」後的畫面，所召喚出對於不可見世界的性欲，帶有另種借屍還魂式的、比真實更真實的「攝魂」視覺魅力。潛意識裡踰越的欲望，不只是戀屍癖式的對肉體蠢蠢欲動的褻瀆，對藝術家而言，更重要的還包含揭露那些屬於精神靈交的佔有與毀滅的暴力想像。告別了有限的肉身、告別道德規範的「陽世」牢籠後，反而引致更強烈的恐懼與吸引的情慾想像。

華人民間宇宙觀裡以父系為主的情慾文化，提供「女鬼」旺盛性慾的聯想。從〈春宵夢〉到〈夢魂術〉，孤寂難耐的自我、投射到另一個情慾想像的「他者」——鬼魂悄悄現形。在性幻想的支配與被支配的痛感與快感上，兩個「我」變成同一個「我」時，自我同一與矛盾的雌雄同體欲望裡，在進出收縮過程裡無盡的拉拒。生命噴張的極致，就是隨即死亡毀滅之時，這正是精神與肉身合一、也是精神與肉身互相毀滅的剎那。生命最難以理解的誘惑之所在，不就是在最快樂的時候毀滅自身？就在這臨界點上，精盡人亡的男性防衛機制在這時湧現，夢醒了，戲散了，是誰魂飛魄散了呢？還是，還好，只是演戲作夢罷了？

四、來到「聳而美」的「污穢」高處…

生命如此不真，所以才如此令人驚豔。—李友煌[23]

耐人尋味的美學「曖昧性」—既「優雅」又「猥褻」、既「警世」又「敗德」的臨界。—吳天章

吳天章說：「也許條條馬路皆可通羅馬，我以華麗、幽默、優雅的手法呈現『潛在的人類底層的慾望』是不是一樣可以相通呢？」[24]。在九〇年代後期吳天章進行了多種視覺意象的實驗，這些實驗濃縮了台灣通俗文化與民間信仰既有的視覺意象，以及藝術家探索傳統道德、死亡禁忌與追求情慾之間的矛盾掙扎。透過「偽裝」的超現實複合媒材手法，吳天章試探挑釁社會的界線，也試探藝術市場接收的限度。被藝術家稱之為「污穢異物」的視覺意象，鑲上金蔥布和亮珠的條飾、透過畫框外柔滑的深色絨布的綿延，閃鑠著既華麗又猥瑣、光鮮又腐臭的挑逗感，莫測高深的偷窺欲與戀物癖的快感，以及越墮落越「聳」擱有力的誘惑。

看哪！那敗德所激起的防衛機制——從「污穢異物」[25]的命名開始，藝術家就先搞起偽裝自宮了，先把越界的欲望向觀者自首吧。來來來！小弟這次搞的是「骯髒」「污穢」限制級戲碼哦，請各位拭目以待。（不過不要也跟著長針眼哦，小弟已經為各位先演一齣「長針眼」了，請看〈合成傷害 II〉）。

那些被稱為「污穢異物」的究竟是指什麼呢？讓我們開始這段上升至「聳」而美的「污穢」高度的鳥瞰吧。首先，第一種是以「污穢」玩「污穢」。吳天章一方面影射死亡與喪葬相關的禁忌，另一方面又加以顛覆。這些被台灣社會視為污穢與威脅的死亡禁忌，相信與死者直接或間接接觸，可能導致災禍與不幸的恐懼。民間習俗將死者視為充滿凶厲之氣

的污染源，必須透過儀式或其他陣頭、綜藝表演團，想盡辦法將死者的靈魂送往陽界以外的死後世界隔離安頓。

吳天章的〈傷害告別式〉系列，那幾幅「戴孝」的遺照式作品裡，乍看像搞佛洛伊德口腔期的自虐，卻又像偽裝成死者，在「告別式」會場上惡搞耍寶[26]。這一系列作品表達出對於傳統喪禮喜喪不分的荒謬，以及面對死者一去不返的「無情」，所產生的被「拋棄」失落感時，如何透過精神內在的反抗與自我解嘲來擺脫缺憾。〈傷害告別式〉系列讓人分不清是看得見的自虐「傷害」，還是看不見的精神上或價值觀上的「傷害」；令觀者啼笑皆非，又想入非非。或許吳天章早已察覺一般人對於喪葬禁忌的恐懼、反感與拒斥都太沈重了[27]，何不透過幽默、戲謔、自嘲、惡搞，來跳脫視「死亡」為毀滅與終結的無奈；何不在笑鬧中孕育動力，迎向下一輪生命新面目的出場。

第二種「污穢」不同於第一種，是在不該長東西的地方長出「異物」，而這些「污穢異物」仍帶有吳天章追憶童年的戀物癖，總是既排斥鄙夷又被撩撥吸引。吳式的曖昧感讓人摸不清這樣無厘頭地在身體

合成傷害 I, II Composite Damages I,II

部位長異物，是疾病、傷害、懲罰、還是自虐惡搞呢？看看〈合成傷害I〉那貌似醫學黑白相片的胸部，長出靈芝、滲出黏稠分泌物（彷彿男性或女性的體液），像五、六〇年代那些四處流浪、甚至招搖撞騙的江湖郎中，故意展示當時社會衛生習慣尚未改善前，所導致的身體局部疑難雜症的誇張病變，來吸引注意。對疑難雜症的懷舊再轉化，吳天章將之誇大，讓異物長的部位與形狀，產生「道德」禁忌與「性」的曖昧聯想。在〈合成傷害II〉畫面上，黏在眼睫毛上、讓人睜不開眼睛的黏稠海參屍或蠶繭屍，像一般民間認為看見不該看見的東西，以致於長針眼的症狀。污穢物還帶有敗德的懲戒警告的意涵[28]，藝術家似乎頑皮地暗示觀者──小心！你也正在看「不該看」的東西哦。

再看另一幅在不該長東西處出現「異物」的作品〈情慾海〉。那腥臭又綴飾珠寶的魚身口中，伸出一截塗有粉紅指甲油的性感手指，撫摸著那看似泥淖又色澤曖昧的深色絨布。畫面上彷彿散發腥臭腐敗的氣味，讓人想掩鼻，卻非但沒被隔離，反而正經八百地放進以金蔥亮片與花簇鑲邊的畫框裡，掛在展示場潔淨的牆面上。「污穢」意象沒被唾棄反被高舉的曖昧情緒，是吳天章作品對於「勿看」、「勿觸」、「勿食」等感官禁忌的踰越。吳天章透過「錯置」的視覺意象的踰越，揭露了被壓抑與否定的本能衝動，藉此進入視覺意象尚未抵達的心靈深度，乘著下墜欲望的重力，尋找生命本真的面目。

第三種「骯髒」、「醜陋」是亂倫禁忌的試探。這是除了喪葬、死亡禁忌所帶來的「不潔淨」，以及視覺心理不符衛生乾淨的黏稠腐臭的「骯髒」之外，挑戰華人社會道德禁忌最底線的「髒」，甚至帶有「罪惡」的譴責。在兩幅〈親密家庭〉系列裡，觀者像潛進陰暗、混濁、悶滯、發霉的閨房一隅，屏息偷窺一場猥瑣、不登大雅之堂的偷情。主角們呢，腥紅絨蝴蝶結遮住了雙眼，彷彿置身在遮掩身份、為所欲為的化妝狂歡派對。

在〈親密家庭I〉裡嬰孩的小腳丫子，似乎踢撫著母

親豐滿的乳房，在〈親密家庭II〉裡小男孩的小手正深入那位「母親」的裙底，兩人都露出了性快感般的神秘笑容。一旁魚缸中兩條對望的魚，和魚缸上正視畫面卻像目空一切的肥貓，似乎正悄悄進行一齣不爲人知的詭計。吳天章不像某些超現實主義者，以優雅浪漫的畫風製造聖像般的詩意，來作爲反諷或障眼法，偷渡亂倫敗德的挑釁。反而表現手法與表現主題雙管齊下，一起搞「聳而廉」的贋品式實驗，在僞裝春宮畫的「性」意象裡，夢魘般地如眞似幻。弔詭的是，這種直接出手的「戀母情結」亂倫主題，反而宛如另一種更深不可測的欲望不滿的僞裝。吳天章偶而爲之的大膽露骨的情色意象，不知這些苦心製造的「低俗」與「廉價」的挑釁背後，是否還埋藏著藝術家面對現實社會裡，親密關係崩解時，難以意表的折磨與吶喊。

第四種「污穢」——具有性挑逗的性別認同曖昧感。如上所述，華人文化裡對於反串扮裝並沒有禁忌，但是牽涉到性意識的直接表達或隱喻時，就被冠上「低俗」、「污穢」、「下流」的聯想。儘管在民間廟會慶典裡，性挑逗被視爲狂歡節式的民俗曲藝裡的娛樂重點，但是那些強調禁欲或「性」的禁閉私密性的社會機制者，仍然貶抑與污名化民俗娛樂的性挑逗，藉此來達到對於普羅庶民性慾上的控制。

吳天章性別認同的曖昧手法，同時顛覆藝術作品在情慾上和階級意識上的設限。〈戀戀紅塵II——向李石樵致敬〉將李石樵原作〈市場口〉典雅寫實風格的榮市場裡、暗藏階級張力的驚鴻一瞥，換裝成暗室裡虛實交替的情慾掙扎。吳天章對於陽光下的美女，總是懷著一窺其陰暗面的曖昧情慾想像。在吳天章所凸顯的「低俗」與「污穢」的視覺意象裡，「次」文化的僞裝意象，反而像照妖鏡一般，照見菁英文化所標榜的典雅、潔淨、高尚的視覺意象底下，更多已經失落的血肉與活力。

吳天章並沒有要重現或複製社會現實，而是透過視覺意象上的再創造，將欲望的戰場拉回到明暗、正邪、好壞、墮落與超拔，難分難解的臨界處。陰暗

因爲有光作爲反差，彷彿一塊絨布上所展現的光彩與陰影；腐朽來自金玉其外與敗絮其內的反差；荒謬來自將現實的矛盾強行縫合，所造成理性判斷上的兩難。而以上這些又都在吳天章視覺「僞裝化」的不確定感裡，引人進入眞假難測、曖昧與神秘的意境。

「污穢異物」的意象，和之前所提及的欲望想像的「他者」之間關連密切。在吳天章的視覺意象裡，「污穢異物」並非負面否定的標籤，而是具有顛覆與踰越意涵的「否定」——跨越性別、跨越階級、跨越年齡、跨越族群，甚至跨越道德（亂倫、戀屍癖）與跨越生死。「污穢異物」在此不只是特定實體，而是藝術家創造出來的一齣齣視覺意象的事件（event）。那些「污穢異物」從「事不關己」的「物」，變成了和生命休戚與共的「你」。藝術家沒有義務要說服觀者如何「告別傷害」、「告別死亡」、或者「找到新身份認同」，因爲藝術最重要的就是：把每一個「我」捲進來、一起凝視那還無法凝視的「你」——情慾禁忌、死亡禁忌、權力禁忌，以及進入那還沒被看見、還無法言說、介於意志整體化與意志虛無化的歇斯底里臨界點。然後，再從「你」「我」之間離開，因爲，所有將藝術創作收納到想像共同體的權力意志，都只是藝術精神的土壤與發射站，而不是最後的目的地。

五、「邪邪」魔術秀的精神「分裂式」

歷史是歇斯底里的，只有當人注視它時才存在—要想注視它，必得置身其外。—羅蘭·巴特[29]

2000年之後，吳天章依然繼續各種視覺意象的實驗風格，從虛幻中製造眞實，和觀者玩著眞假難辨的迷藏。吳天章透過數位攝影的技術之助，完成比本尊更寫實的複製，以及不著痕跡的塗改／增刪／拼貼，將他向來眷戀的「繪畫」的「現在進行式」的「過程」，繼續融入「攝影」「過去完成式」的「瞬間」。但不同的是畫面中的「戲碼」，顯然已經異乎從前了。

觀看吳天章在2000年之後的作品，彷彿走進一場怪誕「邪邪」的綜藝魔術秀。這種怪誕詭譎不只是影像中的人物特質，還包括吳天章所使用的電腦合成的「技法」，所製造出來的「形上」意涵。最明顯的「變形」想像，一種是吳天章運用「分身像」的概念[30]，讓畫面上的主角一分為二，另一種則是將模特兒容貌體態加以扭曲變造，成為唐氏症、侏儒或遲緩兒等異乎常人的視覺意象。

「分身」只是一種視覺上影像合成的技巧嗎？還是包含潛意識裡「我」追尋另一個「我」時的曖昧情愫的「視覺化」呢。「分身」同時帶有自我「同一」的渴望，以及踰越自我「同一」的「分裂」欲望。當兩個「我」忽然現身眼前，那種不可能的可能性──「就是他！」的驚訝，把潛意識裡的對立曖昧

性，從不可見的想像拉到可見的畫面來印證，宛如不可思議的夢境或魔術幻象，「真實」地出現在眼前。「分身像」在吳天章的數位影像裡，有時像是「我」的鏡面般反射，有時像打破或消滅「我」的「主體性」的強敵。或者，「分身」其實是「我」最深的黑夜與最迷惘的誘惑，那種逼「我」消失、取而代之的潛意識裡最「邪」的恐懼[31]。

但是「分身」的概念再加上「變形」扭曲，又將呈現怎樣的視覺張力呢？〈永協同心〉裡協力車上一分為二、身殘形缺的特技團團員，紅豔的彩衣禮帽下，濃妝裡綻放著殭屍般的笑容。〈黃樑夢〉則在曖昧光線下，「分身像」的馬戲團侏儒「王子」，騎在小丑背上，風光亮相。〈同舟共濟〉圍繞在遺照般陰影下，四位唐式症的小丑踩高蹺、擺出划龍舟

親密家庭 II　Home Sweet Home II　1996

的故作歡樂狀。〈日行一善〉則籠罩在冷桃色系的氛圍裡，「分身像」的中年侏儒童子軍看似風霜又像孩童的神情，一左一右抬擔架，和抬擔架上肥腫、綁著染血緞帶的遲緩症女子都面露微笑。這些影像，彷彿我們都看到笑的痕跡，但卻都聽不到笑聲[32]……吳天章這一系列「邪邪」異人誌作品，詭譎地和目前藝文圈裡所瀰漫的都會中產階級品味——乾淨、健康、優美、高檔名牌的氛圍保持距離。這種距離感卻又在更深處藕斷絲連，若隱若現地折射出另種不同於九〇年代「假假」風格的精神變貌。

九〇年代「幽靈」的「沙龍照」風格下場休息，換上場的變成了「邪人」、「殭屍」魔術秀的「劇照」。不過，這些吳氏「假假」的魔術團「劇照」，不只是沙龍照風格對於中產階級或大人物階層阿Q式精神的反諷；也不只是透過「意淫」逝者的情慾禁忌，企圖對於中產階級的社會道德暗諷與戲謔。我認為2000年過後吳天章這一系列作品，尤其到〈日行一善〉（2007），所提出的偽裝與矯飾風格，帶有將「鬧劇」與「悲劇」互相偷渡的實驗，企圖從「形而下」的物質感的迷亂，通透到「形而上」精神狀態的「分裂式」。

在此，一個有趣的問題可能早已浮現了：吳天章為何一直都在搞「偽裝」？到底要「假」到什麼時候呢？其實，答案就在問題裡面。或許這種一直都讓觀者意識到的「偽裝」，其實是「假假」「真」迷藏。原先以為「真實」與「虛假」的界線，並不見得是真正的界線。相反地，原先以為「真實」的，可能反而是「假」的偽裝。這難道是吳天章長久以來拒絕對於真／假劃出臨界線的表態嗎？還是，正好相反，他一直提供我們來到真／假臨界線的「箭頭」指標，他的作品就是臨界線的自身呢？吳天章這一系列我稱之為「邪邪」魔術秀的作品，至少具有三種視覺意象上的精神「分裂式」。

第一種精神「分裂式」，在於吳天章將目前消費社會所熟悉可見的強弱權力現狀，來了個「狂歡節」式的變裝秀。這種狂歡變裝秀的戲要作用在於：從低俗、遲緩、污穢、贋品、殘缺、被邊緣化的異常中，提煉出彷彿「狂歡節」的去階級化——所有尊卑、大小、強弱、智愚、哄笑與悲慘都將融為一體[33]。

吳天章讓那些原本被蔑視鄙夷、被遺忘的「卑賤」者、不幸者或邊緣者，透過扮裝秀裝模作樣的體態，以及數位攝影高畫質合成，將那些坎坷幽暗的人生綢摺——「殘缺」與「過度」（發育太慢、太快老去、太胖、太矮、太醜、太笨……）所造成的命運陰影，風光地「定格」。這種「定格」彷彿正面凝視命運的暴力捉弄，讓不幸者與被鄙視者，剎那間享有被「加冕」一般的虛榮。吳天章透過這些像孩童又像老者、長太快又長太慢、混雜著「形殘貌醜」、「贋品」與「異常」的變形扮裝「定格」，逼出內藏在「剎那—永恆」變化之間生命「顯真」的靈光，以訕笑或微笑對殘酷命運的漂亮回擊。

第二種精神「分裂式」，與第一種「狂歡節」精神狀態之間，則出現了真／假認同差異上的分裂張力。第二種精神「分裂式」的特色，反而揭露了第一種「狂歡」節凝視的精神偽裝。請看，這「狂歡節」並非你原先所認為的狂歡節氛圍啊！藝術作品、觀者、展場之間的關係，並不是打成一片的「嘉年華」。相反地，數位攝影輸出的作品，透過吳天章向來刻意製造的誇張、僵化疏離又帶有溫潤陰森的冷色調，我們所看見的只是嘉年華式視覺氛圍的偽裝，其實更像一場喪葬儀式裡，不可見的非人類、鬼靈妖怪的歡樂派對。

當觀者看到這些作品的時候，可能並沒有參與廟會慶典或者狂歡派對時的快感。觀者無法在眾聲喧嘩、縱情吃喝玩樂中，暫時遺忘自己在現實世界裡的身份與處境。相反地，觀者冷靜警覺地、甚至忐忑恐懼地，凝視牆面上這場被「定格」的歡樂葬禮：陰森的色調、如封似閉的場景、詭譎的微笑、又老又小的侏儒肉身、被強行扭曲靜止的表演動作。觀者開始意識到，眼前這些主角們彷彿一群濃裝豔抹、穿著體面壽衣來表演綜藝秀的逝者，他們正在歡渡自己與他人的死。或者，這些主角們像那

些以手工紙紮的俗豔靈厝周邊的金童玉女與神話人物，正準備將身爲死者的「我」送往西天極樂世界。

意識到這層的「我」正在歡送死去的「我」時，毛骨悚然的恐懼感刺穿了消費文化想把一切物體系的符碼，納入虛擬的物化、安全化、可買賣交換的掌控模式。因爲這一切都已經來到生死禁忌的臨界線了，「我」的死無法被「我」所消費，「我」一死就陷入難以測度的想像深淵了。從僞裝的嘉年華到「歡樂」的喪禮，那難以被對象化、難以被化約的「他者」竟然與「我」如此親密，彷彿那些異「人」就像「我」的「分身」一般──死亡、消逝、虛無化、欲蓋彌彰、昭然若揭。

這時，我們來到第三種精神「分裂式」，我稱之爲僞裝的「支離疏」[34]。上述的僞裝嘉年華中欲蓋彌彰的死亡禁忌，所展現出來的怪誕與距離感，並沒有來到因爲揭露虛無、消逝、死亡與生存之間的巨大張力所激起的恐懼感時，就嘎然而止。那種起初的隱藏與後來的辨認所造成的戲劇張力，以及在「有限」抉擇中去對抗「絕對」與「無限」的悲劇性格，只屬於悲劇英雄式的自我淨化、自我超越、爲理想犧牲、生命只此一遭、直線式時間觀的絕對化美感。這並不見得是吳天章這些作品裡所關注精神狀態或者「靈光」所在。

吳天章所企望的「僞裝」或者「矯飾化」美學，帶有一種詭譎的「笑」的姿勢，看見「置於死地而後生」、「方生方死／方死方生」、「一切都可以重新來過」的生命意志。羅蘭·巴特曾寫道：「歷史是歇斯底里的，只有當人注視它時才存在──要想注視它，必得置身其外。」[35]必須具有深入虛／實辯證運動中抉擇的核心，才能在那奔流向終點的關鍵時刻，奮力一縱跳出這場戲之外，開創另一次生命劇場新生的機會。「重新來過」並非逃避推託的藉口，而是生命意志面臨否定的危險臨界時，所翻轉出來的「笑」的豁達與契機。既然現實生活裡無法企及，何不透過藝術來製造幻見、享受幻見呢。

吳天章藉由攝影畫面的停格靜止，不動如動，讓這些作品中彷彿消逝的人物，像招魂一般從過去走向現在。另一方面，卻因爲停格之故，他們不動的彩妝打扮，更像不動的屍身，或者說即將被時光燒化的有形物身。明明沒有生命，卻僞裝有生命，明明是消逝的刹那，卻僞裝見證永恆的祝福。這些享有「殊榮」展示在我們面前的主角們，不是叱吒一時的風雲人物，也不是大眾傳媒裡的流行偶像或寵兒，而是幾乎未曾在我們記憶裡停留過（卻曾經活躍在電視機尚未取代真人的六〇到七〇年代的綜藝特技秀場）[36]，一直躲藏在客觀社會現實與主觀意識的邊緣與暗處──那些被視爲底層、污穢、卑賤、受詛咒、彷彿《莊子》內篇〈德充符〉中形殘貌醜的奇人。透過數位攝影，他們可以一再複製不會消失，作品的意象弔詭地接近「不死」，而作品所流露的死亡況味，卻像一再進行喪葬儀式的綜藝表演。難道這就是莊子「方生方死／方死方生」的現代贗品版嗎？

六、無所不在的「僞裝」謝幕

不要問我是誰，也不要要求我保持不變。──傅柯[37]

如果說吳天章1990年代「假假」沙龍照，具有對於1960年代的反諷與戲仿，透過把「我」投射或扮裝成另一個不是「我」的「我」，來突破禁忌，對抗或反諷權威所造成的壓抑與疏離的心理陰影。那麼，2000年過後「邪邪」的異人秀系列，依然是對於過去「那個時代」的回溯與禁忌的踰越嗎？或者其實物換星移，物質條件與時代精神的戰場已經不一樣了，整個時代氛圍已經轉變了。

從上世紀末到這世紀初，吳天章的「僞裝化」創作風格，已經變成探討一個封閉的共同體裡，不管是否面對外在強權，都一再「僞裝」的精神狀態了。或者基於一直有外力壓迫，或者被外力所迫的意識已經內化到不再在意是否有外力來源了。爲何一再僞裝？爲何繼續裝模作樣？如何看待必須以「僞裝」、扮裝來贏得注視的自我肯定、自我匱乏與自我欺騙的矛盾心態呢？在扮裝中究竟是把自己封閉起

日行一善（數位輸出）　Perfect Day Trip　2001

來、還是反而成為另一種無所不露的暴露狂呢？

狂歡節的「笑」是對生活的危機而笑，因為「笑」鬆動了原先戒備森嚴或劍拔弩張的秩序。對危機的笑，帶有希望的肯定和譏笑的否定[38]。但歇斯底里的「笑」，並沒有面對危機，而是陷入自以為跳脫危機的幻見之中。那麼，偽裝的歇斯底里呢？在吳天章視覺意象裡那深藏「偽裝」中，看不見的「冷笑」，堪稱對當前社會自我膨脹又自我疏離的精神「分裂式」傳神而幽默的「定格」。以無所不在的偽裝，來戲仿自我封閉裡的衝突與匱乏，以及在自閉中不斷內爆、虛張聲勢、瀕臨歇斯底里的狀態。

藝術家彷彿眼見狂奔向「未來」或「末世」時間即將終結，趕緊以「決定瞬間」的「攝影」定格，趕在被擠壓到最緊迫的時空裡，為不堪回首的人生，按下快門，留下一次又一次完美謝幕的「偽證」。再藉由為「我」「送終」的偽裝下，進行更深不可測的自我遁逃；製造永遠「揮別」的同時，卻又偷偷地

以「易容術」出場。

這是眼前台灣的精神狀態嗎？是吳天章的視覺意象嗎？還是「我」這位書寫者的幻見呢？或許這場書寫吳天章，只是另一種擦身而過的逼真「偽裝」。但藝術家究竟想說什麼呢？傅柯(Michel Foucault)不也幫吳天章說過：「不要問我是誰，也不要要求我保持不變。」欲知吳天章是否就是「真正」的吳天章[39]？吳天章視覺魔術秀，進行中，請進。　■

（本文原刊於2008年2月，《現代美術》第136期）

註釋

1. 本文的完成非常感謝：藝術家吳天章在畫作與創作理念等資訊上的協助，台北市立美術館陳淑鈴小姐與典藏組同仁在觀看原作時的協助，劉韋廷先生、李峰銘先生、陳玉樹先生、陳琬琦小姐在文字資料、影像與錄音整理上的協助。

2. 改寫自尼采(Friedrich Nietzsche)，《查拉圖斯特拉如是說》（Also sprach Zarathustra），林建國譯（台北：遠流，1989），〈墳墓之歌〉，頁118-119。

3. 參見羅蘭·巴特(Roland Barthes)，《明室》（La Chambre Claire），許綺玲譯（台北：台灣攝影，1997），48節。

4. 作者／王鏡玲。

5. 黃春秀，〈中國人物肖像畫試析〉，《史博館學報》第十期（1998），頁153。

6. 羅寶珠，〈歷史／現實·虛擬／妄像的同構與拆解—吳天章的藝術歷程〉，《現代美術》第121期（2005），頁40-41。

7. 陳香君，〈吳天章：笑畫批判家國的史詩〉，《典藏今藝術》2003年1月號「藝術檔案·社會閱讀」，頁113。

8. 在中國民間禁忌裡曾認為將人畫成漫畫、把某一身體部位、特徵誇大，所表現的幽默或諷刺，對被畫者而言是難堪的恥辱（莊伯和，〈民間肖像畫談〉，《美育》99期（1998），頁34）。因為這些畫像並不只是色彩與線條的視覺元素，而是包藏作畫人有意或無意地掌握畫中人神韻、干預了畫中人的未來。這種不可見的命運機緣的操控權，即使是獨裁強人在民間信仰的體系裡，也不例外。萬物有靈的信仰認為宇宙力量之間有其互動關係，物物之間並沒有因為一個對象目前享有帝王般的至高尊榮，就任其變成像基督宗教的上帝一般，永恆不變、全能無敵。相反地，它依然要參與在和他人互動的命運變動之中，即使被視為一國最高權威的君王畫像也不例外。

9. 根據2007年11月10日對吳天章的訪談。參見姚瑞中，〈攝魂術還是夢魂術？吳天章的數位輪迴〉《大趨勢》藝術雜誌：吳天章專輯，春季號（2004）頁72-73。

10. 在此請容我借用本雅明(Walter Benjamin)在〈攝影小史〉裡對於「靈光」的使用，詳見本雅明，《迎向靈光消逝的年代》，許綺玲譯（台北：台灣攝影，1998），頁27-40。

11. 《明室》，頁124。

12. 詳見陳映真，《石破天驚》，〈台灣經濟發展的虛相與實相—訪劉進慶教授〉（台北：人間，1988）頁177-192；陳映真，〈反對言偽而辯〉（台北：人間，2002），頁31-33；楊渡，《強控制解體》〈導論--強控制解體的年代〉（台北：遠流，1988）。

13. 陳儒修，《台灣新電影的歷史文化經驗》（台北：萬象圖書，1997），頁29-34。

14. 吳嘉寶 http://www.fotosoft.com.tw/book/papers/library-1-1005.htm；羅青，《什麼是後現代主義》（台北：學生書局，1989），頁317-318。

15. 莊伯和，〈民間肖像畫談〉，《美育》99期（1998），頁34。

16. 根據吳嘉寶的說法，「台灣攝影文化的第一次開花期，也是沙龍攝影在台灣攝影史上的全盛期。時序可以從台灣光復初期的1950年左右計算到1960年代中葉為止。」「在1970年以前不食人間煙火、不但無法獨自開創新局甚至還與世界攝影思潮發展開始脫節的沙龍攝影，就成了這段時期台灣攝影文化的唯一顯學了。」http://www.fotosoft.com.tw/book/papers/library-1-1005.htm。郭力昕，《書寫攝影》（台北：元尊文化，1998），頁34-35。

17. 吳天章說：「青春稍縱即逝，我要青春泡在福馬林的感覺」，2007年10月2日對吳天章的訪談。

18. 引自吳天章2007年11月12日回覆我的電子郵件。

19. 引自吳天章2007年12月01日回覆我的電子郵件。

20. 這是吳天章在自述中，以及我所進行的四次訪談（2007年10月02日、10月09日、10月24日、11月10日）中，一再出現的看法。

21. 這部份吳天章與藝術家黃進河有異曲同工之妙，詳見筆者〈形可形，非常形—黃進河視覺美學初探〉，《當代藝家之言》2004秋分號，頁76-86。

22. 〈紅玫瑰·白玫瑰〉是《戀戀紅塵II—向李石樵致敬》這部影像創作的現場音樂。

23. 李友煌，〈見與不見—來途昭彰，去路蒼茫的藝術進程〉，《台灣美術與社會脈動2—寶島曼波》（高雄：高雄市立美術館，2007），頁21。

24. 引自吳天章2007年11月29日回覆我的電子郵件。

25. 黃海鳴，〈滲出豔麗、慾望及記憶的洞口—試分析吳天章97個展中的時空結構〉，《山藝術雜誌》90期（1997）頁103。

26. 黃海鳴，〈台灣當代藝術：虛擬聯結·批判·歸復共時交識的三種現象〉，《台灣台灣—面目全非》（台北：台北市立美術館，1997），頁24。

27. 佛洛伊德(Sigmund Freud)，《圖騰與禁忌》(Totem and Taboo)，楊庸一譯（台北：志文，1986），第二章：禁忌和矛盾情感。

28. 根據吳天章2007年11月12回覆我的電子郵件。

29. 《明室》，頁82-83。

30. 「分身像」通常是指將同一位拍攝對象，照兩次後，合成同一畫面。參見陳申／胡志川／馬運增／錢章表／彭永祥合著，《中國攝影史》（台北：攝影家，1990），頁111。

31. 杜斯妥也夫斯基（Fyodor Mikhailovich Dostoevsky）的小說《雙重人》(The Double)裡，具有強烈自尊心的小官吏柯里亞金，鄙視工於心計與巧言令色，但這位主角在自尊極度受辱之際，他所鄙視的性格現身，在小說裡成為柯里亞金第二，主角不斷被自己腐敗殘酷的分身之間的衝突糾纏，終究被送入精神病院。詳見《雙重人》，邱慧璋譯（台北：爾雅，1976）。

32. 巴赫金（M.M. Bakhtin），《巴赫金全集》第五卷《陀斯妥耶夫斯基詩學問題》（石家庄：河北教育，1998），頁219。

33. 《巴赫金全集》第五卷，頁162-163。

34. 「支離疏」借用自《莊子》內篇〈德充符〉與〈齊物論〉的概念型，指形貌醜者，自己忘其殘缺，也讓別人忘其殘缺，在此，我引申為吳天章透過「劇場化」的視覺意象，作為一種可以達到忘其殘缺、「方生方死」「方死方生」意境的偽裝。

35. 《明室》，頁82-83。

36. 2007年10月9日對吳天章的訪談，以及11月29日吳天章回覆我的電子郵件。

37. 米歇·傅柯(Michel Foucault)，《知識的考掘》(L'archéologie du savoir)，王德威譯（台北：麥田，1993），頁88。

38. 《巴赫金全集》第五卷，頁166-167。

39. 改寫自霹靂布袋戲系列《霹靂劍魂》第九集「外域來的統治者」裡「命七天」的化身「照世明燈」所言：「歐陽上智就是真正的歐陽上智！」，該劇主軸之一即是武林群俠追殺武功高強、善於易容術、神出鬼沒、高深莫測的大魔頭歐陽上智，可惜歐陽上智最後被編劇匆匆賜死，草草謝幕。文字劇情參見 http://blog.xuite.net/henry10187/whitewing

Is the Real Wu Tien-chang Really Wu Tien-chang?

Exploring Wu Tien-chang's Images [1]

Wang Ching-ling

The phantom of youth, too early did ye die for me, ye fugitives. Yet did ye not flee from me, nor did I flee from you: innocent are we to each other in our faithlessness. [2] -Nietzsche

The first time I saw Wu Tien-chang's series "Dreams of Past Era", my mind unconsciously drifted back to the scene of a local funeral where those stately paper homes, mixing Japanese baroque and Fujian style architecture and festive decorations, were burned as a symbol of the inexhaustible riches of the afterlife in exchange for their material bodies. At the center of this stately home, under the gleam of colorful lights, there was a black and white photograph of the home's owner, whose blank stare that was watching everything and seemed to be full of implications.

This funeral portrait, by virtue of the fact that it is a photograph of someone who once had truly existed, brings back an image of the deceased's corporeal body and also a vivid feeling of presence from that place we imagine death to be. This that has passed, but is called back by our imagination of death, uncovers our fears of death, which we thought to be calmed by funeral rites, and our inexplicable rejection, fascination and emotional attachment for the reappearance of the dead. The subject, who is no longer with us in the human world, stares out from the picture more vividly, and menacingly than when he or she was alive. Roland Barthes once said that photography recalls madness[3]. Aren't these invisible feelings of amazement and treachery that Wu calls forth from the visible material in his images exactly the depths of madness? At the same time, Wu's images present a tension between spewing forth and restraining madness.

I. Returning to the Origin of Making Believe Memories

An artist must create a construct and use it to capture and reinvent reality, not just reflect reality. -Francis Bacon [4]

After martial law was lifted in 1987, Wu turned from his expressionistic paintings, like "A Symptom of the World Injury Syndrome", which narrated stories of national violence and calamity to portraits of political strongmen and dictators, as in the "Four Eras" series. In this new portrait phase, Wu introduced his skillful political caricatures originally published in underground magazines during the martial law period, and blended them with a large scale poster board format and mural painting style. In this series, we can already sense the ambiguity that is so commonly found in Wu's later works. This ambiguity at first glance is a mutual antagonism, yet as we look deeper, becomes an indistinct boundary of opposition which creates a mutual shielding and make believe harmony.

In these portraits, Wu Tien-chang presents three kinds of image based ambiguous relationships. The first kind relies on a large format to create a visual effect. Wu combines traditional styles found in portraiture of emperors and ancestors along with movie poster and martial law period political poster styles to create a feeling of imposition and authority. The second kind uses bloody images of injured or killed people which are reminiscent of traditional patterns on an imperial dragon robe[5], and a symbol of power. Together these two elements lead to the third feeling of ambiguity, which is created when Wu Tien-chang attempts to expose the perpetrators of Taiwan's historical calamity,

關於毛澤東的統治 The Rule of Mao Zedong 1991

and also expresses the feelings of love and hate in the creed "one general achieves renown over the dead bodies of ten thousand heroism."[6] These over-sized tombstone like oil paintings seem to be bidding a solemn farewell to the shadow of autocratic rule[7], and also, like the small-minded parodying banter of kuso similar to Lu Xun's Ah-Q, feebly struggles with dictatorship, defeat and despair. It seems we might as well make self indulgent cartoons and faces to pester the powerful behind their backs[8].

At the end of the 1980s, and beginning of the 1990s Taiwan shook off martial law era with amazing force and set new boundaries of subjective consciousness. Wu Tien-chang preserved, tore apart and set free the severe atmosphere of political violence of the old era

and symptoms of collective injury with his exaggerated style of oil painting that blends monuments and comic book drawings, which can be seen in "A Symptom of the World Injury Syndrome" and "Four Eras". From within the collective imagery of this violent and closed off system, Wu Tien-chang found an exit for this frustrated desire to extend outward. Wu turned from using oil painting to photography, and went deeper into memories of an injured subjectivity buried in the past. In this way he created another kind of real subjectivity that pretends by performing a lie. The artist quotes different time periods in his work to seize and recreate feelings of intimacy or distance, including the wound caused by not being able to constitute or satisfy the self. With his art, he turned deep and long term suffering into masochistic joy, using laughter to release

pain.

At that time, Wu Tien-chang wished to use images as a means of expression but was struggling with his ideals and reality. He was wondering how to create images that presented reality and theatrical tension without real outdoor scenery, actors, a production team or large expenditure of money. Wu very cleverly remembered that the director Huang Ming-chuan had said an aesthetic is formed by limitations. Wu Tien-chang's aesthetic of artificiality evolved out of trying to fight big with small and making real out of fake by using salon photography to substitute for movie sets and outdoor scenery, which in other words was essentially making something out of nothing. Wu's mannerist aesthetic of artificiality initially came from his previous creative period when he was materially impoverished. The artist went through this period of trial by fire, which made his work even more shamelessly gaudy, employing a mannerist mentality mixing real with fake, and high with the cheap and crude counterfeit culture that fills our everyday lives.

Wu Tien-chang doesn't pursue documentary photography nor does he attempt to present the most natural features of the photographed object solely as it appears. Conversely, he intervenes in the photograph like a writer/director, using role-playing, costumes, props and backdrops that he makes himself [9]. Figures in the photographs are all looking into the camera lens, however all expression has left their eyes, and it seems as if they are putting on an act that is difficult to fathom. Wu Tien-chang's meticulously constructed salon style not only reproduces memories and recorded reality, but also relies on fabricated, excessive recollections to block memories.

Memories constantly shuttle back and forth through a world where reality and fantasy are hard to differentiate, and the deeper we go in, the more difficult it becomes to find our way back. At this critical point of being lost, we are induced to create extra memories to make up for those that are lost. Wu Tien-chang tests our memories with the decisive historical moment of the 1960s or earlier. It is in this era that he is searching for lost time and also the inspiration for creating these memories. He recreates

these times with big and small things that he is fond of, including clothing styles, different fabrics, postures, music, furniture, backdrops and lust. These all invite the viewer into this forgotten world, which seems as if it once existed in a distant time and also feels a little familiar.

These kind of subversive yet fashionably nostalgic simulated scenes aren't like the photography that captures the moment at hand or bears witness to a certain kind of life. Wu Tien-chang draws in the viewer with these fabricated images, and they are compelled to stare at the aura[10] of a time that has passed and will not return. Viewers can use these fabricated images like a flashlight to explore the cellar of the soul, and together spy on the internal texture of those old dust-laden times. However, Wu Tien-chang doesn't lead us to any specific or concrete historical past that once existed, but rather brings us to the entrance of an even farther away, more oppressive and longer ago make-believe memory, and this entrance, where we can't distinguish between true and false, seems to turn inwards towards the remains of an isolated memory, and also seems to be like a window where imaginary desires spread outwards.

His images serve as a starting point for the return of these difficult to substantiate memories, and the use of portrait photography as an artistic style combine the motive power of desire and the popular belief in the indestructibility of the soul. When looking at Wu's work, our conscious imagination boundlessly extends from the visible world of desire into the invisible underworld and to the wheel of karma which eternally revolves through generations and the ages, like a spirit lingering in its funeral portrait that does not wish to disperse. Like painting with two brushes at the same time, Wu employs metaphysical imagination and the physical body of portrait photography to express an older time, time differences and the layers of old souls that pervade everything. This kind of association to the collective subconscious has often shocked the viewers when looking at Wu Tien-chang's portraits. Because they are mostly equipped with a typical Han concept of the universe, viewers see these images as terrifying taboos associated with the supernatural and symbolic world of the dead. However, in Wu's compositions of

dissembled, gruesome humor we also sense safety from his exaggeration, sarcastic play and the suggestion of a certain distance from reality.

II. Making Lifelike Salon Photography out of Fantasy

The essence of the image is to be altogether outside, without intimacy, and yet more inaccessible and mysterious than the thought of the innermost being.. [11] *- Blanchot*

This phony, mannerist quality has always been regarded as Wu Tien-chang's principle style. According to Wu, this comes from the rough, replaceable, temporary attitude held by the exiled rulers of Taiwan as well as popular culture which often substitutes the bad for the good. With his blatantly phony and dissembled material-based style, Wu Tien-chang creates an ambiguous, make-believe world which alternates between the void/false world and substantial/real one. We can roughly catch those elements created by Wu based on real aspects of society, as well as indications of the artist's manipulations from his time contrasts and class consciousness in his false/real salon photography imagery.

First, regarding time contrasts, Wu used a quality of salon photography that vividly reflects Taiwan's transition from a society based in agricultural and handmade industries to a modern one based on mass production. The 1960s is a time that is often the focus of Wu Tien-chang's work, and is the time which formed his adolescent memories. This time was also part of the period from the 1950s to 1960s, when the United States viewed Taiwan as an important stronghold in the East Asia cold war and so invested a large amount of money in Taiwan. Assistance from the United States stabilized and improved Taiwan's financial and basic structure, and also made Taiwan dependent on the U.S. economy. The local government began allowing foreign capital into Taiwan and established policies encouraging foreign investment in the 1960s, combining foreign capital with private enterprises, accelerating industrialization and spurring high-speed economic growth. With guidance from the U.S. in transnational foreign investment, Taiwan became a manufacturer and exporter of low-priced light industrial products, which contributed to the gradual increase of middle and working classes in Taiwan. [12]

Agricultural development gradually declined in this period due to the shift in government policies encouraging industrialization. A large portion of the population left farming villages and went to the factories to become workers, leaving the past settled lifestyle of large families, crops and a close relationship with the natural environment behind, and entered into a lifestyle of urbanization, functionalism and mechanization, where a foreign land is turned into hometown. During this period, education gradually became universal, and the literate population with a western world view gradually increased. Methods of economic production gradually transformed as more people accepted the capitalist economic system, with its machine related manual labor, in place of the agricultural world view emphasizing natural work and rest cycles. The previous consumer economy based in handmade goods and local self sufficiency also gave way to industrialized mass production and interregional consumerism.

At that time, photographers trained in Japan or Mainland China established photography studios in urban areas and more photography started to appear in Taiwan's newspapers and magazines. Starting in the 1960s motion picture entertainment became more widespread, [13] televisions entered homes producing a new mass-media culture. [14] Knowledge and leisure-time entertainment disseminated by machines gradually replaced the face to face, first-hand participation in activities of the past. In the past in agricultural times, it was believed that photography could steal a person's soul[15]and therefore cameras were rejected as instruments of witchcraft but this belief was gradually abandoned as more people in cities accepted machine produced goods. After people accepted the camera it no longer possessed metaphysical, spiritual power, and using the camera to quickly record important events at home became a part of life. Starting from this period, photography replaced traditional portrait painting in Taiwan and became the most important medium for funerary portraits of family members. It was also in this era that photography became an important testimonial object

再會吧！春秋閣 On the Damage to "Spring and Autumn" 1993

recording the lives of youth of the time.

However, in this time period which saw the gradual widespread use of the camera and increased industrialization, due to the political environment of martial law, many artists were held back from pursuing their ideas, consequently in this period of economic advancement and flourishing photography activity, what was popular in ordinary society was just salon photography culture, which tallied with the official governmental yardstick of correct or secure, and wasn't closely related to reality. Governmental controls of the time held public opinion to the notion that "salon photography was the only genuine photography." [16] At this time when the economy was shaking off poverty and people were seeking basic material comforts, going to a photography studio wasn't a common occurrence for most people, but rather like attending a formal event or putting on stage make-up and performing a role. Therefore, dressing neatly and sitting nicely for the photographer to commemorate a moment like an important person was a conceit for average people at this time. This affectation of dressing up in fancy attire, made possible by newly developing mechanical technology, gave the average person the fantasy of feeling important for at least an instant.

On the other hand, from the point of view of class consciousness, why would people want to put on an act or make an empty show? Could it imply that these people knew perfectly well that there was no way for them to really scale the dizzying heights of the social and economic ladder and make a genuine display of wealth? Nevertheless, with bluff and bluster these people took back the appearance of being on par with their rivals through imitation. This Ah-Q-like spirit seems like contemptible affectation to outsiders, but for those being photographed it was a serious display of vanity. Since there was no way to create new self-worth quickly or independently, they thought why not opportunistically emulate the others to vent their feelings or deceive and ridicule themselves. Isn't this the covert disposition of an underdog who has no means to contend with power and authority, and who doesn't want to be harmed or denied or even annihilated, in return launching a counter attack on the cultural playing field for the sake of survival or vanity?

This is exactly the essence of what Wu Tien-chang's images make obvious, but he doesn't only present these two qualities of salon photography from the past. Wu takes it a step further and presents us with sexual desire that wouldn't normally be seen in this kind of photography (for example the feminized sailor with an ambiguous erection, or the young woman playing with her breasts), and also memorial photographs of the dead and references to funerals (such as rings of artificial flowers and mourning clothing). What I find paradoxical is that we see an inevitable and difficult to mask reality in Wu's repeated funerals of bidding farewell and his dissembled salon photographs. By creating loss, Wu Tien-chang stirs up the desire to possess, and with fictions seeks concealed or lost reality. Loss and pretending unexpectedly become the most authentic existence for the self.

Wu goes so far as to deliberately hide the eyes of the figures in these works. Does he do this to intensify the portrayal of injury and spiritual oppression? Or perhaps, he tries to break away from the former self by applying a mask or other forms of disguise? Or do these hidden eyes catch sight of a world that can't be seen with the naked eyes? Who knows? If these figures set aside their bow-ties, glasses and flowers one day, and they are given eyes and thus brought to life, what kind of world will they see?

In these portraits, Wu Tien-chang reveals an ambiguous complex of satire, ridicule, pity, consolation and salvation for those who have been defeated and marginalized through some quirk of fate, and therefore cannot take center stage. Within the closed world of the photography studio, simulated background scenery and affected transformations of identity make photography just like magic, and allows the subject to temporarily shed his or her true identity of disadvantage and play a new role in a make-believe world. However, in the decisive moment when the shutter is released, an image is created of false appearance that actually once existed, and which serves as a forgery harboring malintent, betraying the vanity

and illusions of the subjects in the images.

Who really cares about the identity of these people in these portraits? Phony or real, perhaps they are all just projections of the artist's own lurking self or caricatures of society. They are similar to characters in a Dostoevsky novel, in that they present multi-layered and conflicted identities full of restless worry, over-stimulation, self-importance, self-abasement, inhibition and bombast. When looking at these photographs, "who is that?" becomes "who am I?" and observing these conflicted characters, viewers discover ways to justify self-contradictions. There is no longer a standard answer to the question of who is real and who is phony, but rather the question becomes why the real, underlying and shocking nature of things is forced to the fore with these artificial settings and costuming, fabrication, and simulation techniques.

These simulated salon photographs which "steep youth in formaldehyde,"[17] not only obsessive compulsively addresses the wounds of an era, of those who are struggling but getting nowhere and carried ahead by the times but haven't stopped looking back, but also present something that is not exactly the past but rather the artist's fantasies of ambivalent desire. Wu Tien-chang hasn't completely entered the mechanical age; he still sentimentally keeps one foot in the previous handicraft era. The artist is infatuated with lost time–with the special spirit of the old days before it was replaced by machine technology–and the handmade textures throughout his work, "*velvet, gold lame fabric and sparkling beads all seem to give off the feeling of looming, unbridled lust.*"[18] With his fetishized objects, Wu uses figures to call attention to materials, the materials to call attention to the feeling, and then with the aid of digital photography he resurrects the spirit of old objects that have been almost completely forgotten in today's industrial society.

In images made with digital photography techniques, elements from different times and places can be arbitrarily combined in a photograph, creating a virtual decisive moment. In the world of virtual imagery, all visible elements are deconstructed and arbitrarily recombined. This seems to provide an opportunity for unlimited combinations and interchangeability among elements, however different individuals' taste in images is definitely not equal, doesn't depend on their quantity, but rather on their quality. There are always those images which fascinate us, like those disloyal or ambiguous lovers situated between eternity and nothingness, and Wu Tien-chang continually pursues this kind of profound mystery in his images.

Wu Tien-chang's work isn't mired in the current trends of rootlessness, all inclusiveness or high speed, high capacity image production, but rather is engaged in a Don Quixote-like attempt to rediscover photography, in such a way that the "image in the photograph will recreate the mixture of awe and misgivings people felt when photography was first invented."[19] This artist is like a reincarnated spirit who did not drink Mengpo soup to forget his past life; on one hand he wants to hold on to the sea of desire, of loves and hates from his past life, and also can't wait for his dazzling new muse of life and love. From one role to another, Wu has wrapped himself in both the bottomless past and unknowable future.

III. Transversing the Threshold of Sexual Desire

The illusion of false testimony that photography creates, even if it is an old, yellowed photograph, can still arouse the mystical feeling that the people in the photograph are still alive. –Wu Tien-chang[20]

The biggest difference between human vision and a camera lies in the fact that a camera can freeze a fleeting appearance, while human vision cannot. What I find interesting is, although human vision cannot do this, human memory can. Photographic images are surreal symptoms of a reoccurring mental illness, in that they reproduce frozen memories of the past. Thinking this through, what kind of memory can eternally dominate and repeatedly appear, never hesitating to show itself in a dream even though it is repressed? It is exactly those memories that make us the happiest and are the most attractive, and also the most terrifying, menacing and destructive memories.

The happiness and self preservation mechanisms we pursue even under the threat of death are the basic operations that suppress or reveal desire.

春宵夢 I　Dreams of Past Era I　1994

The exploration of sexuality in Taiwanese society has always been severely repressed, even more so than political discussions were during martial law, and was an awkward topic for public discussion. The artist was often called to account publicly for his use of sexual subject matter by commentators. When commentators are looking at sexual subject matter they often dis-empower sexual subjects, sully the artist's name or publicize it, in an attempt to manage or avoid facing the awkwardness caused by introspection or the possibility of transgressing society's taboos.

Sexual subject matter was the primary direction of Wu Tien-chang's work in the period following the mid 1990s, which was an addition to his appropriation of funeral portraits and other funeral-related images and in this way launched a dual offensive against the two taboos of sex and death. The first challenge to the viewer was to inspect the tension created between simulated sexual subject matter and morality.[21] The second challenge to the viewer was a sexual fantasy, blasphemy and taboos regarding death with its ambiguous feelings bordering on terror and seduction. Wu Tien-chang's work that challenged death related taboos faced difficulties on the art market at the time, and the artist had no choice but to tone down and disguise his work with ambiguity.

In "Spirit Dreaming Conjuration", Wu Tien-chang provided a vivid explanation of his ideas regarding desire while making his work "Dreams of Past Era":

When a man is dreaming of having sex with a woman, this woman is actually a projection of the man's anima, or the essence of femininity in the man's subconscious. This subconsciously satisfies the man's physical and psychological need for sexual gratification and compensates for the lack of an actual relationship with a woman.

The female figure in Wu Tien-chang's work "Unwilling to Part from Worldly Life II" , is a man dressed up as a woman. With this fantasy of transformation to the opposite sex, he produces a split self possessing both seduction and desire. The split self combines into one again during the sexual fantasy. Desire isn't limited to fantasies about one's own self, but also has a close relationship with the object of desire, which usually

doesn't only stop on one individual, but like a honeybee, goes from rose to rose.[22] The self hesitates between fidelity and betrayal, while worrying about getting hurt even though it cannot stop expecting and therefore feels the insatiable pangs of infinite emptiness.

Artwork always uses a limited self to reveal what seem like unlimited others, one after another. The desire to have multiple selves which is united in one is used by the artist to deal with conflicts between the human, animal, god and devil selves and transcend them. However, Wu Tien-chang sees how far one can go away from the real world, so in the dimly lit room of the photograph, the wretched little costumed figure with a touch of kuso walks back into the picture frame and waits for one of the many limitless opportunities to step over the line. This work, "Unwilling to Part from Worldly Life II" uses machinery to constantly play out the cycle of setting out, gratification and a return to a never ending destiny, until the electricity runs out or the machine breaks down.

Affectation, formal or obscene poses, as well as disingenuous smiles and deliberate mystifications hidden under glasses, eye covers, artificial flowers and fake jewelry in Wu's series "Dreams of Past Era" and "Unwilling to Part from Worldly Life II", seem to stir up destabilizing undercurrents and conspicuous attempts to hide something with a rebellious ecstasy. Wu Tien-chang doesn't have a confrontational style, rather he always uses techniques like play acting, dissimulation, concealment and ambiguity to act as a cushion and conceal his own intentions. Wu Tien-chang doesn't directly reveal or confront, but rather always play acts in a way that makes it difficult to determine the truth, and in this way avoids the difficulty of antagonism. Under the control of a staged photograph, Wu Tien-chang mixes vulgarity with a counterfeit style. On one hand, he tantalizes, provokes and seduces, and on the other taunts, feigns, alternately holds back and releases sexual teasing, which lets each viewer enjoy fantasy, frigidity, infatuation, disgust and confusion.

The woman's appearance in the series "Dreams of Past Era" is worthy of our attention. Sometimes she is

dressed as a gracious and upright young woman in fashionable clothing, and at other times like the diva of a dance hall or a sex worker. When she appears as the classically fashionable woman, she projects a dignified air and is seductively touching her breast. As the seductive, world-weary, mature woman, she projects the oppressed feeling of someone who must put on airs to maintain a pose of sophistication. Yet another character making an appearance is the taciturn woman who has something weighing on her mind but artificial flowers are issuing from her eyes and mouth. Taking another look at how the material is pieced together, most of the frames for the series "Dreams of Past Era" are covered with brightly colored artificial wreaths or flashing light bulbs, and have a visual effect like funereal scenes performed by theater troupe. Looking carefully at the photographs, we can detect some areas of the print where the color registration is deliberately off, which creates the feeling of low quality printing, especially in "Dreams of Past Era I". What is this phony, mannerist funeral trying to say farewell to? Are we bidding farewell to our mores so we can tease out our hidden and deeply repressed desire to transgress taboos? Are we expected to revel in the thrill and terror of the ultimate transgression of having intercourse with these women in funereal portraits?

If these pictures imply funeral portraits, then the modernizations of technological civilization aren't only replacing emotional tendencies of religion with machinery, but on the contrary, create sexual desire that is directed at an invisible world with imagination transformed into imagery with technology, and bringing with it a different kind of resurrection even more real than the real visual attraction that absorbs the soul. This subconscious desire for transgression isn't only the writhing blasphemous desire of the necrophilia, but even more importantly for the artist, is the exposure of those imagined destructive and violent spiritual connections. Bidding farewell to the limitations of the flesh and the mores of the world of the living draws out even more intense dread and sexual imagination.

The patriarchal culture of desire in the Chinese folk concept of the universe provides a connection to the vigorous sexuality of a female ghost. From "Dreams of Past Era" to "Spirit Dreaming Conjuration", the lonely self projects its desire onto the imagined other in sexual fantasies, and the ghosts thus quietly form. The pleasures of both the sadist and masochists are keenly felt, and as the two selves become one self, it is pulled back and forth and in and out in the same way as the inherent conflict of the hermaphrodite. The extreme of life spurting out is present at the moment of death, and this is spirit and body combined into one, as well as the moment that the body and spirit destroy one another. Isn't the most difficult to understand allure in life the desire to destroy oneself at one's happiest moment? On this critical point when climax is achieved a man's defense mechanism reemerges, and as the dreams turn into reality and the show is over, has the soul been lost? Or was he just waking up from a show or a dream?

IV. The Garish, the Kitschy, and the Filthy...

Life is so unreal that it strikes us with its beauty. - Lee You-huang [23]

The aesthetic of ambiguity that stays intriguing - where elegance borders perversion and proverbs meet decadence - Wu Tien-chang

Wu had said, "Since every road leads to Rome, then is it possible that my use of extravagant, humorous and graceful ways to present latent desire could also take me somewhere?" [24] In late 90s, Wu had taken on many visual experiments in which he attempted to extract imagery from popular culture and folk beliefs, struggling between the search for morality, death anxiety and sexual desire. Using mixed media to fabricate surreal scenes, he intended to push the limits of social norms, and to test the capacity of art market. Created by the artist, those filthy and uncensored images include decorative frames made of gold lamé and sequins, smooth dark velvet, glittering glamorous perversion, stale freshness, and mysterious excitement from obsession to voyeurism and fetish. The more decadent and garish they are, the more seductive and powerful these images get.

Let us take a look at the defensive mechanism activated by decadence. By calling his imagery "the filthy and

uncensored," [25] Wu has been playing with castrating his border crossing sexual desire, making a confession to the viewer. It's like he is hailing everyone to come and watch this X-rated dirty show, and advises them to mind the sty they might contract from looking at his work, such as "Composite Damages II".

What exactly are those filthy and uncensored images? Perhaps we should look at them from the garish perspective of kitsch. The first type of filthy imagery arises from deliberately manipulating the idea of filthy. On one hand Wu plays with taboos to reflect upon our anxiety about death and funerals, on the other hand he subverts these taboos. In our society, people believe that having any contact with the dead, be it direct or indirect, will very likely bring about disaster and misfortune. Taiwanese custom sees the dead as a source of evil breath, so we have to relocate the souls of the dead somewhere away from the earth with certain ceremonies, parades and entertaining performances.

In Wu Tien-chang's series "Wounded Funeral", we can see those figures in funeral portraits acting as the deceased and playing sadistic tricks, like they are still stuck in a Freudian oral stage and making kuso performances. [26] This series expresses the absurdity of happiness mixed with sadness, which is commonly felt at a traditional funeral, as well as the escape from sorrows through a defiant attitude and self ridicule when facing the loss of the deceased and related feelings of ruthless abandonment. "Wounded Funeral" overlaps the visible wounds (with sadistic acts) and invisible wounds (in the mind or values). These scenes make it difficult for us to react reasonably to them. Perhaps Wu thinks people carry too much emotional baggage, fear, repulsion and rejection towards funerals[27], so he decided to use humor, parody, self-ridicule and kuso as springboards to transcend our usual perspectives. Not seeing death as fatal mortification, he suggests we gain strength from mischievous tricks and embrace a new cycle of life.

Then there is the second kind of filthy imagery which appears in the most unexpected areas. These uncensored objects are always despised yet at the same time are attractive to us. This signifies Wu's memories of childhood fetishes. These uncensored images grow on human bodies for no reasons. This makes the viewers bewildered due to the ambiguity between disease, wounds, punishment and sadistic acts. In "Composite Damage I", the picture looks like some black and white medical picture, a reishi mushroom grows from the breast, oozing out gooey discharge resembling body fluid. These images remind us of the charlatans in 50s or 60s, who wandered from one place to another, showing people exaggerating pictures of body parts suffering from medical disorders and took advantage of society before it had improved its hygiene situation. Wu Tien-chang uses the memories of these images of medical disorders and transforms and embellishes them so that the positions and shapes of these uncensored objects connect taboos with sexual desire. In "Composite Damage II", we see something that looks like a dead sea cucumber or a silkworm cocoon stuck on the figure's eyelashes and keeps the eye from opening. The image resembles a sty, which is a symptom of seeing something you are not supposed to see. Imagery of filthy objects also serves as a warning of punishment for decadence. [28] The artist seems to be sending out some mischievous advice to the viewers, suggesting that they too are looking at something they are not supposed to see.

Another example of uncensored objects can be seen in "Sea of Desire". A sexy looking finger with pink nail polish sticks out of the mouth of a smelly fish decorated with jewelry, and touches muddy, shady velvet in the background. The picture looks as if it emits a fishy smell and therefore drives viewers away. However, the artist did not hide this away, but instead he marshaled all his effort to frame the image with gold lame and clusters of flowers, and hung it on the clean wall of the gallery. The illicit manner with which Wu treated this filthy image, the fact that he did not spurn but instead praised the image, shows Wu's intention of challenging the physical taboos of do not look, do not touch and do not eat. By displacing visual imagery, Wu challenges and exposes instinctual impulses that are oppressed and denied. He rides on the weight of desire and reaches a spiritual depth that is still new among the usual visual imagery, and in so doing he has been able to find truth in life.

The third type of filthy imagery is used by Wu Tien-chang to tackle the taboos regarding incest. Besides the

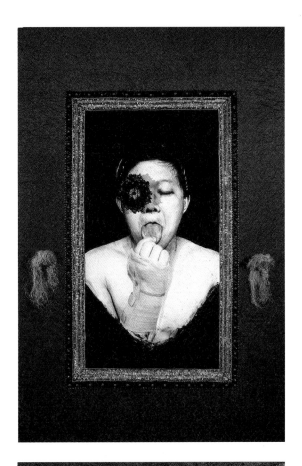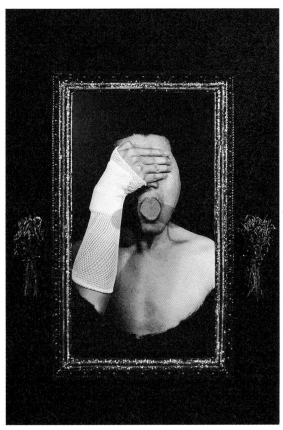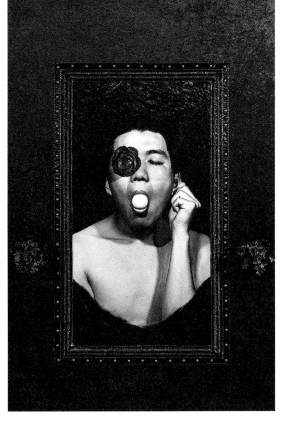

傷害告別式 I —IV Wounded Funeral I-IV 1994

filthy feeling of anxiety over death and funerals, and the filthy feeling caused by anxiety over hygiene issues caused by gooey, stale visual imagery, incest is the taboo that provokes moral issues the most in Chinese society, and is even condemned as a sin. In the two paintings from the series "Home Sweet Home", viewers find themselves lurking in a dark, murky, stagnant and moldy room, holding their breath and peeping at a perverted sexual affair where the figures are blindfolded with scarlet velvet ribbons. The figures look as if they are participating in a secret and wild masquerade.

The little baby's feet in "Home Sweet Home I" are kicking and caressing the mother's full bosom, while in "Home Sweet Home II", the boy is using his little hand to explore inside the skirt of a lady who may or may not be his mother. Both of these children are wearing a mystical smile that comes from sexual pleasure. Two fish in the fish bowl are looking at each other and there is a cat gazing out of a painting. The cat's empty eyes seem to be plotting some mysterious conspiracy. Unlike those Surrealists who create poetic icons in an elegant and romantic way so that they can employ them as ironic commentary or as a tool to blindfold the viewers and secretly challenge incest and decadence, Wu Tien-chang chose a garish and cheap approach to create his imagery, experimenting and fabricating pornographic scenes, to present nightmarish illusions. I find it paradoxical that such a straightforward way of introducing the Oedipus complex appears even more mysterious than if he just insinuated the topic. It is like disguised unsatisfied desire. This kind of hardcore pornography is not often seen in Wu's work, so perhaps what prompted these

情慾海 Sea of Desire 1997

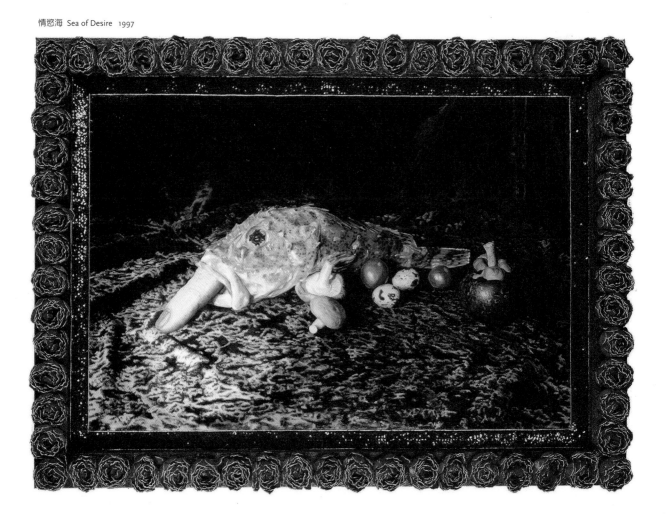

garish, cheap and provocative images has something to do with his unspeakable suffering when facing the breakdown of relationships.

The fourth kind of filthy image indicates a seductive and ambiguous sexual identity. As stated above, Chinese society has no specific restrictions concerning transvestitism, however, anything related to sexuality, directly or indirectly, is considered vulgar and filthy. Although sexual teasing is a part of folk rites or temple ceremonies, these social institutions which advocate abstinence or the private aspect of sex still try to demean and defame the sexual tease in entertainment in order to dominate sexual desire.

Wu Tien-chang plays with ambiguous sexuality. In his art he breaks through boundaries between sexual desire and social stratum. In "Unwilling to Part from Worldly Life II", Wu adapted the realistic painting "Market" by senior painter Li Shih-chiao, and replaced this scene of a market where tensions are caused by different social strata with alternating views of a sexual struggle in a dark room. Intrigued by the dark side of sunny girls, Wu always wants to project some ambiguous, lusty thoughts on them. Just like in a monster-revealing mirror, we see flesh and energy in the fabricated vulgar and filthy imagery Wu Tien-chang draws from subculture, which long ago lost the graceful, neat and high visual quality advocated by high culture.

Wu Tien-chang does not intend to reproduce or represent social reality, but instead he creates his own visual imagery to bring our attention back to the border between shade and light, good and bad, nice and evil, decadent and transcendent, or moreover the battlefield of our entangled desires. Shade comes from light, as shown on a piece of velvet; corruption is highlighted by contrasting characteristics between decay and the wholesomeness and absurdity forcefully stitches together contradictions in reality causing a dilemma in rational judgment. All of these are created by Wu Tien-chang in his fabricated visual obscurities to lure the viewer into a blurred state of ambiguity and mystery.

These filthy and uncensored images are deeply connected to the "other" mentioned earlier in this article. In his opinion, the filthy and uncensored imagery is not a label for negativity, instead it serves as a means to counteract, subvert and transcend; a way to break through gender, class, age, ethnicity, or even morality (for example, incest and necrophilia) and life and death. What is filthy and uncensored here is not just a visual object but rather a visual event, and so viewers can't help but be deeply engaged in these objective events. It is not the artist's responsibility to suggest how viewers part from wounds and death, or how to find a new identity. What art does is to engage every one of us, and force us to look at ourselves in a picture we are unable to stare at: taboos regarding sexuality, death and power, and to reach the invisible and unspeakable critical point where our state of mind evaporates: the edge of hysteria. And from there we can separate from the roles we play, because using will power to include art into our collective imagination is just the beginning of an art journey, not the end of it.

V. Schizophrenic Disorders in a Heretical Magic Show

History is hysterical: it is constituted only if we consider it, only if we look at it – and in order to look at it, we must be excluded from it.– Roland Barthes[29]

After 2000, Wu Tien-chang still experimented with different visual styles, fabricating reality to manipulate viewers. Through the technology of digital photography, Wu Tien-chang was able to reproduce images that were more realistic than subject models. Seamlessly altering, adding, subtracting and piecing together, he applied the painting process that he has all along loved to the captured moment of photography. However, his line up of acts was different from what he previously presented.

Looking at Wu Tien-chang's work after 2000, it seems we are entering into a strange mixture of magic and art. This kind of eccentric atmosphere wasn't only due to the characters in his photographs, but also included Wu Tien-chang's computer image manipulation techniques, and the metaphysical content that he creates. To create the most obviously deformed images, Wu Tien-chang uses a technique of double exposure[30], generating two versions of one figure in the image. Another kind of deformity is twisting the features or

posture of the model, so that they appear to have Down Syndrome, dwarfism or mental retardation.

Is doubling just a technique for composite images? Or is it a visual manifestation of the ambiguous feeling when the self is searching for another self subconsciously? A double also signifies a desire to both unite different selves, and to split the united self by transcending it. When two versions of the self suddenly appear before our eyes, it is exactly the surprising impossible possibility - which makes us shout out, "That's him!" - that takes the ambiguity of the subconscious and drags it from the impossible imagination to the verifiable image, just like the inconceivable land of dreams made real before our eyes. Wu Tien-chang's digital images of the double are sometimes just like reflections of the self in a mirror, and at other times like an enemy destroying the subjectivity of the self. Perhaps the double is the darkest and the most mysterious desire within the self, that forces the self to vanish, and the most heretical part of the subconscious[31].

However, what kind of visual tension does deformity added to the double? In Wu's work "Two Would Treat Each Other", the doubled and dismembered acrobats are riding a tandem bicycle, dressed in bright red costumes with matching hats, wearing thickly applied makeup and wide grins like zombies. In "Dream of Impermanence", the dwarf prince of the circus under the ambiguous lighting rides on the back of a clown and strikes a pose. In "Be in the Same Boat", four sickly looking Down Syndrome clowns joyously walk on stilts in a dragon boat. In "Perfect Day Trip", the doubled figures are middle aged children in scouts uniforms, looking a little put out but with childlike expressions and are shrouded in a cold, peach-colored atmosphere. They are carrying a litter that holds a heavy retarded woman smiling through makeup with her arm in a blood-stained sling. These images seem to bear traces of ridicule but we don't hear the sound of laughter[32]. The treachery in this heretical, inhuman series by Wu Tien-chang seems to be very distant from the middle-class cultural climate of cleanliness, health, beauty and high quality name brands that currently fills the culture circle. There is a feeling of distance, but the two styles aren't completely unconnected, thus this series reflects different stylistic features from his work in the 90s.

The specters in his 1990s salon style has been retired and replaced with still photos of heretics and zombies at a magic show. However, these phony stage stills by Wu aren't only Ah-Q-like salon photos sneering at the middle classes or important people, they also aren't merely attempting to subtly satirize middle-class morals through the forbidden desire of the necrophilia. I believe that the phony, mannerist style in Wu's work after 2000, especially down to "Perfect Day Trip" (2007) experimentally shuttles between farce and tragedy in an attempt to connect the confused feeling of material form with the metaphysical form of schizophrenic disorders.

Perhaps an interesting question has arisen here long ago: why does Wu Tien-chang always want to pretend in his work? When will he stop with all of this phoniness? Actually, the answer is in the question. Perhaps by consistently making the audience aware of phoniness, Wu is hiding the realness in the fake. What we thought to be the boundaries between real and fake weren't necessarily real. On the contrary, what we thought was real was perhaps pretending to be fake. Is this the posture that has been adopted by Wu Tien-chang all along to avoid making clear the line between real and fake? Or is it the exact opposite; he has been pointing the way to the boundary between real and fake for us, and so his work is the dividing line itself? I have called this series by Wu Tien-chang "heretical magic" and at least there are three different kinds of visual traces pointing to schizophrenic disorders.

The first kind is in Wu Tien-chang's familiarity with contemporary consumer culture which he dresses up in a carnival atmosphere. This carnival is played out with vulgar, retarded, filthy, counterfeit, fragmentary and marginalized irregularities, and extracting and purifying and forging together a carnival with no social class he mixes respected/reviled, big/small, strong/weak, intelligent/stupid, hilarity and sadness all into one[33].

Wu Tien-chang mixes these despised, forgotten lowly, unfortunate, fringe characters, with the use of make-up, acting and high quality digital photography, with

rough dark life folding, incomplete and excessiveness (they grew too slowly, aged too quickly, are too fat, too short, too ugly or too stupid) to suggest the shadow of destiny by framing these scenes. This framing seems to look into the violence of destiny, crowning the unlucky and despised with our attention to their suffering, for an instant of vanity. Wu Tien-chang has framed these old child-like people, who have grown too quickly or too slowly, with fragmented bodies, fake and abnormal forms and deformed with make-up to force out life's genuine qualities hidden within a moment of eternity, and to fight back against cruel fate with a smirk or laughter.

A splitting tension in identity differences arises between the second kind and the first kind of carnival mentality. The second kind of imagery exposes the first kind of carnivalesque disguise. Please have a look, this carnival isn't the one you recognize! The relationship between the artwork, audience and exhibition space isn't compiled into the golden years. On the contrary, in his digital photography, Wu Tien-chang has always used meticulous, exaggerated processing methods to solidify rigid, detached and juicy-cool colors. What we see is merely a fabrication of a visual atmosphere of the golden years, which actually looks more like a funeral or a party of invisible inhumanity, monsters and goblins.

When the audience sees these works, they probably won't get the same joy they get from attending temple festivals or carnival parties. There is no way for the audience to temporarily forget their own plight in the real world in these noisy and indulgent parties. On the contrary, audience members stare at these framed happy funerals on the walls with solemnity and even dread. The ghastly colors in these isolated scenes, malignant smiles and old and young midgets are playing in some deformed performance. At some point the audience begins to become aware that the players before their eyes seem to be thickly made up and costumed in attractive funerary clothing to perform a show for the dead, happily crossing over between their own and someone else's death. Perhaps, these players are just like mythical figures on paper funerary props that are placed around a coffin, and are preparing to send their dead selves to heaven.

Realizing this layer of the self is happily sending off the dead self, a creepy feeling pierces right through the manipulation mechanism which consumer culture uses to take every symbolic system and include it in a fictitious safe way of buying, selling and exchange. Because all of this already has arrived at the taboo dividing line between life and death, the self cannot consume the death of the self. Once the self dies it falls into a difficult to imagine abyss. From good times wearing make up to a joyous funeral, that difficult to match-up and transform other who has the effrontery to be so close to the self. It seems that those heretical people are my doubles, they were dead, consumed, nullified, and became more clear as we tried to hide from this truth.

And then, we have come to look at the third kind of visual symptom, which I call a Zhilishu disguise[34]. In the carnival disguise described above, taboos concerning death become more obvious as they are intended to be hidden. The feeling of distance and strangeness that arises doesn't stop when the dread are called forth by the enormous tension which is revealed between nothingness, consumption, death and life. However, the theatrical tension created that was originally hidden is later recognized, and the tragic character that uses limited choices to fight against the absolute and unlimited fatal events only belong to a tragic hero, who believes in self purification, self transcendence, sacrifice for ideals, life as a way of no return, and the arbitrary aesthetic of irreversible time. All of the above are not the spiritual aspect or aura that Wu Tien-chang pays attention to in these works.

The phony or mannerist aesthetic that Wu Tien-chang attempts brings with it a strange smile that sees death in life and life in death, so everything can be renewed. Roland Barthes wrote, "History is hysterical: it is constituted only if we consider it, only if we look at it--and in order to look at it, we must be excluded from it." [35] We must dive deeply into the dialectics of emptiness and fullness before we strive to jump out of this fatal scene at this key point in time, and start on a new opportunity of life theater. Renewing isn't really an excuse or avoiding, but is the buoyant and hopeful will to smile when we are facing a dangerous and critical moment. Since there is no way to reach this

夢魂術（數位輸出） Spirit Dreaming Conjuration 2003　　　　　　　　　　　　　　夢魂術文本 Text of "Spirit Dreaming Conjuration" 2003

target in real life, why not use art to create the fantasy?

Regardless of the stillness in Wu Tien-chang's photography, those seemingly dead figures are called upon to walk back from the past as if they are answering to a ritual of invocation of spirits. In another way, because they are stopped in the frame, their motionless colorful makeup and costumes make them look like dead bodies. Perhaps we can say that their physical bodies are on the verge of being cremated by time. They are obviously not alive, but are pretending to be alive, and what is obviously the dying moment is pretending to be a blessing that witnesses eternity. These characters presented to us here who are enjoying a special honor aren't the most important people who can shake the whole world, nor are they the favorite idols of the mass media, but rather someone who never remains in our memories. (however, they were once active in acrobat show business from 60s to 70s when television program has not yet replaces live performance) [36]. Hiding all along in real objective society and on the dark fringe of subjective consciousness those strange people who are regarded as lowlife, filthy, lowly and reviled and are like characters in *Zhuangzi*'s "The Sign of Virtue Complete". Through digital photography, these

characters can once again be reproduced and never die away, which creates the visual paradox of immortality. However, the flavor of death that is revealed in the photographs seems to be an acrobat show repeating a funeral rite. Could we call this a contemporary counterfeit version of Zhuangzi's life in death/death in life?

VI. A Curtain Call for the Omnipresent Pretending

Do not ask me who I am and do not ask me to remain the same. – M. Foucault [37]

If we say that Wu Tien-chang's phony salon photographs of the 1990s possess a theatricality that satirizes the 1960s, by taking the self and dressing it up as a self that is not the self to breakthrough taboos and to challenge or satirize the oppression and detachment created by authority, then after the year 2000, did his series of strange and heretical figures continue to look back upon and transgress the taboos of that era in the past? Perhaps following the seasons, the battleground of material requirements and the spirit of the times have already changed. Has the entire atmosphere of the era already been transformed?

From the end of the last century to the beginning of

永協同心（數位輸出） Two would Treat Each Other 2001
同舟共濟（數位輸出） Being in the Same Boat 2002

this one, Wu Tien-chang's artistic style of pretending has already become an exploration of a closed community. No matter what extrinsic powers he is addressing, they all are always in a condition of spiritual pretending. Perhaps it is on account of external pressure, or maybe the consciousness of this outside force that internalized something to the point where someone no longer cares whether or not there is an external force. Why repeatedly pretend? Why continue to put on an act? How do we regard the act to gain attention by pretending and costuming, and the complex of self affirmation, self deficiency and self deception? In the costume, do they isolate themselves or just turn into total exhibitionists?

Carnivalesque laughter is a response to the crisis of life because it relieves the original tension created by rigid or stressful orders. Laughing at crises brings with it an affirmation of hope and negation of ridicule[38]. However, hysterical laughter does not address crises, but rather allows one to fall into the illusion that the crises have been averted. Then what about pretending hysteria? In Wu Tien-chang's images, sneering that is deeply hidden in the act of pretending frames a vivid and humorous picture of contemporary society which is splitting into self expansion and detachment. Wu uses omnipresent pretending to parody the deficiency and conflict of self isolation, and the endless implosions, empty shows and borderline hysteria in self isolation.

As if witnessing time as we approach the last stage of an age, the artist had decided to frame the critical moment in photography before it was too late, by pushing the shutter on the camera he can create another forgery that demonstrates a perfect curtain call for this unbearable life. By way of the theatrical funeral held for the self, one carries out a deeper and more mysterious escape; after waving the last goodbye, the self secretly appears on the stage in disguise.

Is this the current situation in Taiwan? Is it Wu Tien-chang's imagery or is it my own hallucination? Maybe this writing about Wu Tien-chang is just another scrape with real phoniness. However, what exactly does the artist want to say? Michel Foucault can help Wu Tien-chang express it: "*Do not ask me who I am, and do not expect me to remain the same.*" Do you want to know if Wu Tien-chang is the real Wu Tien-chang?[39] Wu Tien-chang's magic show is about to begin, please step inside.

(This article was originally printed in February 2008, *Modern Art* No.136)

Notes

1 The writer of this article would like to thank Wu Tien-chang for assistance in providing information regarding artwork and creative concepts; Celin Chen and the staff of the Collection Department of Taipei Fine Arts Museum for access to original art; Mr. Liu Ting-wei, Lee Ming-fung, Chen Yu-hsu and Ms. Chen Wan-chi for assistance in editing text, images and tape recordings.

2 This sentence is paraphrased from 'The Grave Song', *Also Sprach Zarathustra* by Friedrich Nietzsche; translated by Lin Chien-kuo, Taipei: Yuan Liou Publishing Co., 1989, p. 118-119

3 Roland Barthes, *La Chambre Claire*, trans. Hsu Chi-lin, Taipei: Taiwan Photography Trimonthly, 1997, Section 48

4 The writer/Wang Ching-ling

5 Huang Chun-hsiu, 'On Chinese Figurative Paintings and Portraits', *Journal of the National Museum of History*, vol. 10, 1998, p153

6 Lo Pao-chu, 'The Composition and Decomposition of History/Reality and Simulation/Illusion - The art of Wu Tien-chang', *Modern Art*, Vol.121, 2005, p40-41

7 Chen hsiang-chun, 'A Visual Epic that Ridicules the Nation', *Artco: Art Archive for Society*, 2003, Jan, p113

8 In Chinese custom, doing a caricature of someone, in which the subject's distinctive features or peculiarities are deliberately exaggerated to produce a comic or grotesque effect, would be considered a great humiliation to the subject（Chuang Po-ho, 'On Folk Portraits', Art Education, 1998, Vol. 99, p34）. Because these portraits are not composed of merely visual elements like colors and lines, they are also drawings that capture the spirit of the subject, consciously or unconsciously by the artist, and this has affected the future of the subject. This invisible power of manipulating fate can work on anyone. Even a political strongman can not be exempted from such a system of folk belief which regards all beings as having souls and posits the existence of universal powers that interrelate with one another. Nothing can be as eternal and invincible as God in Christianity even if you are a supreme emperor. Conversely, an emperor will still have to participate in the wheel of fortune and interact with others. This rule also applies to the portraits of an emperor.

9 Based on my interview with Wu Tien-chang on November, 10th, 2007, please refer to Yao Jui-chung's 'Soul Draining or Soul Dreaming, Wu Tien-chang's Digital Recarnation?', *Main Trend Gallery: Wu Tien-chang*, Spring issue, 2004, p72-73

10 Allow me to borrow the term "aura" from Walter Benjamin's 'Little History of Photography', Walter Benjamin Essays, trans. Hsu Chi-lin, ' Taipei: Taiwan Photography Trimonthly', 1998, p27-40

11 Maurice Blanchot, *La Chambre Claire*, trans. Hsu Chi-lin, 'Taipei: Taiwan Photography Trimonthly', 1997, p124

12 Chen Ying-chen, 'The False and Real Aspects of Economic Development in Taiwan: Interview with Liu Chin-ching', *Groundbreaking*, Taipei: Renjian Publishing Co. , 1988, p177-192; Chen Ying-chen, *Against Hypocritical Articulation*, Taipei: Renjian Publishing Co. , 2002, p31-33; 2; Yang Du, 'Introduction: The Era of a Collapsing Tyranny', *The Collapse of Tyranny*, Taipei: Yuan Liou Publishing Co., 1988

13 Ru-Shou Robert Chen, Dispersion, Ambivalence and Hybridity: *A Cultural-historical Investigation of Film Experience in Taiwan* in the 1980s, Taipe: Wanhsiang Publishing, 1997, p29-34

14 Wu Jiabao, http://www.fotosoft.com.tw/book/papers/library-1-1005.htm; Lo Ching, *What is Postmodernism*?, Taipei: Student Book, 1989, p317-318

15 Chuang Po-ho, 'On Folk Portraits', *Art Education*, 1998, Vol. 99, p34

16 Wu Jiabao once said, "The first blooming period of Taiwan photography was also the time when salon photography reached its apex in the history of photography in Taiwan, which started from the 1950s in the recovery of Taiwan to the mid 1960s" , he also said, " before the 1970s, this otherworldly salon photography was the main stream scene in Taiwan photography culture. It not only lacked the ability of creating new developments, but it also was out of touch with photography trends around the world." See http://www.fotosoft.com.tw/book/papers/library-1-1005.htm, Kuo Li-hsin, *On Photography*, Taipei: Yuan Zun Publishing, 1998, p34-35

17 Wu Tien-chang said: " Youth is fleeting, I want to steep youth in formaldehyde."Quoted from interview with Wu on October 2nd, 2007

18 From an email reply to me from Wu Tien-chang on November 12, 2007

19 From an email reply to me from Wu Tien-chang on December 1, 2007

20 This thought has been a recurring theme in the four interviews I had with Wu Tien-chang on October, 2, October 9, October 24 and November 10, 2007

21 This aspect of Wu's work is very much similar to the work of Huang Chin-ho. For more information please refer to my article 'No Ordinary Form: On Huang Chin-ho's Art', *Art Criticism Quarterly*, 2004 Fall, p 76-86

22 'Red Roses, White Roses,' is the background music for the installation site of"Unwilling to Part from Worldly Life II"

23 Lee You-huang, 'The Visible and Invisible Artistic Path: Its Clear Past and Misty Future,' *Artistic Development and Social Transition in Taiwan II: Formosa Mambo* (cat.), Kaohsiung: Kaohsiung Museum of Fine Art, 2007, p21

24 From an email reply to me from Wu Tien-chang on November 29, 2007

25 Huang Hai-ming, ' A Hole Oozing out Garish Desire and Memory: The Chronotope in Wu Tien-chang's '97 Exhibition', *Mountain Art*, vol. 90, 1997, p 103

26 Huang Hai-ming, 'Contemporary Art of Taiwan' GVirtual Connections°DCriticism°DReturnings', *Taiwan Taiwan: Facing Faces* (cat.), Taipei: Taipei Fine Arts Museum, 1997, p24

27 Sigmund Freud, Chapter 2: Taboo and Emotional Ambivalence, *Totem and Taboo*, trans. Yang Yung-yi, Taipei: Chih-wen Publishing Co., 1986

28 From an email reply to me from Wu Tien-chang on November 12, 2007

29 Roland Barthes, *La Chambre Claire*, trans. Hsu Chi-lin, Taipei: Taiwan Photography Trimonthly, 1997, p82-83

30 Double is a technique to take a photo of a same person twice, and composite them into one image. For details please refer to Cheng Hseng, Hu chih-chuan, Ma Yun-tseng, Chien Chang-biao, Peng Yung-hsiang, *History of Photography in China*, Taipei: Photographers Publications, 1990, p 111

31 In Fyodor Mikhailovich Dostoevsky's novel *The Double*, Yakov Petrovich Golyadkin is a proud government clerk. He despises a conspiratorial mind, sweet words and insinuating manners; however, after being deeply humiliated, these less desirable characteristics have been manifested in a double, Golyadkin Junior. Because he was torn between himself and his corrupt and cruel facsimile, Golyadkin finally went mad. For details please refer to *The Double*, trans. Chiu Hui-chang, Taipei: Elite Publishing, 1976

32 *Problems of Dostoevsky's Poetics*, vol. 5, *The Collective of M.M. Bakhtin*, Shijiazhuang: HeBei Education Press, 1998, p219

33 See vol. 5, *The Collective of M.M. Bakhtin*, p162-163

34 This is a concept I borrow from *Zhuangzi*'s Inner Chapters 'The Sign of Virtue Complete' and 'The Adjustment of Controversies'. Zhilishu is the name of a deformed person who forgets about his own disadvantages, therefore people respond to him by the way he acts. Here I use it to suggest that by fabricating theatricality in his imagery, Wu Tien-chang has managed to make the viewer forget about the deformation of the figures in his art and reached a stage of death in life, and life in death.

35 Roland Barthes, *La Chambre Claire*, trans. Hsu Chi-lin, Taipei: Taiwan Photography Trimonthly, 1997, p82-83

36 From an email reply to me from Wu Tien-chang on October 9, 2007 and November 29, 2007

37 Michel Foucault, *L'archéologie du savoir*, trans. David D.W. Wang, Taipei: Rye Field Publications, 1993, p88

38 See vol. 5, *The Collective of M.M. Bakhtin*, p166-167°C

39 This line is taken from Pili Drama Series," Pili Sword Souls". In Episode 9: The Ruler from Outer World, Insightful Lantern is the avatar of Ming Chitien, and said,"Oyang Shiangchih is the real Oyang Shiangchih." In the story everyone is trying to kill the bad guy, Oyang Shiangchih, who is a master of martial arts, disguise, and is able to appear and disappear mysteriously. It is a pity that Oyang left the story in a hasty death. For the details please visit http://blog.xuite.net/henry10187/whitewing

特別感謝
Acknowledgements

張乾琦（Chang Chien-chi）
彭弘智（Peng Hung-chih）
林明弘（Michael Lin）
王文志（Wang Wen-chih）
黃進河（Huang Chin-ho）
郭維國（Kuo Wei-kuo）
許雨仁（Hsu Yu-jen）
陳慧嶠（Chen Hui-chiao）
李國民（Lee Kuo-min）
吳天章（Wu Tien-chang）

旗艦巡航──台灣當代藝術選粹（二）

發 行 人　謝小韞
編輯委員　陳文玲　吳昭瑩　劉建國
　　　　　全永慰　甘恩光　許金兆
編　　輯　陳淑鈴　方紫雲
編輯助理　甘　霈
譯　　者　張至維　魏安德　劉燕玉
美術設計　孫文琪
印　　刷　四海電子彩色製版股份有限公司

著作權人　台北市立美術館
發 行 處　台北市立美術館
　　　　　台灣台北市中山北路三段一八一號
　　　　　Tel: 886-2-25957656
　　　　　Fax: 886-2-25944104
出版日期　中華民國九十七年十一月　初版
定　　價　新台幣500元
統一編號　1009703375
ISBN: 978-986-01-6306-3

版權所有·翻印必究

作品版權所有：藝術家，文章版權所有：作者
圖片版權所有：攝影師

國家圖書館出版品預行編目資料

旗艦巡航：台灣當代藝術選粹. 二／陳淑鈴,
　方紫雲編輯. -- 初版. -- 臺北市：北市美
術館，民97.11
　　面；　公分
中英對照
ISBN　978-986-01-6306-3（平裝）

1. 藝術評論　2. 現代藝術　3. 臺灣
907　　　　　　　　　　　　97022459

Artist Navigators II
Selected Writings on Contemporary Taiwanese Artists

Publisher: Hsieh Hsiao-yun
Editorial Board: Chen Wen-ling, Wu Chao-ying, Liu Chien-kuo,
　　　　　　　　Chuan Yung-wei, Kan En-kuang, Hsu Chin-chao
Editor: Chen Shu-ling, Fang Tzu-yun
Editorial Assistants: Kan Pei
Translators: Eric Chang, Craig D. Stevens, Andrew Shane Wilson,
　　　　　　Liu Yen-yu
Graphic Designers: Melody Sun

Printed at Suhai Design and Production Inc., Taipei, Taiwan
Publisher by Taipei Fine Arts Museum
181, ZhongShan N. RD., Sec. 3, Taipei, Taiwan
Phone + 886 (0)2 2595 7656, Fax + 886 (0)2 2594 4104

November 2008, Taipei Fine Arts Museum, Taipei, Taiwan

All rights reserved. Copyrights of the works are reserved for the
artists; of texts for authors; of the photographs for the photographers

GPN: 1009703375